THE GENIUS OF THE FUTURE

Anita Brookner

THE GENIUS OF THE FUTURE

STUDIES IN
FRENCH
ART CRITICISM

Diderot Stendhal
Baudelaire Zola
The brothers Goncourt
Huysmans

PHAIDON *London · New York*

Phaidon Press Limited, 5 Cromwell Place, London SW7

Published in the United States of America by Phaidon Publishers, Inc.
and distributed by Praeger Publishers, Inc.
111 Fourth Avenue, New York, N.Y. 10003

First published 1971
© 1971 by Phaidon Press Limited
All rights reserved

ISBN 0 7148 1497 0
Library of Congress Catalog Card Number: 75-156471

Printed in Great Britain by
Western Printing Services Ltd Bristol

Contents

List of Illustrations

Acknowledgements

The publishers wish to thank the following for providing the photographs:

Archives photographiques of the Caisse nationale des Monuments historiques: 1, 2, 5, 7, 9, 14, 15, 18, 19, 20, 21; Photo Giraudon, Paris: 3, 10, 25, 28; R. B. Fleming and Co., London: 4; ACL, Brussels: 8; Coll. Viollet, Paris: 12; Mansell Coll., London: 6, 23; Galerie Bernheim-Jeune, Paris: 17; Courtauld Institute, London: 22, 24; Radio Times Hulton Picture Library, London: 26; Sherwin, Greenberg, McGranahan and May Inc., Buffalo: 30. No. 4 is reproduced by permission of the Director of Art, Arts Council of Great Britain.

'La place est balayée pour le génie de l'avenir'

—ZOLA, Salon of 1879

Introduction

THIS BOOK WAS ORIGINALLY planned as a course in French art criticism to be given at the Courtauld Institute of Art. The course then escalated into six of the Slade Lectures which were delivered at Cambridge in 1967–8. Since that time, while continuing to teach the subject, I have become more and more impressed by the prophetic nature of such criticism, and by the fact that for men of letters works of art provide an ideal vehicle for expressing truths about their experience not only of pictures but of life itself. Rather than any kind of abstract philosophy of the fine arts, the art criticism of Diderot, Stendhal, Baudelaire, Zola, the Goncourts, and Huysmans exudes a peculiarly strong flavour of personality and this is perhaps the most obvious link between them.

For most of the writers in this study, with the single exception of Baudelaire, painting was a marginal activity, completely external to their own preoccupations, something which could never aspire to be weighed in the same balance as moral philosophy or *la chasse au bonheur* or the completion of an epic. Painting was either a vehicle for reminiscence or a symbol of an absent friend but it was rarely as important as the train of thought it originally or habitually gave rise to—Stendhal, for example, when talking about individual pictures, can rarely be bothered to stick to the point for more than two sentences. Like travellers cheerfully disembarking on some fairly alien shore, they tell us more about their own journey than about their point of arrival.

Some of this may be due to the extremely elastic limits of art criticism as a branch of academic criticism. The genre was not the rigid toadying exercise that it has become today but rather a career open to all the talents, the field in which the man of letters could not only reveal the extent of his own dilettantism but could say something untoward, let slip some information about himself, his knowledge of, and feeling for, the artist, some cardinal fact about the long slow climb towards interpretation which is the true subject of all criticism. In the period under discussion here, artists rarely saw fit to print their own views; the field of letters belonged very definitely to the man of letters, and this is even more true of the situation in France where the barrier between the genres was symbolized by the fact that each discipline had its own specific tribunals. The situation was further crystallized by the fact that

the word of the man of letters was regarded as law. In the nineteenth century there is no example to compare with Falconet, who got fed up with the interpretations foisted on him by Diderot and published his own flaming rebuttals in the form of letters. The sharpness of the in-fighting here makes one look rather askance at the Impressionists who had reasonable grounds for taking issue with Zola's eventual condemnation of their aims but never actually thought to refute it in print. Even Cézanne, who laboured for thirty years in the shadow of Zola's implicit disapproval, never considered a reasoned counter-manifesto, although this would have done an immense service to his friends and incidentally to the biographers of Cézanne himself.

By some odd rule of reverses, this situation makes us side with the painters who gain wisdom by their silence and appear to us not only as sages but as martyrs into the bargain. The slashing and irreverent critics, often totally unqualified and inaccurate, now stand before us slightly scarred by the verdicts of posterity. They truly rushed in where angels feared to tread. By the highest standards of judgement they may all be said to be slightly flawed— by their common hatred of sculpture, and by their failure to accept the art of their time as being the art of their time—but there is no mistaking their intoxicating generosity of temper or their great expectations of the future. Generally speaking, the writer's life is less gregarious than that of the painter: writers do not or should not move around in groups, nor are they generally provided for by patrons or dealers. The art critic in particular can feel very isolated, humiliated by the apparently menial nature of his task, and acutely conscious of his relative lack of creativity. The critic Planche, in a surprisingly bitter outburst, described his calling as . . . *une oisiveté officielle, un perpétuel et volontaire loisir. C'est la raillerie douloureuse de l'impuissance, le rôle de la stérilité, c'est un cri d'enfer et d'agonie.* ('Official idleness, a permanent and self-imposed form of inactivity. It is the poignant mockery of impotence, the part played by sterility, an infernal, agonized cry.') It is precisely the absence of this bitterness and rancour that has impressed me in the six characters chosen for this study. Out of the welter of their duties, usually lonely ones, these writers performed their journalistic task with an innocence, that is to say, a genuine lack of worldliness or compromise, which compels not only

our admiration but our very deepest respect. For them, criticism was an article of faith, and for us, the readers, their criticism now appears in some curious way to be about the very nature of faith itself.

In this enterprise I owe a debt of gratitude to my publishers and to my colleagues in London and Cambridge, notably Alan Bowness, John Golding and Bruce Laughton. David Wakefield very kindly undertook the translation of the passages in French (with the exception of the Baudelaire essay, where some of the longer extracts are quoted in Jonathan Mayne's admirable version). My interest has been kept alive by my students who alone can furnish that *sensation du neuf* which is the teacher's greatest reward. To all these people I extend my sincere thanks.

DIDEROT

Diderot

IF THERE WERE ONLY one test of literary greatness in France, Diderot would pass it with flying colours: Sainte-Beuve admired him. The prudent, canny, and infinitely melancholy Sainte-Beuve, crowned critic of the nineteenth century, did not bestow his heartfelt appreciation lightly, and it is appropriate that a study devoted mainly to art criticism in nineteenth-century France should begin with a salute, from that century, to Diderot, the greatest critic of his age. There are, in addition, obvious and overwhelming reasons to link Diderot with the succeeding epoch. His art criticism was indeed a nineteenth-century discovery, for the *Salons*, and a number of his other works, remained unpublished during his lifetime. With a carelessness or, more properly, a fruitfulness utterly alien to our twentieth-century way of thinking—it was already considered phenomenal in the nineteenth—Diderot wrote as naturally as he talked but was not ambitious for literary fame. Many of his manuscripts remained lost for years. The most famous case in point is his brilliant semi-fantasy, *Le Neveu de Rameau*. The original manuscript was not discovered until 1891, and discovered accidentally, by someone rummaging through the book boxes by the Seine in Paris. An earlier copy of the text had been smuggled out of Russia, given by Schiller to Goethe who translated it in 1804, and translated back into French from Goethe's German in 1821. Therefore, although Diderot's contemporaries knew that he wrote, they did not know him as a writer so much as a polymath, an outstanding, widely respected and above all popular intellect. He was affectionately known as *le Philosophe*, much as Jean-Jacques Rousseau was, less affectionately, known as *le Citoyen*, and his name was inseparable from the gigantic enterprise of the *Encyclopédie*, that attempt to present the French with an enlightened version of all existing knowledge, cunningly cross-referenced to provide the initiated with even more enlightenment and bearing only a vestigial resemblance to the work that inspired it, Chambers' *Cyclopaedia*. Of this enterprise Diderot was the justly famous editor, assisted, in alternating bursts of boldness and prudence, by d'Alembert.

Sainte-Beuve has given us an excellent thumb-nail sketch of Diderot at work (so has Diderot himself, for that matter), and it is therefore easy to envisage this great, expansive, democratic personality, with his unflagging

verve, his almost boring virtuosity, and that touch of the unfinished in his make-up which led him to prize the brilliant sketch, the great potential, the genius of the future. On a day-to-day level, he was a hard-working journalist, usually short of money and time, but otherwise enjoying absolute moral independence, give or take a few months' imprisonment on a minor literary offence in 1749 and a double-cross by his publisher Le Breton in 1764. Although he was seen to behave as a journalist—editing, translating, writing his daily stint—he had the temperament of some divinely appointed moral tutor. Born in Langres of a family of artisans and priests, he had in fact been intended for the priesthood himself: he was educated by the Jesuits and was a Master of Arts of the University of Paris. He was an exceptionally learned man, with a particularly profound knowledge of Greek and Roman history and philosophy and the natural sciences. This serious side of Diderot was translated into practical terms; the aim of the *Encyclopédie* was both intellectual and altruistic and it was a project in which Diderot had a fierce belief. Contributors included Montesquieu, Voltaire, Buffon, d'Holbach and Marmontel; subject matter was occasionally of revolutionary audacity. Although one might read a careful article on weaving by Diderot himself, who had, of course, visited a weaving shed for this purpose, one was equally likely to come across a stiff piece of anti-clerical propaganda, written by d'Alembert under the innocuous heading *Geneva*. The labour of editing all the entries, of translating a number of them from the original English or Dutch, of playing cat and mouse with the royal censor, who was well aware of the subversive nature of the whole enterprise, was Diderot's day-to-day task, one which he discharged with an astonishing verve for twenty-five years but which eventually took its toll of his expressive and expansive powers.

Nevertheless, there is a streak of the true journalist in Diderot. He is the first of the great popularizers. Although he wrote on the most abstruse of subjects, his works of philosophical speculation, like the *Lettre sur les Aveugles* or the intoxicating *Rêve de d'Alembert*, can be enjoyed even by those who have no understanding of such matters. They are written with a great rush and speed of vitality, a fantastic pile-up of verbs, to which one instinctively responds. Absolutely typical in this respect is Diderot's definition of that mid-

century phenomenon sensibility, which begins soberly enough but soon gets out of hand: *La sensibilité, selon la seule acceptation qu'on ait donné jusqu'à présent à ce terme, est, ce me semble, cette disposition, compagne de la faiblesse des organes, suite de la mobilité du diaphragme, de la vivacité de l'imagination, de la délicatesse des nerfs, qui incline à compatir, à frissonner, à admirer, à craindre, à se troubler, à pleurer, à s'évanouir, à secourir, à fuir, à crier, à perdre la raison, à exagérer, à mépriser, à dédaigner, à n'avoir aucune idée précise du vrai, du bon et du beau, à être fou.* ('Sensibility, according to the only meaning that has been given to this term up to now, is, it seems to me, that disposition which accompanies weak bodily organs, and which results from the mobility of the diaphragm, liveliness of the imagination and sensitivity of the nerves, inclining us to pity, to shudder, to admire, to fear, to be disturbed, to weep, to faint, to help, to flee, to cry, to lose our reason, to exaggerate, to despise, to spurn, to have no clear idea of the true, the good and the beautiful, to be mad.')[1] We shall hear a great deal more about that 'mobility of the diaphragm' which is Diderot's paraphrase for rapid and total response to the phenomena of this world. Another reason for Diderot's intense readability is the fact that he has no love for abstract terms, so he makes them flesh, turns ideas into humours, transforms an exposition into an imaginary dialogue with a real person, i.e. into the report of a conversation which he might have had with Jean-François Rameau or with d'Alembert but which he in fact had with himself.

It is important to realize that there is nothing meretricious in journalism as practised by Diderot. On the contrary, it is a wholly honourable activity and one which is inseparable from his status as a *philosophe*. Although our main concern here is with Diderot's activities as an art critic, a field in which his position is absolutely secure and his primacy widely acknowledged, he must be put into his general intellectual context if only we are to understand the full meaning he attaches to the terms 'nature' and 'morality'. A *philosophe* is not so much a philosopher as a propagandist, and a propagandist, moreover, of a very special sort. The *philosophe* is *against* the miraculous explanations of the world's existence given by orthodox theologians; he is *in favour of* an attempt to understand this world in terms of natural causes. He is, in a word,

a second generation disciple of John Locke, whose *Essay concerning Human Understanding*, translated into French in the very last years of the seventeenth century, had a far more sensational effect in France than it ever did in England. The main points of Locke's *Essay* are as follows. There are no innate ideas. All knowledge is the outcome of a dual process of sensation and reflection. The origin of our knowledge is to be sought in our senses. Knowledge thus acquired is translated into judgement or reason. This is our only instrument for finding the truth and we must apply it constantly: 'Reason must be our judge and guide in everything.' It is important that moral truths, which govern our conduct, be submitted to the test of reason unless they have been made known to us by a direct *personal* revelation by God. (Revelation to another person is not valid.) Reason and faith (revelation) are therefore entirely different processes. This should be acknowledged. As we cannot, within the limits of our reason, know God, we should use our faculties for what they seem best fitted: a knowledge of the world and of ourselves ('the direction of nature where it seems to point out the way'). Our knowledge of good and evil, and of what is good or bad for us, is determined by our reaction of pleasure and pain. Our interest and our duty lie in a 'careful and constant pursuit of true and solid happiness', i.e. a greater proportion of pleasure than pain.

This is, in fact, a very reasonable and practical doctrine, but when it reached France it was given a completely different emphasis and regarded as a teaching of revolutionary implications.[2] The peculiar circumstances operating in France served to make certain points stand out in high relief so that to the French Locke's message appeared as follows: the root of our knowledge is in our senses which we must use in order to acquire material on which to reflect. Our body will tell us what is good or bad by setting up feelings of pleasure or pain—but we must wait for our body to tell us. If good equals happiness, we must multiply the occasions of pleasure. Knowledge of God must be left to mystics. One must opt for either faith or reason. And, by inference, the doctrines of original sin, grace and redemption are not valid since we have no personal proof of them, and sacraments and priests are useless since our instinctive call to good or happiness serves the purpose

equally well. The distinction between reason and faith, to which Locke devotes a whole chapter, becomes one of the basic tenets of eighteenth-century French thought.

The immediate effects of this apparent destruction of Christian first principles are dramatic, and the most dramatic of all is the removal of pessimism. The eighteenth century as a whole, the Enlightenment in particular, are incredibly optimistic. Diderot is a case in point here. We know enough—but not too much—about his poverty, his journalistic hard labour, his gall-stones, the stupidity of his wife, the death of three of his four children, the apostasy of his friends Rousseau and Falconet, to realize that his daily life was in many ways unrewarding. Yet all we hear from Diderot himself is a sustained note of joyous enquiry. The second effect of the materialist or sensualist philosophy is an emphasis on this world, a positive approach to man and his place in society. By the same token, man is seen as the sole guardian of his powers and moral instincts and of his faculties as instruments for experiment. Voltaire's unceasing war on *l'infâme*, i.e. religious superstition, Rousseau's prolonged examination of the mainsprings, or what is now called motivation, of his conduct, Diderot's visionary exercises (he is careful to call them dreams) in which he glimpses on matters as vast as evolution and the conditions for psychic health, all relate to this central tenet of eighteenth-century doctrine. And perhaps an equally important legacy of English philosophers like Locke and Shaftesbury (whom Diderot preferred and whose *Essay on Merit and Virtue* he translated in 1745) was the anglomania that appears in phenomena as divergent as the popularity of Samuel Richardson's novels, Voltaire's *Lettres philosophiques*, and the impulse behind the *Encyclopédie* itself.

But Diderot belongs to the second generation of materialists. If Voltaire remains tied to the first generation by his iconoclasm and his hatred of the church, Diderot reveals his modernity precisely by acknowledging in himself a piety which does not relate to the God of the Christians. It would be a very grave mistake to regard the *philosophes* as atheists or even agnostics. Even Voltaire recognizes the need to believe in the idea of God. The famous dictum: 'If God did not exist, it would be necessary to invent Him' is not a wise-crack; it is a revelation. Diderot is much more open. In the *Salon* of

1769 he suddenly cries, *Je souffre mortellement de ne pouvoir croire en Dieu*, and one cannot read any of his writings without realizing that he is by nature a truly devout man. Even his famous vision, in the *Rêve de d'Alembert*, of a purely materialist life cycle has something awestruck, religious, about it: *Vivant, j'agis et réagis en masse . . . mort, j'agis et réagis en molécules . . . Naître, vivre, et passer, c'est changer de formes.* ('Alive, I act and react as a mass . . . dead, I act and react in molecules . . . to be born, to live and to die is to change form.') Therefore the outstanding characteristic of the *philosophes* is their attempt to find an alternative morality to that of Christianity, a morality 'less hostile to the things of this world . . .'.[3] The two main areas in which this morality was sought were Nature and Antiquity. The full relevance of Nature to man was not completely investigated until the nineteenth century; the connection, nevertheless, exists as an eighteenth-century phenomenon. But the attempt of the *philosophes* to re-create the ideas, the forms, and the institutions of Antiquity came to fruition well within the boundaries of their own century. The art-historical version of this attempt is called Neo-Classicism, and art historians are shamefully lazy in probing its ideological background. It is salutary and very relevant to remember that Voltaire had a peculiar affection for Brutus, that Jean-Jacques Rousseau said it was Plutarch who taught him to be brave and free, and that Diderot, as far as he was able, became Socrates.[4]

When Diderot-Socrates applied himself to art criticism the genre was in its infancy. There existed on the one hand a band of scribblers, usually anonymous, who wrote reviews of the Salons, and on the other hand men of scholarship, like La Font de Saint-Yenne and Cochin, whose tracts on contemporary painting are didactic in character and disapproving in tone. Diderot is the first man to investigate and to enjoy the art of his time, and his *Salons* span his maturity as a writer and a thinker. They were written for a private fortnightly newspaper called *La Correspondance littéraire*, of which Friedrich-Melchior Grimm, expatriate, lover of the arts, and former secretary to the Prince of Saxe-Gotha, took over the editorship in 1753. This journal had a small but distinguished list of subscribers which included the Empress Catherine of Russia, the Queen of Sweden, the Grand-Duke of Tuscany, and

a number of German princes, and its purpose was to provide these persons with the latest news of what was going on in Paris, the capital of Europe. As it was not published, it did not have to submit to French royal censorship, and it was of course untouched by the laws of libel. Hence the outrageous but usually justifiable rudeness of its most illustrious contributor, Diderot, a tone which the liberal nineteenth-century art critics adopted as their own. Manuscript copies were sent to subscribers; none of the *Salons* were published in France before 1798. However, Diderot had extra copies made for his friends, and it can safely be assumed that his views were known to the more intelligent and sympathetic of his contemporaries—certainly, Mme Necker mentions them in her letters. A word of praise here for Grimm, surely the most permissive editor of all time, who copes with texts of increasing length and volume while remaining on the best of terms with Diderot, to whom he refers as *mon philosophe* or *mon Diderot*. Diderot, on his side, addresses all his remarks to *mon ami Monsieur Grimm*.

It is possible that the *Salons* of Diderot are less read today than they should be, for a variety of reasons. In the first place, his criticism is confined to the works of his contemporaries, and the eighteenth-century French school is still far from rehabilitated. It bears a stigma of flossiness and untidiness which is seen to compare unfavourably with the graver ideals of the seventeenth and nineteenth centuries, and it is true that when Diderot began his career as an art critic, in 1759, the French school was characterized by an abundance of talent and a lack of genius. Boucher, Chardin and Greuze were the outstanding names; La Tour, Fragonard and Vien were soon to win popular acclaim. With the exception of the still lifes of Chardin and the portraits of La Tour, every picture told a story, and not much of one at that; no painter corresponded to the vein of deep seriousness that informed the investigations of the *philosophes*, although an enlightened observer could note the mutation of themes and styles, and perhaps still more of standards, that would result, as the century drew towards its close, in one of the most serious moments in the history of art.[5] Diderot is, of course, such an observer, although he is honest enough to delight in the undress aspects of the art of his time.

This delight is richly expressed, perhaps too richly for the modern reader;

Diderot has a maddening taste for digression and mystification, so that he himself is not so much in the centre of the stage as bounding about tirelessly on the periphery, making it exceedingly difficult for the disciple to concentrate. Then again, anyone trying to extract a logical and consistent line of thinking from Diderot's *Salons* is in for a disappointment: Diderot, moved solely by the mobility of his diaphragm, changes his mind all the time. One can say, in a general way, that his disapproval of Boucher and approval of Greuze set in train certain inevitable changes in subject matter, but one must qualify even this statement by reminding oneself that Diderot continued to consider Boucher as potentially the most gifted painter of his generation, and that he abandoned Greuze at the most critical moment of the latter's career. Hence, in 1769, the impenitent remark, *Je n'aime plus Greuze*, followed by a delighted account of the latter's disastrous Academy reception picture, *Severus and Caracalla*, an unfortunate example of misplaced ambition which failed to reach its target. Similarly, it is possible to extract from the *Salons* a general statement of total admiration for Poussin and Le Sueur, whom Diderot uses as a corrective with which to castigate any imprudent painter who does not have a full understanding of the passions. And there occurs in the *Salon* of 1767, à propos of Baudouin, Boucher's abysmal son-in-law, a recommendation that statues of French heroes from every walk of life would be more enlightening to the public than much of the near pornography admitted to the official exhibition. This proposition was put into force in Diderot's lifetime in the series known as *Les grands Hommes de la France*. Four statues were exhibited at the Salon of 1779, which Diderot did not review, and four more in the Salon of 1781, which he did (see Fig. 7). It is in fact the last echo of an old and splendid conversation held in 1749 with Jean-Jacques Rousseau and appropriated by the latter for his *Discours à l'Académie de Dijon* of 1750.

It is very probable that attempts to prove that Diderot was in favour of one type of painting or another, that he contributed to the Neo-Classical or Pre-Romantic movements, are beside the point. There are lines of continuity in Diderot's criticism but it would be unhistorical to read that criticism as contributing towards a style of painting. The nineteenth century has accus-

tomed us to think that the practising artist exists on a higher plane than the critic, that the critic's main function is to serve as a humble intermediary between the artist and the public. The first point to be made about Diderot is that in the eighteenth century the relationship between artist and critic was very different. In the eighteenth century, criticism was a valid form of philosophy,[6] and the critic (or Diderot, for there is no one like him) enjoys if anything a much higher status than the painter, who is still controlled by an archaic system of rewards and punishments and is hardly ever allowed to choose his own subject matter.

Hence the princely, expansive enthusiasm with which Diderot tackles his task. Hence too his completely shameless habit of repainting pictures which do not quite satisfy him or re-sculpting statues which he finds lacking in expression. The most famous example of this type of criticism in action was occasioned by Falconet's *Pygmalion*, exhibited in the Salon of 1763. The statue enchanted Diderot, who gives an enthusiastic description of it, and, as so often happens, enthusiasm carries him far away from the subject under discussion so that he winds up with a *Pygmalion* very different from the one actually executed by Falconet. Surveying the two concepts with interest, Diderot concludes, *Il me semble que ma pensée est plus neuve, plus rare, plus énergique que celle de Falconet*. ('It seems to me that my idea is newer, more original and more powerful than Falconet's.')

However, this critical autonomy never for a moment approaches dilettantism. There is no suspicion of art for art's sake in any line of Diderot's aesthetic writings. On the contrary, they are controlled by two concepts with which Diderot was deeply familiar: necessity and utility. The *Salons* are in fact very close in intention to the *Encyclopédie*: they were meant to instruct. And if the readers of the *Salons* were a mere handful of more or less enlightened European despots, this does not in any way affect Diderot's ardour, because basically Diderot is a teacher, if not a preacher. He considered it his duty to become familiar with the language and material of painting and sculpture. He had, of course, like every philosopher, a knowledge of the history of aesthetics, but few critics can have spent so much time in the studios of contemporary artists. He spent hours, days, with Falconet, with

Greuze, with La Tour; he seems to have learnt much from Chardin, whose words have only come down to us through the medium of Diderot, from Vernet, from Louis-Michel van Loo. There is indisputable evidence in his writings that he would have seen those paintings belonging to the King that were exhibited at the Luxembourg and those of the Duc d'Orléans visible at Palais Royal.[7] Certainly he knew the great Parisian private collections. He refers to those of Randon de Boisset, La Live de Jully, and Watelet, and it should not be forgotten that he negotiated the sale of the Gaignat and Crozat collections to Catherine of Russia. Although he had not been to Italy, he knew many Italian pictures, and after his journey to Russia in 1773 he knew the major Dutch and German collections. He was a collector, like most of his contemporaries, of engravings. And the thoroughness of his training can be judged by the fact that in his *Salons* he can, as it were, repaint a landscape as well as an altarpiece, a genre picture as well as a mythological scene.

Diderot wrote nine *Salons* and some of them are very slight. By way of compensation, others are so enormously long that one cannot read them at a single sitting—the *Salon* of 1767 is a case in point. Although Diderot addresses his remarks to Grimm, he is not unaware of his small but powerful audience, and to begin with he has difficulty in finding the right idiom. The *Salon* of 1759, the first he ever wrote, is sketchy and awkward: it is perhaps the only one of Diderot's writings to appear provincial. Nevertheless, it contains one of his most important dicta, usually quoted out of context. Comparing a *Raising of Lazarus* by Vien with one thought to be by Rembrandt (in reality by Lievens) Diderot criticizes those guilty of facile picture making. *Ils ne savent pas que le premier point, le point important, c'est de trouver une grande idée, qu'il faut se promener, méditer, laisser là ses pinceaux et demeurer en repos jusqu'à ce que la grande idée soit trouvée.* ('They do not know that the first and most important point is to discover a great idea, and that until they have discovered this great idea, they must walk about, meditate, lay down their brushes, and keep still.') The *grande idée* was to be particularly important to those Neo-Classical painters—David is the outstanding example—who had learned, from Diderot among others, to think in terms of moral pictures in the manner of Poussin. Another prophetic remark is made with

regard to Chardin: . . . *ses tableaux seront un jour recherchés*. This admiration for Chardin is a constant in Diderot's writings, as is that for Vernet, but in this *Salon* he devotes few words to either. The whole *Salon* is in any event brief and a little tentative.

In 1761 Diderot is much more at ease in his task, as can be seen in the length of his sentences and paragraphs which have none of the wispy quality noticeable two years earlier. Moreover he is proud of the state of the arts in France which he thinks superior to the situation in Flanders, Italy and Germany. One gains the impression of a keen sense of enjoyment and also more mastery of his means. He 'repaints' Doyen's *Diomedes and Aeneas* with great skill; he admires the picture, and admiration, as always, frees his own creative gifts. In addition to his exasperated enthusiasm for Boucher, he enjoys the Chardins, the Vernets (somewhat less this year), the Deshays (*Ce peintre est, à mon sens, le premier peintre de la nation*) and the *Death of Socrates* of a minor artist named Challe. The picture is now lost but in view of the later achievement of David, whose picture of the same subject was exhibited after Diderot's death in 1787, it is almost uncanny to read these words which could apply to the latter painting as they must have done to the former: *On dirait que c'est une copie d'après quelque bas-relief antique. Il y règne une simplicité, une tranquillité, surtout dans la figure principale, qui n'est pas de notre temps.* ('It is like a copy after some antique bas-relief. It is dominated by a calm simplicity, especially in the principal figure, which belongs to another age.') David, who in 1761 was a boy of thirteen, could not have known this judgement, and the conjunction between Diderot and David remains one of the most amazing in the history of art. It was David who was to bring to perfection that amalgam of antique prototype and passionate modern feeling necessary to bring the Neo-Classical style to life. It is significant at this stage that although Diderot found Vien's *Jeune grecque* reminiscent of a bas-relief, he did not consider this quality worthy in isolation, i.e. without the transforming power of emotion, the power which David so outstandingly possessed. But this is 1761 and Diderot is not quite ready for Neo-Classicism. The mode of the day is sentimental genre and the critic reserves his longest panegyric for Greuze's *L'Accordée de Village* (Fig. 2) which was submitted

late when the Salon had already been open for some time. Diderot gives us detailed descriptions of the appearance, emotions and ages of the characters, without seeming to notice, so great was the power of *sensibilité*, that parents in their sixties would be unlikely to have children as young as some of those in the picture. But such discrepancies were swept aside. *Une femme de beaucoup d'esprit* went so far as to discern that the father of the bride was a peasant and the mother a saleswoman from the Paris market: such was the general level of observation stimulated by Greuze's works and Diderot fairly represents his age in describing, with a novelette of his own, a picture which was essentially bourgeois and literary in inspiration.

By 1763 Diderot has perfected that note of stunning spontaneous rudeness which all his successors will try, unsuccessfully, to emulate. He found much to admire in this Salon and his humour is of the sunniest. This does not prevent him from addressing Challe, whose *Death of Socrates* he had previously enjoyed, in the most impudent of terms: *Mais, dites-moi, monsieur Challe, pourquoi êtes-vous peintre? Il y a tant d'autres états dans la société où la médiocrité même est utile.* ('But tell me, Monsieur Challe, why are you a painter? There are so many other professions in which mediocrity is actually an advantage.') As against this disappointment there are pleasures such as the pictures of Deshays, Vernet and Chardin, the sculpture of Falconet, and the début of a young German landscapist, Loutherbourg. For Deshays' *Mariage de la Vierge*, a peaceable subject, he has inflammatory words of praise, including a digression not really surprising in an age that was both secular and 'sublime': *Jamais aucune religion ne fut aussi féconde en crimes que le christianisme . . . C'est une belle chose que le crime et dans l'histoire et dans la poésie, et sur la toile et sur le marbre.* ('No religion ever produced so many crimes as Christianity . . . Crime is a fine thing both in history and in poetry, both on canvas and in marble.') But his greatest admiration is divided between the two painters of his election, Chardin and Greuze, who represent respectively the excellence and the contemporaneity of his taste. For Chardin he reserves his simplest and most forceful praise. This is how he hails the author of *La Brioche* (Fig. 5): *C'est celui-ci qui est un peintre; c'est celui-ci qui est un coloriste . . . On n'entend rien à cette magie. Ce sont des couches épaisses de couleurs appliquées*

les unes sur les autres, et dont l'effet transpire de dessous en dessus . . . Approchez-vous, tout se brouille, s'aplatit et disparaît; éloignez-vous, tout se crée et se reproduit. ('Here is a painter; here is a colourist . . . Such magic leaves one amazed. There are thick layers of superimposed colour, and their effect rises from below to the surface . . . Come closer, and everything becomes flat, confused and indistinct; stand back again, and everything springs back into life and shape.') When one reads a passage like this one is inclined to think that the nineteenth century discovered nothing that was not already evident to Diderot.

Yet the most notable characteristic of this *Salon* is the acuity with which Diderot notes the moment at which styles go bad, look wrong, or become out of date. This is the standard by which he now judges Boucher and Nattier, whose mythologies begin to have an overloaded and cosmetic quality, or examines the novelty of Vien, first popularizer in France of the 'Greek' taste. This is also the standard by which we must judge the panegyric devoted to Greuze's *Dying Paralytic*, a picture in the same vein as *L'Accordée de Village* of the previous Salon. A moral note is sounded here. *C'est vraiment là mon homme que ce Greuze . . . D'abord le genre me plait; c'est de la peinture morale. Quoi donc! le pinceau n'a-t-il pas été assez et trop longtemps consacré à la débauche et au vice?* ('This fellow Greuze really is my man . . . First, I like the genre—it is moral painting. What! Haven't painters used their brushes in the service of vice and debauchery long enough, too long indeed?') [This is an obvious reference to Boucher.] *Ne devons-nous pas etre satisfaits de le voir concourir enfin avec la poésie dramatique à nous toucher, à nous instruire, à nous corriger, et à nous inviter à la vertu?* ('Shouldn't we be glad to see him at last collaborating with dramatic poetry in order to move, to educate, to improve us and to induce us to virtue?') Greuze is the only factor standing in the way of Diderot's effortless transition from man of letters to art critic, Greuze who is the equivalent in painting of Diderot's less defensible enthusiasms, his worship of the novels of Samuel Richardson, and his terrible middle-class, middle-brow dramas, *Le Père de Famille* and *Le Fils naturel*. Naturally Diderot was not alone in his admiration for Greuze. That archetypal *femme de beaucoup d'esprit* was only too ready to shed tears before his touching

scenes, and Greuze was swept to premature fame on precisely this kind of false appreciation.

Diderot is fiercer in 1765, finding much to argue with, notably the election of Boucher to the office of *premier peintre* on the death of Carle van Loo. Boucher's style now comes in for serious moral criticism: *La dégradation du goût, de la couleur, de la composition, des caractères, de l'expression, du dessin, a suivi pas à pas la dépravation des mœurs.* ('Depravity of morals has been closely followed by the debasement of taste, colour, composition, characters, expression and draughtsmanship.') What can one expect, asks Diderot, from a man who consorts with prostitutes of the lowest degree? As against this, the bourgeois piety of Greuze stands out in sharp relief: *Voilà votre peintre et le mien, le premier qui se soit avisé, parmi nous, de donner des mœurs à l'art et d'enchaîner les événements d'après lesquels il serait facile de faire un roman.* ('Here is your painter and mine, the first among us to have had the idea of making art moral and of constructing a sequence of events which could easily be made into a novel.') This does not prevent him from giving a highly subjective and undoubtedly correct interpretation of the *Girl weeping for the death of her canary*, a picture now in Edinburgh, one of those allegories of lost virginity in which both Greuze and Diderot so delighted. But undoubtedly the most sensational picture submitted to the Salon of 1765 was Fragonard's *Corresus and Callirhoe*. Diderot pretends not to have seen this but to have had a dream on the same subject which he recounts to Grimm, an ingenious way of describing this most visionary of academic exercises. Also, by using the dream device, Diderot is able to give his own imagination a run for its money. In 1763 he had complained that Boucher left nothing to his imagination. This is not only a criticism; it is an expression of frustration. For Diderot, criticism is an empathetic exercise: the painter's imagination will inspire the philosopher-critic to take the image one stage further.

Again, profound appreciation of Chardin and Vernet, and in the section on sculpture a word of commendation for the great German scholar Winckelmann, *enthousiaste charmant*, whose love of Greek art led him to propound a false-naïf ideal of imitation of the ancients, a thesis which was responsible

for most of Neo-Classical art and for certain aspects of the Romantic movement. Diderot dismisses this thesis in a single sentence: *Il me semblait qu'il faudrait étudier l'antique pour apprendre à voir la nature.* ('It seemed to me that we should study the antique in order to learn to see Nature.') This apparently simple dictum must be read as a prologue to the great and lyrical digression on the *modèle idéal* contained in the *Salon* of 1767, a digression which is Diderot's instinctive protest against the more rigorous and archaeologizing aspects of the Neo-Classical revival which were given birth in the teachings of Winckelmann.

The *Salon* of 1765 is followed by an *Essai sur la Peinture* (1766), a monstrously neglected text which contains the celebrated dicta: *Il faut aux arts d'imitation quelque chose de sauvage, de brut, de frappant et d'énorme . . . Touche-moi, étonne-moi, déchire-moi; fais-moi tressaillir, pleurer, frémir, m'indigner d'abord; tu récréeras mes yeux après, si tu peux.* ('The arts of imitation need something wild, primitive, striking and monstrous . . . First of all move me, surprise me, rend my heart; make me tremble, weep, shudder, outrage me; delight my eyes afterwards if you can.') This essay has an air of protest which seems to link up with the unexpectedly mournful introduction to the *Salon* of 1767, when he warns Grimm not to expect too much of him this year. He is depressed. He complains that his friend Falconet has gone to Russia, that the Salon contains nothing by Greuze, Falconet, or La Tour. And then, says Diderot, I have given up hope of going to Italy. Because he is depressed, he sees signs of decadence, bad habits leading to the decline of taste among artists who should choose subjects from Greek and Roman history. There follows an outburst against thoughtless imitation of the antique, and one begins to understand Diderot's sudden longing to get to Italy, for 1766 was the date at which Pierre Sellius published a full translation of Winckelmann's *Geschichte der Kunst des Altertums*, extracts of which had appeared in the *Journal Encyclopédique*, translated by Pierre Rousseau, two years earlier. We may assume that Grimm, as a fellow German, was enthusiastic. Perhaps Diderot began to feel the burden of his journalistic slavery which had kept him chained to Paris ever since 1759. Frustration sharpens his intuition. Without mentioning any names, he completely demolishes Winckelmann's theory of

the *beau idéal* as unhistorical. He asks how the Greeks formed their style. For the Ancients, Antiquity signified barbarism, savagery, a state of nature. The Ancients, in fact, had no Antique to copy. So what did they copy? Here comes Diderot's profession of faith. The Ancients copied their *modèle idéal;* they copied from nature those elements which, if not already perfect, could be seen to be perfectible. Perfectibility, the leit-motiv of Diderot's intellectual existence, should be the rule for the moderns as it was for the ancients. Diderot, who, like Winckelmann, believes that the art of the Greeks was superior, provides a purely materialist explanation of this superiority: given their climate, habits, customs, and exercises, the Greeks were able to pare away the grosser deformities of nature and thus put into operation the principle of perfectibility. This is not unlike Taine's theory of *race, milieu, moment* to explain the rise and fall of schools of painting, and it establishes another link between Diderot and the nineteenth century.

Having got this irritant out of the way, Diderot reverts to his normal captivating good humour, and the *Salon* of 1767 is the most inordinately long and outrageously subjective of them all. It contains an image of the *philosophe* in person, a portrait by Louis-Michel van Loo (Fig. 1) which Diderot finds almost as charming as the original, although he feels bound to point out that he could never afford such an expensive dressing-gown. This *Salon,* which took a year to write, abounds in digressions and fantasies. The landscapes of Vernet, for example, are presented as a series of country walks which Diderot enjoyed with a friend and interlocutor. There is a paraphrase of Burke on the Sublime; there is a dialogue with Grimm *'contre le luxe',* and there are innumerable references to writers, painters and even actors of earlier times, which show Diderot to have been a man of mammoth erudition. Art-historically speaking, this *Salon* is important for the début of Hubert Robert, the abstention of Greuze, *'feu notre ami Greuze',* with whose pretensions Diderot had parted company, and for the exhibition of two of the most important altarpieces painted in the eighteenth century, Vien's *Prédication de Saint-Denis* and Doyen's *Miracle des Ardents,* of which Diderot gives a long account. Nothing is quite moral or serious enough for him, and speaking of Lagrenée, he harks back to Poussin: *O le Poussin! o le Sueur! . . . Où est le*

Testament d'Eudamidas? Nevertheless, he continues to admire, and a short table drawn up at the end of the Salon gives a handy summary of his admirations: Chardin, Vien, Vernet, La Tour (both La Tour and Chardin are described as *grands magiciens*); Robert (*grand artiste*); Loutherbourg (*grand, très-grand artiste*), Greuze, Durameau, and Boucher who, he says, could have been the greatest of them all had he so wished.

This marvellous verve never reappears. The *Salon* of 1769, cast in the form of seventeen letters, is much shorter and slighter. Either Grimm or the copyists had evidently complained. There is only one sentence of note and that is the astonishing one: *Je souffre mortellement de ne pouvoir croire en Dieu.* ('I suffer grievously because I cannot believe in God.') Its appearance in this context makes one wonder whether Diderot is beginning to succumb to the art critic's syndrome: a need to dismiss paint and canvas as vanity of vanities and a corresponding hunger for something great and unchanging. The *Salon* of 1771 is unfinished, written only in sketchy outline. There are grounds for believing that Diderot merely took notes and let another writer transform them into readable paragraphs. In any event, there is a sense of boredom and effort, and all that Diderot can find to say of Houdon's miraculous bust of him is, briefly, that it is *'très-ressemblant'*—'very like'. In 1773 Diderot was in Russia. The *Salon* of 1775 is slighter still, cast in the form of a dialogue between Diderot and a pupil of Boucher and referring to very few works. If we read the last *Salon*, that of 1781, with close attention it is because it marks the conjunction of two epochs: the apologist of modernity has been overtaken by a new generation of moderns. This Salon bristles with Greek and Roman subjects: Vien, Lépicié, Brenet, the two Lagrenées, and Vincent all exhibit scenes of antique virtue, piety and belligerence. Ménageot, with his *Death of Leonardo da Vinci*, has plunged straight into the Romantic Movement, to Diderot's evident delight: *très beau tableau, surtout d'une magie d'effet et de couleur étonnante.* ('A fine picture, particularly in its magical effect and amazing colour.') Diderot is ill; his sentences are short and they convey exhaustion. Nevertheless, he gives all his attention to a promising newcomer, just back from Rome, Jacques-Louis David. He recognizes the début of a master. Of the *Belisarius* (Fig. 3) he says, *Ce jeune homme montre de la grande*

manière dans la conduite de son ouvrage . . . ('This young man shows noble style in the execution of his work . . .'), and adds the singular praise, . . . *il a de l'âme* . . . ('. . . He has a soul.') Yet Diderot remains invincibly modern in giving his preference to the *Portrait of Count Potocki*, exhibited in the artist's studio, of which he says simply, '*superbe tableau*' (Fig. 4).

This was the last *Salon* he wrote. In 1784 he died. He haunted many writers of the nineteenth century: only twentieth-century scholarship has laid him to rest.[8] The lessons to be learned from the *Salons* are confused but potent, and the key to some of them can be found in the *Pensées détachées* . . . *pour faire suite aux Salons* which were not published until 1798 but which Diderot certainly made known to his friends as and when they occurred to him. The famous maxim, *Peindre comme on parlait à Sparte* is a case in point; a statement of an impossible ideal, it was to bear such fruit as David's *Oath of the Horatii*, painted in the same year as Diderot's death. The *Pensées détachées* are a set of aphorisms in which Diderot subscribes to a favourite eighteenth-century mode, one used to effect by such writers as Vauvenargues, Chamfort, Duclos, Rivarol and Joubert. Disconnected though they are—and they must have been written down at different times—the common denominator is an emphasis on the *extravagant*, or excessive, and the *naïf*. Both concepts play an important part in Diderot's enjoyment of painting. In many passages he confesses his love of strong emotions, his hunger for sensations, even for crimes, so long as they are on a sufficiently grand scale. *J'aime les fanatiques*, he says, with Baudelairean abruptness. A man naturally given to excess himself, he values evidence of this in others. *En quelque genre que ce soit, il faut encore mieux être extravagant que froid.* ('Whatever the art form, it is better to be extravagant than cold.') Coldness above all implies a certain alienation from nature. Therefore in painting Diderot is naturally drawn to subject matter which makes his heart beat faster; by the same token, he demands that the artist be passionate, that he should communicate his passion to the spectator. But in his extremely subtle essay on the art of acting, *Paradoxe sur le Comédien*, Diderot recognizes that any artist or executant must conceive of his role in a state of passion and play it out when the passion has been modified or corrected by judgement or

technique. From this premiss stems his dissatisfaction with the two painters who had seemed to promise so much: Fragonard, who has as much passion or temperament as anyone could wish but who never learns to take it any further and therefore degenerates into sketchiness, and Greuze, whose aims may be admirable but who is possessed by a sort of mean-minded calculation which cannot by any stretch of the imagination be called *extravagant*. Hence, too, Diderot's regret over the way Boucher turned out, for Boucher had both the gifts; on his return from Italy he was a truly lyric painter, and certainly no one was more adept at finishing a canvas so that it is as immaculate today as it was when it left Boucher's studio. But Boucher was lazy, too easily satisfied and self-indulgent to harness these great gifts to anything more serious than nymphs and shepherds bathed in a footlight glow. In a sentence which almost comically foreshadows Zola, Diderot reproaches Hubert Robert, who also has this gift of facility: *Mais Robert, il y a si longtemps que vous fates des ébauches, ne pourriez-vous pas faire un tableau fini?* ('Come, Robert, you have been doing sketches for so long, couldn't you paint a completed picture?') For this reason, Diderot prefers painters like Loutherbourg and Casanova to the amiable Robert whose works are technically and intellectually superior. This is a recognizably eighteenth-century taste of Diderot, one which has not worn very well today but which gave him unique insight into the shape of things to come.

By the same token, there is perhaps something backward-looking in his pleas for *naïveté* and even for '*quelque grande idée morale*'. These pleas are not constant. They amount to vague but fervent demands which crop up perhaps once in two or four years and eventually fade out altogether. When under the spell of Samuel Richardson, i.e. in the early 1760s, Diderot is only too prone to see innocence or morality in the works of Vien or Greuze. But he is rapidly disenchanted and finally unsatisfied. And this is how it should be, for in asking for morality in painting Diderot was really demanding that the artist should be a *philosophe*, and in Diderot's lifetime no painter had that kind of ability or genius. A few virulent, almost Voltairean remarks in the Salon of 1763 indicate the depths of Diderot's dissatisfaction with traditional morality as it was painted. It will be remembered that referring to a picture

by Deshays, Diderot makes the stunning if inaccurate remark, *Jamais aucune religion ne fut aussi féconde en crimes que le christianisme*. ('No religion ever produced so many crimes as Christianity.') The antidote would be a style of painting which would give whole-hearted instruction in the morality of the Stoics, with special reference to those two great heroes of the eighteenth-century iconoclasts, Seneca and Socrates.[9] Diderot's devotion to these men was well known. He signed his letters with a Socrates seal; he described the death of Socrates so vividly in his essay *De la Poésie dramatique* that the painter Challe was able to follow his recommendations when fabricating his *Death of Socrates* for the Salon of 1761. The subject was attempted, timorously, from time to time, but no attempt retained Diderot's attention or satisfied his exacting requirements. What tears he would have shed, what recognition he would have felt, had he lived to see David's great picture at the Salon of 1787! The subject, a Stoic one: Diderot upheld the Stoic ideal of self-mastery and independence from external control in an age when Lockian permissive-ness was still overwhelmingly persuasive. The format, Poussinesque: an illustration of Diderot's recommendation that artists should return to the seventeenth century, when *grand sujet* was most appropriately enshrined in *grande manière*. The effect, exemplary: in the sense that it taught a lesson in moral deportment. The overtones, religious: the layout of the picture is sacramental and indeed there are twelve figures present instead of the regula-tion six—twelve apostle-surrogates to represent the laicized religious impulse which Diderot himself embodies and which he wished to pass on to his age in the form of undenominational, moral, and, if necessary, civic, symbols. The approach, sentimental: we have it on record that in order to get himself into the appropriate mood of tragic solemnity, David was obliged to read a few refreshing chapters of Richardson's *Clarissa Harlowe*, and this detail is perhaps the most telling of all, for Diderot, in addition to his more stringent moral and formal recommendations, insists that the artist preserve his sensi-bility, his autonomous freshness of response. Hence the telling paradox, familiar to any student of the *Salons*, that Diderot pursues two apparently conflicting lines of argument. On the one hand he advances a Messianic theory of genius which is strictly speaking out of period, while on the other,

and at the same time, he grinds on towards the formation of a neo-Poussinist, neo-Stoical style which would appear to deny the executant much originality of treatment. Both these requirements were met to an appreciable extent by David, whose mature work Diderot never knew.[10]

Are there any constants in Diderot's art criticism? The answer is surely yes, the most important constant of them all. Diderot was a man of sublime moral health; he was a devout man who devoutly enjoyed this world, and he was a teacher who wanted to convey the richness of this world to others. For these privileges, Diderot, being a true materialist, gives thanks to Nature. Nature he loves, and next to Nature, Art. Therefore his most fervent approval and gratitude go out to those who re-create for him, through the medium of art, the natural world, and those painters are Chardin and Vernet. Vernet, considerably undervalued today, provides Diderot with his most accessible images of the natural world. Vernet is, in addition, *extravagant*, can affect the mobility of Diderot's diaphragm with an image of storm or shipwreck. But Vernet can also serve as a vehicle for Diderot's fantasies, turning Diderot into a *promeneur solitaire*, revealing a lesser-known aspect of this man whom we think of in an almost exclusively Parisian context. None of this is perhaps very distinguished, and no doubt Vernet performed the same service for a considerable brood of lesser nature lovers. But Chardin is another matter altogether. Chardin confirms Diderot in the knowledge not that life is picturesque or exciting or frightening, but quite simply that life is there, that there is food to be eaten and wine to be drunk. And when one's philosophical lot is pitched in with the material of this world, such knowledge is sustaining. *Vivant, j'agis et réagis en masse . . . mort, j'agis et réagis en molécules . . . Naître, vivre et passer, c'est changer de forme.* ('Alive, I act and react as a mass . . . dead, I act and react in molecules . . . To be born, to live and to die is to change form.') Moreover, Chardin is not simply a gifted realist who is particularly good at painting peaches and biscuits. Chardin is a 'magician'—the word recurs several times. *Chardin est entre la nature et l'art.* ('Chardin stands between nature and art.') This apparently simple sentence contains the highest praise that Diderot can offer. For Chardin, who brings to his unequalled perception of the phenomena of the natural world the genius of his craft or

discipline, is, paradoxically, the nearest equivalent to a *philosophe* that Diderot can find in the entire spectrum of contemporary painting.

It is tempting to evaluate Diderot almost entirely in terms of his influence, not only on a later generation of painters but on a whole century of critics. Stendhal, Baudelaire, Zola and the Goncourts all owe him an inestimable debt. From this fact alone it would be possible to deduce the modernity of Diderot, and it has been truly said, appropriately enough by the Goncourts, that Voltaire is the last of the classical writers, and Diderot the first of the moderns.[11] Compare Voltaire's fulsome and generally odious compliments to Frederick of Prussia with Diderot's excited arguments with Catherine of Russia: the Empress complained to Madame Geoffrin that after a conversation with Diderot she was covered with bruises, for he tended to hit her on the arm or jab her on the knee to emphasize a point . . . The mobility of the diaphragm again. Moreover, the philosopher-critic, who has been described as '*un croyant sans la foi*',[12] has, despite his identification with Socrates, an element of wildness, of prophecy, that demands comparison with the idea of Romantic genius. The fantastic relevance of Diderot to the Romantic movement has yet to be evaluated.[13] More particularly, we may note his relevance to the generation of Stendhal and the young Delacroix. Does Diderot foreshadow the concept of the 'happy few' in his *petite église invisible d'élus* ('Small invisible church of elect')? Probably not, for Diderot's ideal was that of his century: a happier majority. But it is virtually impossible not to think ahead to the paintings of Delacroix when reading this magnificent aside in the essay *De la Poésie dramatique*: 'When shall we see poets born? It will be after a time of disasters and great hardships, when beleaguered nations begin to breathe again. Then will the imaginations of men, set on fire by the terrible sights they have seen, describe unbelievable events to those who did not witness them . . . Genius is of all time, but men who possess it may remain unaware unless some extraordinary event, which affects the whole mass, will bring them to the fore. Then feelings will develop in their consciousness and will give them no peace, and those who have the power will long to speak out, will speak out, and will find rest.'

This passage is incredibly prophetic, for the date is 1758. In it Diderot does

not minimize the horrors that are to come, nor does he rub his hands over them as one might expect from any other member of the 'sublime' generation. His message to his nineteenth-century followers is characterized by that same innocence with which he bids goodnight to a moonlit scene by Vernet: *A demain, lorsque le soleil sera levé.* ('Until tomorrow at sunrise.')[14]

NOTES

1. *Paradoxe sur le Comédien.*

2. Paul Hazard, *Crise de la Conscience européenne*, Paris, Boivin, 1935.

3. Peter Gay, *The Enlightenment*, London, Weidenfeld and Nicolson, 1967.

4. See Jean Seznec, *Essais sur Diderot et l'Antiquité*, Oxford, Clarendon Press, 1957.

5. See Sainte-Beuve, *Causeries du Lundi*, 20.1.1851.

6. See Gay, *op. cit.*

7. See Seznec, *Le Musée de Diderot*, Gazette des Beaux-Arts, May, 1960.

8. See J. Seznec and J. Adhémar, *Diderot. Salons*, Oxford, Clarendon Press, 1957–1967.

9. See Gay, *op. cit.* and Seznec, *Essais sur . . . l'Antiquité.*

10. I am indebted to the Editor of the Burlington Magazine for allowing me to reproduce part of a review which appeared in May 1964.

11. Goncourts, *Journal*, 11.4.1858.

12. Pierre Trahard, *Les Maîtres de la Sensibilité française au 18e. siècle*, Paris, Boivin, 1932.

13. *Ce Diderot est plus neuf dans la querelle du romantisme que le Globe.* ('This man Diderot is more up to date in the battle of Romanticism than Le Globe.') Letter from Victor Jacquemont to Stendhal, beginning of July 1825.

14. *Salon* of 1763. Sainte-Beuve uses this as a pretext for a comment on Diderot's atheism.

STENDHAL

Stendhal

IT IS ONLY RECENTLY that Henri Beyle, who chose for himself innumerable pseudonyms, of which the best known is Stendhal, has come to be considered as an aesthetician or commentator on the fine arts. He has long been revered as a novelist, as a diarist, and as a letter-writer, and in these three fields his performance has been seen as unique, highly personal, very idiosyncratic, and stamped with a virile, almost military character which was natural enough in his own early years but which, as the nineteenth century progressed, took on the aura of a vanished age of heroism. After long years of neglect, attention has once more turned to his writings on the fine arts which, it is true, are not the most important of his works. But interest in this aspect of Stendhal, now more active than at any time during the last thirty years, has been stimulated, in a sense, retrospectively. Anyone studying Baudelaire, who has been placed on a somewhat artificial critical eminence, will be aware of a trenchant spirit of combat, at least in his early writings, and will be led to wonder why he should continue to try to define Romanticism and to equate it with the spirit of the age as late as the 1840s when, presumably, the mass of his public could take it as read. Again, anyone studying the polemics of that great civilian campaigner, Émile Zola, will be aware that he has affinities not only with Baudelaire, but with a more fearless, less literary prototype. And in this way one will be led back to Stendhal. One will re-examine Stendhal's writings on the fine arts—the *Histoire de la Peinture en Italie* of 1817, the pamphlet *Racine et Shakespeare* which appeared first in 1823 and in a second, amplified, edition in 1825, and the *Salons* of 1824 and 1827—and in them one will find a notable example of engaged or committed criticism, and, moreover, criticism written from a strictly amateur standpoint, which will have a long and glorious posterity in France in the nineteenth century.[1]

Now Stendhal is a far more complex figure than either Baudelaire or Zola. He is far less at home with words than either of them, and it took him far longer to become fully articulate or to present himself to his public without taking excessive precautions in case he should not be accepted. He is, in a sense, an intellectual whose ideas were brought to birth by a career of almost philistine activity. Although he set out to be a man of letters, he did not in

fact write much until the most active part of his life was over, and this of course is what sets him apart as a writer: he has the authority of a man whose preoccupations are not exclusively literary and who is informed at all times by memories of the immense experiences behind him.

The circumstances which led up to the emergence of Stendhal the writer are exceedingly glamorous, but perhaps the major precipitating factors are the place and date of his birth. He was born in 1783 and therefore belongs to the generation which is dominated by Napoleon and his exploits. Although Stendhal was sceptical and enlightened enough to realize that Napoleon's ambitions were never historically justifiable, he could not tolerate the comfort and timidity that came with the greater security of the Bourbon restoration in 1815. He had worn the uniform of an officer in Napoleon's army and he was irrevocably marked by the experience. The opening paragraph of *La Chartreuse de Parme*, the unfinished manuscript of his *Vie de Napoléon* breathe out a sense of the ideal, of that kind of heroic happiness which Stendhal found in his activities as an army officer. And this gives him the undoubted right to pronounce on Romanticism as a way of life rather than as a social and literary fashion.

Secondly, the place of his birth: Grenoble. For a long time Stendhal remains a somewhat cramped provincial character, plotting how to take Paris by storm, like the heroes of Balzac or his own Julien Sorel. He notes in the diaries he kept until 1814 the amount of money he has to spend, the clothes he is having made, the impressions he makes at such and such a gathering, and one senses that mentally he is living in some isolation. There is something provincial or, rather, unmetropolitan, about his ambitions as he describes them in these diaries and although Stendhal was to become the most sophisticated of Parisians, he defended his original position in his *Vie de Rossini*: *Remarquez que tout ce qui a un peu d'énergie à Paris est né en province, et en débarque à dix-sept ans avec le fanatisme des opinions littéraires à la mode en 1760.* ('Note that anyone with the slightest energy in Paris was born in the provinces, and left them at the age of seventeen with the fanaticism of the literary opinions fashionable in 1760.') His most fanatical and out-of-date opinion at this stage was that he could, if he wished, be the Molière of the

nineteenth century, the greatest comic genius of his age, and this explains why he has a certain vested interest in writing on dramatic form as he does in *Racine et Shakespeare*. He took lessons in declamation from Dugazon, he learnt English in order to read Shakespeare properly, he was a rabid and inveterate theatre-goer, and he worked for thirty years on a comedy entitled *Letellier* which he never finished because his talents in the dramatic field were properly speaking negligible.

His second ambition: he wanted power, wealth, fame, status and recognition—all quite straightforward. He wanted these things without actually having to work for them (as who does not?) and his method of making his way in the world was continually to pester his father's cousin Pierre Daru, who held an important position in Napoleon's civil service. It is sometimes forgotten that Stendhal did in fact have a distinguished career in government service, first as an army auditor, then as state auditor, then as *Inspecteur du Mobilier* attached to the Imperial court, and finally, after years of unemployment under the Bourbons, as French consul in Civita Vecchia. It is difficult for the modern reader to imagine Stendhal as the gorgeously clad functionary who filled five ledgers with an itemized list of the contents of the Palace of Fontainebleau, or as the corpulent and ageing consul pacing the landing stage and meeting incoming shipping at a small Italian port. It is easier to think of him in the light of a dozen historic incidents: Stendhal at Haydn's funeral mass or in David's studio; Stendhal arm in arm with Byron in the foyer of La Scala; Stendhal in Moscow in 1812, watching the pianos and sofas being piled onto the blaze; Stendhal at the first night of *Hernani*; Stendhal catching a glimpse of Musset and George Sand as they disembarked at Venice. All this carried off in a brisk and light-hearted manner, or as Stendhal himself would say, *de gaîté de cœur*.

His third ambition: he wanted to please, and this he never really achieved to his own satisfaction. He would decide to make love to a woman who could advance him in society, then fall disastrously in love with her, and simultaneously lose his head and become aware that he was making a fool of himself. Hence the memorable phrase in the *Journal* for 1811: *Heureux, j'aurais été charmant* ('If I had been happy, I would have been charming'),

and the humility of his unsuccessful request for the hand in marriage of Giulia Rinieri. Hence too the depth and subtlety of the emotion which eventually goes into the novels disguised or wrapped up in terse, short military sentences which have more in common with the eighteenth-century aphorists than with more obvious Romantic prototypes.

Of great importance for an understanding of Stendhal's attitude to his age is his actual military career, and this is considerable. He took part in the second Italian campaign, joining up with the Sixth Dragoons in Milan in 1800, and then and there he succumbed to the habits and customs of Italy which remained his ideal to the end of his life. He went with the army to Brunswick in 1807, to Vienna in 1809. Then in 1812 came the decisive experience of his life, the Russian campaign, during which he comported himself with extreme bravery. He left Paris in July, 1812; he arrived in Moscow just as Rostopchin opened the prisons and gave each prisoner a flaming torch and instructions to set fire to all the buildings. He made a note of the cardinal fact that winter started six weeks early that year and that the temperature soon dropped to forty degrees below zero. He described the vital part played by Cossacks in harrying the retreating French. He was so hungry that on one occasion he fell on his knees when he found a few potatoes in one of the villages. At Smolensk he lost most of his possessions, and the moment he got across the border into Poland, boredom set in. This boredom, which increased in Paris, is not the boredom of the dilettante; it is that post-Revolutionary or post-Imperial disenchantment which becomes built into the Romantic movement in France and which swells to a climax in the following generation, the generation that experiences the aftermath of defeat without the compensating memory of heroic action. This is the context into which one puts Stendhal's critical writings.

One should also put them into the context of Stendhal's own literary output. In spite of his two projected plays, *Les Deux Hommes*, on which he worked from 1803–4, and *Letellier*, Stendhal wrote comparatively little until his active life was finished. In 1814, the temporarily restored Bourbons offered him the post of food controller in Paris, a post which he refused. He took himself back to Milan and there re-wrote his *Histoire de la Peinture en*

Italie, the first draft of which had been lost at Molodetschno. This was published in 1817, together with the travel diary, *Rome, Naples et Florence*. In 1822 came the treatise *De l'Amour*, and in 1823 the first edition of *Racine et Shakespeare* and the *Vie de Rossini*, three seminal works which contain the essence of all his future writings. Stendhal's activity as a novelist does not begin until 1827, with the unsatisfactory *Armance*. His best-known novel, *Le Rouge et le Noir*, appeared in 1830, *La Chartreuse de Parme* in 1839, and when he died in 1842 he left unfinished and unpublished two novels, *Lucien Leuwen* and *Lamiel*, and the autobiographical *Vie de Henri Brulard*. His writings on the fine arts, therefore, date from comparatively early in his literary career.

There is a kind of double thread running through Stendhal's moral behaviour. The first relates to his boyhood and youth in Grenoble and Paris, when, hating his father and his tutor, he resolved to make a glittering future for himself as a man of letters, a seducer of beautiful women, a brilliant metropolitan figure. With a view to this end Stendhal studied the moralists and historians, the empirical philosophers of the eighteenth century, Voltaire, Condillac, Duclos, Helvetius, and Montesquieu. A volume of the letters of Mme Du Deffand beguiled him on the long trek back from Russia and in 1817 he wrote to his friend de Mareste from Milan, *Je lis les lettres de D'Alembert, Montesquieu et autres à Mme Dudeffant* [sic] . . .[2] He appreciated the irony, the clarity, the uncompromising lack of affectation of the *philosophes* and the *idéologues*. He emulated their short didactic sentences, their desire to formulate their observations—often the product of ceaseless intellectual speculation—in the form of urbane aphorisms. He inherits their vitality, but he over-estimates their desire not to give the game away. Because for Stendhal, in this mood, life is a game but a game of which the rules can be learned. And for perhaps half his working life, the years of his struggle to find his feet in Paris, he is obsessed with the desire to perfect his gamesmanship. His grotesque comedy, *Letellier*, his equally grotesque affair with the actress Mélanie Guilbert, on which he comments at some length in the early *Journals*, show a man completely led astray from the serious business of his life by a sense of the role which he should play, by a sense of his effect on his

audience. There is an element of dandyism in this. It leads Stendhal to adopt a flippant, convoluted, slightly grating literary style which, until modified by deeper feelings, can appear awkward and was certainly not appreciated by his contemporaries.[3] This style of Stendhal the strategist is brought out most clearly in his treatise *De l'Amour*, which deals, literally, with the rules of the game, interspersed with observations on the behaviour of men and women playing the game.

But through a happy accident of history, the deeper side of Stendhal's character and temperament was engaged, employed, exploited, fertilized, by his experience in the armies of Napoleon. He was not altogether unprepared for this other life as a man of passion. As a boy he had yearned inconsolably for his dead mother; he had been intoxicated by the writings of Rousseau (although he was later to reproach him for his lack of '*beylisme*', i.e. that style of life and feeling which he, Beyle, considered desirable); he had noted in himself a tendency to be thrown completely off course by a love affair—and there were many—even to the extent of losing sight of his objectives in life. Napoleon took him away from his provincial dreams of metropolitan conquest, took him out of the eighteenth century, and introduced him to the new Europe. Stendhal's first visit to northern Italy was made, like all his early journeys, in a military capacity, and the experience marked him for life. Italy remained his ideal country, not the plastic Mediterranean Italy of the Grand Tour, but the brilliant social and musical Italy of the small capitals, where life revolved around a box at the opera or political discussions in the cafés. He sympathized with the emergent liberalism of those *fils de famille* who saw a career in throwing off the yoke of the foreign oppressor or outwitting the equally oppressive rule of the church. He returned to Italy many times but in between visits became an army officer of considerable responsibility. In 1809 came the Austrian campaign: patrolling the frozen Danube took him a long way from worrying about the impact of his entrance into a *salon*, as he had done only three years earlier. And in 1812 there was the Russian campaign, of which he made himself the all too laconic commentator. On the way out, he carried one of the Emperor's portfolios; on the way back he was responsible for the bread ration. The sense of living on an epic scale, in a way denied to

all but what he was to call 'the happy few', that is to say, those privileged by both circumstance and temperament, dispelled for many years the arduously contrived personality for which he had had such ambitions. The task of rising to an inconceivably rare occasion made him even more fearless than usual, but the return to safety in 1813 afflicted him momentarily with some of that terrible apathy which dominates the generation of Delacroix and Musset. The Russian experience was never erased from Stendhal's mind. He gained from it a personal knowledge of life's very great circumstances; he gained the right to speak in the name of the new generation; he assumed the right to weigh all aesthetic sensations against the standard of this particular catharsis. It was the retreat from Moscow that opened his eyes to Michelangelo's preoccupation with destiny. It was, equally, the retreat from Moscow that made him detect in Delacroix's *Massacres at Chios* a soupçon of technical and emotional fiddle-faddle.

All this makes Stendhal a very exacting and rigorous dealer-out of verdicts, and not, it must be admitted, a very secure one. But as well as pronouncing on the works of art of his time, as he does in the *Salons* of 1824 and 1827, Stendhal is concerned with formulating an aesthetic precisely for people like himself, for the children of the Revolution, as he says, and for those younger people who can and must learn from them. One of Stendhal's many remarkable qualities is the fact that his gaze does not remain historically fixed on his own experiences. Much as Baudelaire was to recommend a generation later, he extracted the inner essence of those experiences from the contingencies, and remembering the perfect emotional breadth and freedom they gave him, he applied himself to an examination of the ways of obtaining and perpetuating this grand emotional release, in which Stendhal finds a measure of good conscience. This exercise has nothing to do with conventional morality. It has to do with properly employing and enjoying one's best faculties and feelings. Stendhal calls this undertaking *la chasse au bonheur* ('the pursuit of happiness').[4] This is precisely what guides him towards an original definition of Romanticism: towards an aesthetic that will not restrict the man of full and true contemporary experience.

Stendhal's writings on the fine arts show him at his most sober and

responsible. He achieves a great measure of objectivity, and in reading the two *Salons* or the *Racine et Shakespeare* it would be easy to forget Stendhal the strategist and Stendhal the man of action and passion. Yet it is essential to remember them in order to appreciate his emotional and intellectual boldness in breaking with tedious critical systems, in not being gulled by fashionable artistic trends, and in really scrutinizing the meaning of contemporary history. The art historian in particular should read and re-read *Le Rouge et le Noir* and *La Chartreuse de Parme* which hold the key to Stendhal's artistic temperament and shed a true light on his expectations from the art of his day.

Le Rouge et le Noir purports to take place in the Paris in which Stendhal had recently been pursuing the profession of journalist and pamphleteer. Throughout this heavily plotted novel, in which the hero watches his every move with lynx-eyed attention, there runs a groundswell of desire for the freedom and independence of one's own personality and this erupts into the magnificent riposte made by Julien Sorel to Mathilde de la Mole when she encourages him to appeal against his death sentence by making overtures to his enemies: *Laissez-moi ma vie idéale. Vos petites tracasseries, vos détails de la vie réelle, plus ou moins froissants pour moi, me tireraient du ciel. On meurt comme on peut, moi je ne veux penser à la mort qu'à ma manière. Que m'importe les autres? Mes relations avec* les autres *vont être tranchées brusquement. De grâce, ne me parlez plus de ces gens-là; c'est bien assez de voir le juge et l'avocat. Au fait, se disait-il à lui-même, il paraît que mon destin est de mourir en rêvant* . . . ('Leave me to my ideal life of dreams. Your petty fuss and your trivial details about real life which only annoy me would drag me down to earth. We die as best we can. As for me, I only want to think of death in my own way. What do other people matter to me? My dealings with others are going to be abruptly ended. Please don't talk to me any more about them; it is enough seeing the judge and the barrister. In fact, he said to himself, it seems that my fate is to die dreaming.') This passage is more 'romantic' in the Stendhalian sense than the *grand guignol* ending with a crepe-hung Mathilde de la Mole traversing France, her lover's guillotined head cradled in her arms. It demonstrates the difference between Stendhal and *les autres* and indicates the buoyant emotional substructure that lies below the surface of his judgements.

There is perhaps even more to be learnt from *La Chartreuse*, in which, again, Machiavellian intent is liberated into actions not quite of this world. *La Chartreuse de Parme*, with its apparent formlessness, its wickedly offhand attitude to construction and time-sequence, its endless series of picaresque episodes, is really several novels in one.[5] It purports to tell the story of its hero, Fabrice del Dongo, a high-born young mercenary decked out with many surprising graces, but its most memorable characters are the hero's aunt, the Duchess of Sanseverina, and her lover, Count Mosca. The action purports to take place in Parma and revolves around the court of the ruler, whom Stendhal calls Ranuce-Ernest IV. However, Italian court life in the nineteenth century was never like this and it is clear that Stendhal has lifted a great deal of the actual plotting from various Italian romances of the Renaissance and the sixteenth and seventeenth centuries. The plot is almost impossible to summarize. In the first part of the book we follow Fabrice, who is an ardent and idealistic young man, on his travels, the most important of which is to the battlefield of Waterloo. Then we cut back to Gina Sanseverina, who is in love with her nephew, and her efforts both to establish herself and further Fabrice's career at the court of Parma. Gina is an exceptional creation, for through her Stendhal explores those minute shifts in the balance of favour which are an amorous woman's constant preoccupation. Then we follow Fabrice again through a few political adventures, and half way through the book we come to the long delayed second plot, when Fabrice falls in love with Clelia Monti, an action which causes him, for reasons which are too complicated to go into here, to be incarcerated in the local stronghold, the Farnese Tower. From this point, the tone of the novel, which has been urbane, ironic, elliptical, and sometimes maddeningly jocular, changes completely and turns into the narration of a series of dream-like events: Fabrice escapes, becomes a priest, has a child by Clelia, sees them both die, and retires to the charterhouse of Parma. From being a kind of early nineteenth-century Candide, Fabrice becomes a kind of early nineteenth-century Tristan.[6] Both these states of soul sum up in perfect form the peculiar and quite unique quality of Stendhal's Romanticism.

The first part of the novel, which of course makes literary history, is con-

cerned with the hero's experience at the Battle of Waterloo. It makes literary history because it subjects its young Romantic hero to a completely unheroic and anti-Romantic process. Fabrice is sixteen years old. For as long as he can remember he has wanted to fight for the Emperor and he makes his way to Waterloo where he is told that the Emperor will shortly carry off a tremendous victory. He dreams of military glory and of being able to say to his grandchildren, 'I was there.' But was he? When he gets there he can't find anyone. Plenty of soldiers standing around, discussing things, complaining, but not the demi-gods and heroes in glittering battle array that the whole world thought of in connection with Napoleon's armies. Fabrice decides that he must have a horse. He charges up to a gloomy French corporal, levels his musket at him, and in an uncertain but fervent voice tells him to hand over his horse or be shot. To which the corporal merely replies, *Tu te fous de moi?* ('What the Hell?') Finally, on the far horizon, he sees a wavering line of officers, the significance of which has to be explained to him: he is witnessing the French in full retreat. So here is one of the great epic subjects of the age, the greatest single historical reason for *le mal du siècle*, debunked by a man who knew what battle was about, who relived through his hero the aspirations which should surround it but was sober enough to realize that one is just as much the victim of one's expectations as one is of their outcome. It is this serious but sceptical attitude that led Stendhal to reject, in another context, all literary definitions of Romanticism, to say, in effect, 'But I was there.' This is what he says when he reviews Delacroix's *Massacre at Chios* in the Salon of 1824, although his attitude is not quite formulated: he suspects the second-hand emotional reaction to a terrible event, knowing that the first-hand one is usually more provisional and more practical.

The other half of Fabrice-Stendhal is as a man of passion. In the beginning Fabrice is a cardboard figure, a stranger to complex emotions, and very short on reflection. He is described in one of two ways: either *'frais et dispos'* ('hale and hearty') (as Stendhal reported himself to be at Smolensk)[7] or *'fou de bonheur'* ('crazy with happiness'). When brought up against the great obstacle of his life, the impossibility of freely loving and marrying Clelia Monti, Fabrice changes. But he does not change into the well-worn figure of the

despairing Romantic lover. He would have reason for doing so. Consider his situation. He is a well-known trouble-maker with many enemies; he is a declared political prisoner, incarcerated in a fortress from which no one has been known to escape. His gaolers are trying to poison him. Clelia is the rather timorous daughter of a court functionary and she is engaged to be married to someone else. He can only see her by looking through a crack in the window. Yet somehow he arranges a meeting by getting his gaoler to bring her to the prison chapel. At this meeting she impresses on him the danger of his situation and the difficulty of hers. What is his reaction? *Depuis cette soirée dans la chapelle de marbre, la vie de Fabrice fut une suite de transports de joie. De grands obstacles, il est vrai, semblaient encore s'opposer à son bonheur; mais enfin il avait cette joie suprême et peu espérée d'être aimé par l'être divin qui occupait toutes ses pensées.* ('Since that evening in the marble chapel, Fabrice's life was a series of joyous ecstasies. Great obstacles, it is true, still seemed to stand in the way of his happiness; but at last he had that supreme and so little hoped for delight of being loved by the divine person who occupied all his thoughts.') Compared with the attitude of the standard Romantic hero, such as Constant's Adolphe, this is a surprising reaction and one to be retained. Because for Stendhal, the principal element of passion is energy, a truth held to be self-evident in the eighteenth century but already faded from the mind's eye by 1839, and by the end of the book, when this passion and its energy have taken him through more fatiguing adventures and ended in tragedy, Stendhal is nevertheless able to finish the novel with the dedication TO THE HAPPY FEW, which in this connection means those who use themselves to the very limit of their capacities and ideals. Here again is a cardinal factor in the make-up of this aesthetician of the new age.

Scepticism and energy are the keys to Stendhal's writings on the fine arts, which are of course very much more temperate from the emotional point of view but which nevertheless impress us as being the writings not of a pro-fessional *littérateur* but of a man of action and experience. *L'Histoire de la Peinture en Italie* is a curious book, written in a manner more reminiscent of a soldier-philosopher than of a historian and aesthetician. It has a military air, and not just because of the military reminiscences which obtrude. Begun in

1811, but incorporating chapters written in 1807, the book was interrupted by the Moscow campaign, was resumed in 1813, and completed in Milan in 1816 or 1817. It consists of a skeletal history of the Florentine school, culminating in the life of Leonardo, which forms the first volume. The second volume, dedicated to the happy few, contains a long socio-moral tract on *le beau idéal antique* and *le beau idéal moderne* which may have been the last chapters in date to be written. The rest of the work is devoted to the life of Michelangelo, and there is a clear difference of approach between the first half of the book and this more passionate second half, written when Stendhal had more feeling for the spirit of the age and could divine in works of art those qualities which corresponded precisely with this spirit.

In form, the book is impertinent, for Stendhal was only too willing to abandon his history for an aphorism or an epigram: Chapter 101, for example, bears the title which so delighted Baudelaire, *Comment l'emporter sur Raphael?* ('How to improve on Raphael?') Certain so-called chapters are only one paragraph in length. It is essentially a confected book, for Stendhal knew the limits of his own scholarship and took the greater part of his material from Lanzi's *History of Italian Painting*, which he supplemented with his own readings of Vasari, Condivi, Bellori, Malvasia, and the Edinburgh Review.[8] All this is quite scholarly, but the book only comes to life when Stendhal digresses from the main narrative. In this respect Stendhal's criticism is like that of Diderot; both tell the story and add reminiscences of their own. But, as Stendhal was constantly dinning into his readers' heads, between 1780 and 1823 it was the character of the reminiscence that had changed, and had changed for ever. Stendhal's whole stance in the *Histoire de la Peinture en Italie* devolves on this point and his attitude is justified by the circumstances of the book's history. The first draft was lost at Molodetschno during the retreat from Moscow and the book had to be entirely rewritten. Stendhal feels, therefore, that as the author has survived such personal perils he is allowed to take an independent and never entirely reverent or submissive attitude to his material. In this connection, the most memorable passage occurs when subject matter and author coincide, when, on going into the Sistine Chapel, Stendhal understood Michelangelo's intentions in the light of

his own experience. 'When, during our wretched retreat from Russia, we were suddenly awakened in the middle of the night by a burst of cannon fire which seemed to be coming closer all the time, all our strength appeared to flow into our hearts: we were in the presence of destiny, and, indifferent to matters of vulgar interest, we prepared to measure our lives against fate. The sight of Michelangelo's pictures reawakened in me this almost forgotten sensation. Great souls are sufficient unto themselves; others become frightened and go mad.' He then goes on to give a magnificent and uniquely emotional description of the Sistine frescoes. 'The lofty expression on the figures in the Sistine Chapel, the daring and power which permeate all their features, the slow, grave rhythm of their movements, the strange, unprecedented way the draperies envelop them, their striking contempt for what is merely human, everything declares them to be beings to whom Jehovah is speaking, through whose mouths He pronounces judgement.'

'Painters who cannot paint make copies of statues. Michelangelo would deserve this criticism if, like these painters, he had stopped at what is merely *unpleasing*; but he has gone on to the *terrible*, and, what is more, the figures represented in his Last Judgement had been seen nowhere before him . . .' It is interesting to note that the apparently impervious Stendhal had several '*accès de nerfs*' when looking at and writing about Michelangelo.[9]

In a completely unformulated way Stendhal is already preoccupied with the question of *le beau idéal moderne*. In a famous passage he defines *le beau idéal moderne* as a collection of ravishing physical and moral qualities, of which perhaps the most important is the capacity to dance at a ball all night and die in battle the following morning. This is not as superficial as it may seem. The invention of modern weaponry, says Stendhal, has made the athleticism of antique art appear out of date. Strength of will and character are now measured by expression, not by muscles. And, with admirable prescience, he divines that the master who first understood this, Michelangelo, has much to say to the young modern generation of painters who will be preoccupied, as he was, with the situation of the human soul. *Il est difficile de ne pas voir ce que cherche le 19e. siècle: une soif croissante d'émotions fortes est son vrai caractère.* And again, *C'est donc par une peinture enflammée du cœur humain*

que le 19e. siècle se distinguera de tout ce qui l'a précédé . . . La soif de l'énergie nous ramènera aux chefs d'œuvre de Michel-Ange. ('It is hard not to see what the nineteenth century is looking for: a growing thirst for strong emotions is its true character.' 'It is, then, by passionate depiction of the human heart that the nineteenth century will stand out from all previous centuries . . . The thirst for energy will lead us back to the masterpieces of Michelangelo.') This prophecy was to be borne out within a short space of time by the two great Michelangelesque masterpieces of the Romantic movement in France, Géricault's *Raft of the Medusa* (Fig. 10) and Delacroix's *Dante and Virgil crossing the Styx* It is true that Stendhal never actually hails these works but then, as he explained so disarmingly, . . . *j'aime* le beau *et non* le rare; *ensuite je ne crois que ce qui est prouvé* ('I love *beauty* and not *rarity*: and then I only believe what is proved'),[10] and Géricault and Delacroix were controversial painters not only throughout their lives but long after their deaths.

There is a vast difference between this and Stendhal's next sortie into defining the spirit of the age, the pamphlet *Racine et Shakespeare* which appeared first in 1823 and in a second edition, with an appendix, in 1825. This is a much more limited undertaking, a salvo fired in a battle of literary styles, and perhaps for this reason, despite its remarkable insights and claims, it has a slightly archaic air, as if still bound by the conventions of the quarrel between the Ancients and the Moderns. Yet it is a Romantic manifesto and deserves all the credit given to that slightly later and much noisier Romantic manifesto, Hugo's *Preface to Cromwell* of 1827. *Racine et Shakespeare* has a closely reasoned argument which reads as follows: the traditional French dramatic form, that is, the five-act tragedy of Racine, written in alexandrines and bound by the three unities of time, place and action, is definitively out of date and should be replaced by something more flexible. The natural alternative is the dramatic form of Shakespeare whose plays differ from those of Racine in three vital ways: they are written, or can be written, in prose; they are in no way bound by the unities because the place can vary from scene to scene and the action range over months or years; and they deal with subjects not only to be found in classical writers but in the more immediate past. This is desirable because an audience always identifies more readily

with the immediate than with the remote past. So far, so unexceptional; put into its historical context, *Racine et Shakespeare* should be included in the same chapter as Constant's *Wallstein* of 1809 (imitated, as the name suggests, from Schlegel's *Wallenstein*), and Mme de Stael's *De l'Allemagne* of 1813, both of which are an attack on the French classical tradition in the theatre. Both Constant and Mme de Stael admired German literature, and specifically German Romantic literature, and both voice a plea for a national literary tradition other than that of classicism. These views were reinforced by the translation which appeared in 1813 of Schlegel's *Cours de littérature dramatique*. This is another attack on the classical dramatic tradition and suggests that alternative themes might be found in the Middle Ages, Renaissance Italy, Spain and England. Stendhal's copy of Schlegel has unfavourable comments in it—he claimed that *le système romantique* was *gâté par le mysticisme de Schlegel* ('The Romantic programme was ruined by Schlegel's mysticism')[11] —but in all important respects he follows him closely. This argument continued for another ten or fifteen years but the direction was changed by the popularity of the works of Scott and Byron, all of which were translated into French between 1816 and 1824. In 1822 a troupe of English actors appeared at the Théâtre Saint-Martin. The season was disastrous, for the French, flown with political humiliation, hissed them off the stage. This incident is the direct impetus behind *Racine et Shakespeare*, which is basically an attack on literary chauvinism but given an edge because Stendhal could claim to represent the children of the Revolution who both demanded and deserved new forms of expression.

If Stendhal were proposing a change in dramatic form for purely literary reasons this pamphlet would not be half so exceptional as it in fact is. What he is doing—and this is what is remarkable—is proposing a literary change for historical, social, and moral reasons. He wants a new idiom for a new age. He says that at no time in history has there been so great a revolution in society as in the years from 1780 to 1823: how can there not be a new language to mirror these changes? This is the first and vitally important point that he makes, and he expatiates on it with great feeling, producing one of the few intrinsically beautiful sentences he ever wrote: 'I want my

language to suit the children of the Revolution, the people who look for thought rather than beauty of style, the people who took part in the Russian campaign and who witnessed the curious transactions of 1814.' (*J'ai tâché que le mien convînt aux enfants de la Révolution, aux gens qui cherchent la pensée plus que la beauté des mots, aux gens qui . . . ont fait la campagne de Moscou et vu de près les étranges transactions de 1814.*) Therefore, for the people of this generation, there can be no going back, no comfortable withdrawal into old habits, no sentimentality about tradition. They must bear the burden of being new men, and for this reason they will be nearer in spirit to the Elizabethans and to Shakespeare than to the highly sophisticated courtiers of Louis XIV and to Racine.

The second point made is that although classicism is a hallowed concept in France, it is a completely meaningless one, because although one thinks of Racine as a classical writer he was in fact writing for his own society in his own time, and was therefore in his lifetime a Romantic in that he identified with and reflected the desires and aspirations of his age. From here Stendhal goes on to make the pronouncement famous in all the school-books: 'Romanticism is the art of presenting people with those works of literature which, given the state of their customs and beliefs, are likely to give them maximum pleasure. Classicism, on the other hand, means giving people the works of literature which gave maximum pleasure to their great-grandfathers.' In the urbane rationalism of this statement and the reiteration of the word pleasure one detects a mind grounded in, and still obedient to, the sensualist philosophies of the eighteenth century.

Related to this is a third and equally important point: anyone engaging in the enterprise of Romanticism is not in for an easy time. It takes courage to be a Romantic because one must take risks—*Il faut du courage pour être romantique car il faut hasarder*. There are no precedents to fall back on, and this is what distinguishes Stendhal's definition of Romanticism from all those writers and painters who are simply trying to replace the classical tradition with an alternative mythology, medieval, Christian or Shakespearian. Stendhal in fact equates the life of a Romantic writer, and by implication artist, with that of a man of action, someone automatically cut off from precedent,

someone forced to behave empirically, guided only by the demands of the situation and, by analogy, the spirit of the age.

The relevance of all this to the contemporary situation in painting is that the example Stendhal proposes of the man who has achieved this newness is David. In the preface to *Racine et Shakespeare* Stendhal describes David as the '*génie audacieux*' who realized that the style he used at the beginning of his career—the modified Rococo style of *The Combat of Mars and Minerva*—was completely useless for a portrayal of energetic moral action, and that internal necessity resulted in the evolution of the Stoic pictures, *The Oath of the Horatii*, *Brutus condemning his sons to death*, and *The Death of Marat*. This is important for two reasons. Firstly, very few people in 1823 thought of David as a *génie audacieux*; rather the opposite. Secondly, if we accept this comparison as correct—and there are many reasons why we should—we find that the whole balance of Romantic chronology must be revised, and that the climax or true centre of the movement, usually located around Delacroix, should perhaps be shifted backwards in time. In fact, one can isolate three phases of Romantic evolution. The first phase, the picturesque or sentimental *style national* of the 1780s, is best illustrated by Ménageot's *Death of Leonardo da Vinci* in painting and Pajou's stunning *Turenne* in sculpture (Fig. 7). The second phase—the heroic and committed phase which Stendhal has in mind—is reflected in the terrifying energy of pictures like David's *Marat* (Fig. 8) and the early works of Géricault, such as the *Officer of Carabiniers*. When seen in this kind of perspective, Delacroix's achievement takes on a terminal air, and in spite of everything that Baudelaire has to say in defence of Delacroix's Romanticism, the fact remains that there is no Romantic movement in painting after Delacroix. If we take Stendhal as our guide, Romanticism belongs fairly and squarely where the artist operates as man of action, showing the courage which Stendhal thinks is an essential part of the enterprise and speaking the language *qui convient aux enfants de la Révolution* ('. . . to suit the children of the Revolution'). In fact it is essential to accept this premiss of Stendhal in order to understand why Baudelaire, a generation later, stages such a campaign to promote Delacroix as the hero of Romanticism. Baudelaire is not merely indulging in personal favouritism; he is

destroying an earlier concept of Romanticism, in which the Romantic painter was a kind of poetic realist, in order to promote an alternative concept, in which the Romantic artist operates as a species of spiritual surrogate.

This trenchant work of codification is contained in a surprisingly small number of pages, some of which are so allusive as to be almost incomprehensible. In 1824, when reviewing the Salon of that year, Stendhal assumes a more relaxed attitude, preferring an eighteenth-century position of uncommitted but unfoolable empiricism. He takes some trouble to underline this. He tells us, for example, that he has no intention of reading the catalogue. He warns us that he is not on the side of any of the major interests in the promotion of an exhibition because *Mes opinions, en peinture, sont celles de l'extrême gauche* ('My views in painting are of the extreme left'). More important, *je pense tout ce que j'écris* ('I think everything I write'). Stendhal's ideal audience is composed of those young painters *qui ont du feu dans l'âme, de la franchise dans l'esprit, et qui n'attendent pas, en secret, leur fortune et leur avancement futur des soirées ennuyeuses qu'ils vont passer chez madame une telle, ou de la partie de whist qu'ils ont quelquefois l'honneur de faire avec monsieur un tel.* ('. . . with ardent souls, candid minds and who are not secretly expecting their fortune and future promotion to come from the tedious evenings that they go and spend with Mrs So and So, or from the game of whist which they are sometimes privileged to play with Mr Someone Else.') In fact, *Mon but est de faire en sorte que chaque spectateur interroge son âme, se détaille sa propre manière de sentir, et parvienne ainsi à se faire un jugement à lui, une manière de voir modelée d'après son propre caractère, ses goûts, ses passions dominantes, si tant est qu'il ait des passions, car malheureusement il en faut pour juger des arts.* ('My aim is to make each onlooker question his own soul, define his own way of feeling, and thus to form his own judgement and a way of seeing fashioned on his own character, tastes and predominant emotions, if indeed he has any emotions at all, for unfortunately they are necessary in judging the arts.') In stating all this, of course, he defines the critical position of the nineteenth century which will be taken up by Baudelaire and Zola and which goes back ultimately to Diderot. His opinions, however, do not at first sight appear to be as extreme or indeed as left as one might have expected.

Stendhal is at heart faithful to the generation of David, whom he disliked personally but whom he praises sincerely at the outset of his article. He is not really in tune with the young painters to whom, in theory, he addresses himself. In addition, he does not find it easy to submit totally to the language of pictures. His literary and psychological bias leads him to concentrate on the subject, the message of a painting, and in doing so he misses out the most important part of it. This is a mistake which Baudelaire will not make but which Zola, with one exception, will. However, this very defect puts Stendhal in an ideal position from which to generalize, and his generalizations are of great value. He states that while David is a great painter, and great precisely because he ceased to imitate his predecessors, the pupils of David will be the ruin of the French school because they have returned to copying for copying's sake. This is in fact the argument of *Racine et Shakespeare* adapted to the visual arts: *Et que me fait à moi le bas-relief antique? Tâchons de faire de la bonne peinture moderne.* ('What do I care about antique bas-reliefs? We must try to do good modern painting.') When faced with a canvas showing thirty semi-nude figures engaged in some antique pursuit, Stendhal's reaction is *Je demande une âme à la peinture* ('I expect painting to have soul'). More important, he wants painting to influence the senses in a more abstract way, in a way which prefigures that of Baudelaire. *Dans les arts, il faut toucher profondément et laisser un souvenir . . .* ('In the arts, you must stir deep emotions and leave behind memories.') When we read Baudelaire's art criticism we shall take this kind of concept for granted, but in Stendhal's time it represents a startling breakthrough towards non-material considerations.

Stendhal is aware that the French school is limited in its powers of expression and he notes that the English painters, who were present in force at the Salon of 1824, can command alternative effects. In this connection he singles out Lawrence rather than the more popular Constable. What he has to say about individual pictures is perhaps more predictable. The soldier and the man of action take exception to Delacroix's *Massacre at Chios* (Fig. 9); the verdict is an unpopular but perfectly valid one. Stendhal says, in effect, 'I have tried to admire Monsieur Delacroix, but without success. I cannot help

feeling that his picture was meant to be about the victims of a plague but that he read the newspapers and turned it into a *Massacre at Chios*. . . . But massacre demands both a victim and an executioner . . .' The gravest accusation, of course, is that Delacroix *read the newspapers*; he was not involved in the event itself. In other words, Stendhal picks out unerringly the slightly sentimental, slightly self-indulgent quality in the young Delacroix which is automatically, by Stendhal's standards, non-Romantic. Delacroix's beautiful figures are disposed in a poetic trance of exhaustion, a state which for some reason Stendhal found unacceptable, particularly on the battlefield. He belonged to an essentially keyed-up generation—he relates, with one graphic adjective, how . . . *nos armées se donnaient le plaisir nerveux de gagner des batailles* . . . ('Our armies found a feverish satisfaction in winning battles')[12] —and it is not insignificant in this context to remember that although Stendhal was an ardent defender of Shakespeare, he felt an almost personal dislike for the character of Hamlet. Also, by dwelling on the idea of a plague, Stendhal underlines with great subtlety Delacroix's debt, in this picture, to Gros' *Les Pestiférés de Jaffa*, its great predecessor and inspiration, and a work which Stendhal himself admired for its depth of expression. To both of these he appears to have preferred, according to a note in the *Histoire de la Peinture en Italie*, David's tragic picture of *Leonidas at Thermopylae*. The colouring of this work is dark, the perspective uncertain; there is no beguiling beauty of paint as in the Delacroix but Stendhal looked at the expressions and found that of Leonidas 'sublime'.

Nevertheless, he concedes that Delacroix's work is singular rather than merely mediocre, that it fails in fact through its very singularity. This is the sort of praise that Delacroix himself would have appreciated. Ingres comes in for a similar eulogy. His picture, *The Vow of Louis XIII*, is disliked for its lack of religious unction but at the same time Stendhal adds, *Ce tableau est précieux, surtout en ce moment où tant de jeunes peintres semblent travailler uniquement pour donner des sujets aux graveurs lithographes.* ('This picture is valuable, especially at the present moment when so many of our young painters seem to work solely to provide subjects for lithographers.')

Yet when it comes to another key work in the Salon of 1824, Constable's

Hay Wain, Stendhal becomes strikingly old-fashioned. The eighteenth-century ideologue, with the standards of the eighteenth century, is resurrected when he views this comparatively naturalistic landscape. The verdict is trenchant: Constable has no ideal. *Il n'a aucun idéal, mais son délicieux paysage . . . est le miroir de la nature.* ('He has no ideal, but his delightful landscape . . . is the mirror of Nature.') A little later he says, 'Monsieur Constable is as true as a mirror but I should like the mirror to reflect a magnificent site, such as the valley of the Grande Chartreuse at Grenoble, and not a hay waggon crossing a canal of stagnant water.' This verdict is memorable, not for its intrinsic value or lack of value, but because it had a surprising posterity. In 1827 Stendhal wrote *Armance*. The novel is little read today but its preface is of some importance, for in it Stendhal suggests that novelists are like mirrors and that it is not their fault if they reflect the vices of the age because a mirror is, of its nature, unselective and impersonal. (In *Le Rouge et le Noir* Stendhal attributes this dictum to Saint-Réal; he does not hesitate, however, to use it as his own.) Again, in the preface to *Lucien Leuwen*, Stendhal states that it is the function of the novel to be a mirror, but with one important proviso: *L'auteur pense que, excepté pour la passion du héros, un roman doit être un miroir.* ('The author thinks that, except for the hero's passion, a novel should be a mirror.') The concept was taken up and popularized by George Sand and was fully realized and celebrated by Flaubert. So that Stendhal's verdict on a realistic painting (realistic by French standards, that is) contains the germ of what was to be the apologia for the realist novel.

Stendhal's attitude to Constable is an aberration shared by most other classically trained critics of the period, but his coolness towards French painting is unusual. It was perhaps a reflection of his contempt for contemporary French customs and ideals, just as his memories of Italian art remained bathed in a rosy emotional glow that he himself described as 'Correggiesque'. The nostalgia remained intact, although by 1828, the date of his last important review, Stendhal had said goodbye to the excesses of his youth. He was at best an elderly and bookish youth; by the same token, he preserved the passion and uncertainty of adolescence through the greater part of his adult life. His extreme vulnerability, combined with the virile quality of his

circumstances and preoccupations, resulted in a humane wisdom such as one will not find in any other of the great literary figures of the nineteenth century. Something of this quality is evident in his review of Jal's account of the Salon of 1827, published in the *Revue Trimenstrielle* in July 1828. This is not in fact a review of the pictures but meditations on the state of the arts at that date, entitled *Des beaux-arts et du caractère français*. These meditations take the form of a plea for originality in the fine arts, for an end to copying and imitation and opportunism and painting considered as a career. Both Ingres and Delacroix are commended for their originality, their personality, for preserving a quality which Stendhal does not isolate but which Baudelaire will christen *naïveté* and Zola *tempérament*. So thoughtful were Stendhal's reflections that Delacroix wrote a rare letter of thanks: *J'ai lu l'article de la Revue. Je le trouve excessivement bien et juste, indépendamment du bien que vous dîtes de moi et dont je vous remercie.* ('I have read the article in *La Revue*. I think it is extremely good and apt, regardless of the kind things which you say about me and for which I thank you.')[13] Delighted by this mark of humility, Stendhal became a firm friend to Delacroix and when he moved to Italy in 1830 he promptly invited 'De la Croix' for a visit of at least three months.[14] In these articles the short military sentences have disappeared; the tone is again that mixture of scepticism and almost ingenuous hope which Stendhal made the true voice of the nineteenth-century commentator. He demands from art, as from circumstance, an increased feeling of the richness and complexity of life itself. By the same token, the true amateur of the arts will have some of the qualities of a lover because the pursuit of the ideal—in love or art—is not for *les gens médiocrement passionnés* ('moderately passionate people').[15] One must bring to these matters an ability to be moved and instructed; one should carry away from them a feeling of even greater possibility.

Looking back at Stendhal from the end of the century (one of the moments in time when he expected to come up for judgement), one can see that he acted out for his generation a very basic concept: that of the heroism of modern life. He posited the idea that Romanticism equals the spirit of the age, that Romanticism equals heroism, in fact equals realism. Baudelaire, of course, will re-examine this idea. Stendhal also held that beauty in the fine

arts was something akin to happiness, and he accepted happiness as a viable proposition. This idea got lost, and on the whole nineteenth-century aestheticians did well enough without it. The *'lecteur bénévole'* to whom *Lucien Leuwen* was addressed, became, in a very short space of time, Baudelaire's *'hypocrite lecteur'* and the note of manic suspicion, of which Baudelaire is frequently guilty, jars the brave new world in which Stendhal's thoughts evolve. Madame Jules Gaultier, in a letter of 25 August 1832, summed it up exactly: *C'est vous que aviez créé le romantisme, mais vous l'aviez créé pur, naturel, charmant, amusant, naïf, intéressant, et l'on a fait un monstre qui hurle. Créez autre chose.* ('You created Romanticism, but you created it pure, natural, charming, amusing, spontaneous and interesting; now they have turned it into a roaring monster. Create something else.') The Stendhalian hero is an eternally young man, eternally starting life in a prudent and guileful society. His only priceless asset is his *gaieté de cœur* ('cheerful spirit'), a quality the hero shares with his creator. As a critic, Stendhal is frequently held back by prejudices inherited from the eighteenth century but his urgent desire is to provide an explanation—a *défense et illustration*—of contemporary subject matter for the young man of the present and if possible of the future. Over and above this, Stendhal's work is to widen emotional horizons, his own and other's. He provides the basis for the whole of nineteenth-century criticism and sends many impalpable waves out towards the future. He is the last exemplar of the spirit of 1789 and the first commentator on the spirit of the new age.

NOTES

1. Stendhal has a tonic effect on his biographers. See in particular Jean Prévost, *La Création chez Stendhal*, Paris, 1951; F. W. J. Hemmings, *Stendhal, a study of his novels*, Oxford, Clarendon Press, 1964; Claude Roy, *Stendhal par lui-même*, Ecrivains de Toujours, n.d.; John Atherton, *Stendhal*, Bowes and Bowes, 1965; J. Starzinski, *H. B. Stendhal. Du Romantisme dans les arts*, Miroirs de l'Art, Hermann, 1966; H. Levin in *The Gates of Horn*, Oxford University Press, 1966; J. P. Richard in *Littérature*

et Sensation, Paris, 1954; Stephen Vizinczey, *One of the Very Few*, The Times Saturday Review, 11.5.1968.

2. Letter to Adolphe de Mareste, Milan, 1.12.1817.

3. 'His style, negligently prosaic, agile and stripped for speed, algebraic in its precision and disdain of colour, codifies the situation as exhaustively as a series of letters and figures the state of play in a game of chess. The rest is up to the reader: if he has not learned or cannot intuit the chess of the emotions, the chapter will be devoid of significance. This is why Stendhal means all or nothing, according to the reader.' (Hemmings, *op. cit.*)

4. *La vertu, c'est augmenter le bonheur; le vice augmente le malheur. Tout le reste n'est qu'hypocrisie ou ânerie bourgeoise. Il faut toujours saisir l'occasion d'instruire la jeunesse.* ('Virtue is to increase happiness; vice increases unhappiness. Everything else is only hypocrisy or bourgeois stupidity. We must always seize the opportunity to impress this on the young.') (Letter to Domenico Fiore, 1.11.1834.)

5. See also Louis Kronenburger, *Stendhal's Chartreuse*, Encounter, July, 1966.

6. See Kronenburger, *op. cit.*

7. Letter to Félix Faure, Smolensk, 7.11.1812.

8. Letter to Louis Crozet, Rome, 28.9.1816.

9. Letter to Louis Crozet, Milan, 20.10.1816.

10. Letter to Sophie Duvaucel, Civita Vecchia, 28.10.1834.

11. Letter to Louis Crozet, Milan, 1.10.1816.

12. *Vie de Rossini*.

13. Delacroix to Stendhal, October, 1828.

14. Letter to Frédéric Mercey, Trieste, 2.11.1830.

15. *Avant tout, dans les Beaux-Arts, pour être susceptible de plaisir, il faut sentir fortement.* ('Above all in the Fine Arts you must feel deeply to be susceptible to pleasure.') (*Vie de Rossini*.)

BAUDELAIRE

Baudelaire

WHEN ONE REVIEWS the story of Baudelaire's life and achievements, it becomes impossible to stay within the limits of literary criticism or even, when all is said and done, within the limits of Freudian exegesis. With Baudelaire's life we seem to be reading a chapter in some kind of martyrology, a martyrology that relates not the operatic sufferings of the distressed poet common to the Romantic age, but the withdrawal symptoms of a man of faith who made the choice, perhaps the wrong choice, of operating in the sphere of the beautiful rather than that of the good. This man, instead of occupying himself with the chronicle of a spiritual journey which he was supremely equipped to make, became a poet and earned his living as a critic.

Today Baudelaire's critical writings receive as much attention as do his poems, possibly more. It is a matter for some astonishment that he now ranks as the foremost French art critic of his age, for on the face of it there seems little reason why he should. He possesses none of those requirements which are traditionally considered indispensable for a writer on the fine arts. He has, for example, no artistic education. He has no sense of the past. He confines himself rigorously to his own time and his own place. He never travelled, apart from his widely spaced visits to Mauritius and Belgium, although his notes indicate that had he done so his experience would have been more valuable and fruitful than that of many men in similar circumstances. He seems to have known comparatively few pictures and to have given up the practice of looking at those that he did know with few qualms: a letter to Nadar in 1859 mentions that he has managed to review the Salon of that year after little more than a cursory tour of the gallery. His standards remained fixed within the limits of a concept of Romanticism as something infinitely heroic, melancholy and profound enough to carry men on to some further goal, Romanticism as an almost religious ethos, in fact, which he strove to adapt to the changing requirements of the age. In this he is not unlike Stendhal, although in every other respect the two men are totally dissimilar. Stendhal's aesthetic system was based on a concept which had its roots in the whole personality, in a life of action, and in an attempt to formulate recommendations which corresponded with the needs of the time, or the spirit of the age. Stendhal's views on art are in fact controlled by his

belief that art and literature should be obedient to the circumstances of the present and informed by memories of the recent past. In fact Stendhal takes a historical and utilitarian approach to the aesthetic problems of the day, as one would expect to find in a period of history as crowded with significant events as were the first twenty years of the nineteenth century.

Baudelaire reflects a very different state of affairs. He was born in 1821 and therefore missed the heroic days of the Romantic movement which, in France, followed very closely on the heels of political events; he belonged to a group of writers and painters who were dominated by nostalgia for those great days yet obliged to content themselves with the less heroic circumstances of the present. This group encompasses Vigny, Delacroix, Sainte-Beuve and Musset, and in all their works can be detected a note of historical pessimism and personal disappointment, described at length in Musset's *Confessions d'un Enfant du Siècle* and unforgettably summed up by Vigny: *Les événements que je cherchais ne vinrent pas aussi grands qu'il me les eût fallu.* ('The great events I went in search of failed to come up to my expectations.')[1] Therefore the outstanding characteristic of this group is its search for forms of compensation. For the military glory that their fathers enjoyed, the sons sought a compensating glory in an artistic or literary career. They tried to alleviate their moral boredom by indulging in extravagant personal behaviour: this is the generation that codifies the cult of dandyism, and, at the other extreme, tries to recapture the tremendous sensations described by Stendhal by taking drugs or cultivating a belief in the mysterious forces of the occult. Dominated by the past, irritated by the present and consequently unwilling to come to terms with it, this generation tends to withdraw into the fortress of art for art's sake, transfiguring its idealism into theories, seeking in aesthetic practice or experience sensations which will illuminate and justify their lives. Here we come back to Baudelaire. In the first and heroic phase of Romanticism, it was possible for Stendhal to believe in the search for personal fulfilment: *la chasse au bonheur.* In the second and disillusioned phase, the world is regarded as a vale of tears: *nous célébrons tous quelque enterrement* ('All of us are in mourning for someone').[2] The uniform of the century is no longer the priest's black robe; it is the black frock-coat worn by

the bourgeois in the street. So that the passage from Stendhal to Baudelaire is more than a purely historical one. It is the passage from the search for happiness to the consolations of imagination.

A comparison in their working methods is revealing. Stendhal operates directly on events, on circumstances, on conditioning factors. He has no time for anything that demands lengthy and detached reflection. The tempo of his life does not allow him to spend hours looking at a picture. Baudelaire gives the impression that he has all the time in the world, that he regards leisure as a natural condition of existence, and that any form of regular activity would be an unwarranted intrusion into his mental privacy. In this connection it is perhaps relevant to quote a well-known sentence from his diary which is probably the best key to both his working method and his aesthetic system. *Glorifier le culte des images (ma grande, mon unique, ma primitive passion).* ('To glorify the cult of images—my single, great, original passion.')[3] Despite its familiarity, this is a very significant statement, in which the key word is *culte*. In all his writings on the fine arts, and not only his Salon criticism but, for example, his article on Wagner, Baudelaire is not applying himself directly to his material but glorifying the *cult* of images. Now the word cult implies several things: mystery, inner life, the bending of information towards some abstruse or esoteric end, secret connections, the use of memory. In the case of Baudelaire, it also suggests a non-utilitarian approach to the arts, a sort of temperamental closed shop, a crypto-Parnassian position. It suggests, in addition, a much greater intensity of feeling than has yet been encountered in this context, for even Diderot, with all his enthusiasm, can take painting or leave it alone. But Baudelaire becomes dependent on it in a very singular way and for this reason he sometimes uses the language of religion or mysticism when describing a picture, and sometimes the language of intoxication, that is to say, the tremendous but momentary liberation conferred by hashish or opium. So much so, that when one reads Baudelaire's *Art Romantique* or *Curiosités Esthétiques* as criticism pure and simple one is aware that his personality, or his system, is interposed like a screen between the spectator and the object; the judgements are oblique and curiously self-centred, they do not relate absolutely to the matter under

discussion. Fortunately for historians most of the judgements are brilliant, but one may experience some difficulty in remembering Baudelaire's actual recommendations from one essay to the next. It therefore becomes necessary to realize that one must read Baudelaire's criticism in a slightly different way, because one is in the presence of a new type of critic. Baudelaire has the arrogance and despair of his generation but he also inherits its mourning aspects and its desire to set up a community of rare spirits who will act as a counterweight to the materialist, get-rich-quick philosophy of the bourgeoisie. Baudelaire believes that his reactions to painting or music or literature are as valid as the things themselves. When doing his work as a critic, in fact, he is operating as an artist in his own right. This is a very different position from that of Stendhal, who considered himself to be a critic by virtue of his experiences, and who, by the same token, considered imagination to be vastly inferior to the authenticity of experience. For Baudelaire, criticism is an essentially imaginative or indeed creative exercise. Therefore, criticism as practised by Baudelaire becomes a singularly flexible or autonomous discipline, balanced, rather precariously, somewhere between the cult of images and the charting of responses and associations stimulated by those images.

Although Baudelaire has various arcane theories about the sovereignty of the imagination, the correspondences between phenomena and the magic creativity of the artist, he does not speak an arcane language. In fact so brilliantly clear is the tone of his arguments that it may disguise the fact that one needs a certain amount of help to understand them. Just as it is useful to know that Stendhal was a soldier to understand the source of some of his criteria, one needs to know the circumstances that made of Baudelaire the dangerously short-tempered, anguished, self-destructive, categorical and profoundly worshipful personality that he was to become. In comparison with Stendhal, very little happens to Baudelaire, or rather one can chart few external events in his life; on the other hand, his psychological case history is much more voluminous. He was born in 1821 to parents of vastly different ages, the mother being 25 and the father 61. His heredity was bad; there appears to have been insanity in the father's family—certainly both Baude-

laire and his half-brother (his father's son by an earlier marriage) died syphilitic and insane. The brief sentence with which Baudelaire acquaints us with this state of affairs is particularly haunting: *Mes ancêtres, idiots ou maniaques, dans des appartements solennels, tous victimes de terribles passions.* ('My forebears were either imbeciles or fanatics, living in heavy rooms, all victims of terrible passions.')[4] The father, François Baudelaire, seems to have been pleasant and inoffensive. He had been tutor to the Choiseul-Praslin family, he had served in one of Napoleon's ministries, and he had a taste for the arts; he had known some painters, notably Prud'hon, and he possessed a fair number of eighteenth-century pastels and drawings. But he was such an aged neutral figure that Baudelaire was much closer to his mother, dangerously close, for he formed an attachment to her that was reinforced by the events of his childhood. Baudelaire's father died in 1827; within a year the mother re-married. Her second husband was a professional soldier, Lieutenant-Colonel Aupick, veteran of Waterloo, a stern disciplinarian who was determined to make a man of his stepson. Baudelaire makes few overt references to Aupick but it is clear that he regarded him as a symbol of hated authority: when the 1848 revolution broke out, he was heard to cry, 'Quick, quick, to the barricades, we must assassinate General Aupick',[5] Aupick then being head of the École Polytechnique. On the other hand, the rest of Baudelaire's life is dominated by his feelings for his mother, and these feelings do not grow any older. He rails at her, like Hamlet, for betraying his father, for giving in to her lower nature in such a way that she could not maintain the dignity of a widow but must as soon as possible be a wife again. This ebb and flow of disgust and remorse, activated by the mother, but gradually invading the universe, is the dominant strain in Baudelaire's emotional life.

He rapidly became a problem. He was expelled from school. An attempt was made to ship him off to India, but once on the boat he demanded to be repatriated and was put down at Mauritius: hence the images of the ship, the sea, tropic indolence, Creole languor that pervade the early poems of *Les Fleurs du Mal*. When he came of age he also came into his father's money, and immediately set up house in great style. In 1844, when his portrait was

painted by Émile Deroy, he was living on the top floor of the former Hôtel de Lauzun on the Quai d'Anjou, and he was living as a dandy, a dilettante, a Romantic in the understood sense of the word: fond of impudent or outrageous gestures and remarks, taking enormous quantities of drugs, the proud lover of a spectacular coloured mistress, Jeanne Duval, impeccably tailored, and drawn to the paradoxical figure of Eugène Delacroix, with whom he seems to have felt an almost family resemblance. Although Baudelaire was slightly less well-born than Delacroix, they came from roughly the same milieu, and apart from his passion for Delacroix's art—he had, significantly enough, a complete set of the *Hamlet* lithographs hanging on the walls of his sitting-room, as well as one original oil sketch which he called *La Douleur*—he seems to have regarded Delacroix as a kind of exemplar, a pattern of the sort of man he himself wished to become, an ideal version of himself: infinitely distinguished, extremely *dandy*, free of any suggestion of time-serving, sophisticated, eloquent, attractive, and an artist of the first rank. So great was his enthusiasm for Delacroix that he presumed on their acquaintanceship, to Delacroix's annoyance and our great profit. He began by noting down Delacroix's theories—on colour, on composition, on what to do when faced with a dictionary of material out of which one must compose a coherent statement—and he ended up by interpreting Delacroix's pictures according not to Delacroix's intentions but in the light of his own very much more complex, very much more slanted, understanding of them. It is possible to say that this admiration for, and possibly unconscious rivalry with, Delacroix, is the second dominant strain in Baudelaire's emotional behaviour.

Again Baudelaire became a problem to his family. He was spending money at such a rate that his mother and stepfather, in conjunction with the family lawyer Ancelle, judged him incompetent to administer his financial affairs and for the rest of his life he was made to subsist on a meagre monthly allowance for which he had to apply to Ancelle. This placed Baudelaire in a trap from which he never escaped. He had accumulated an enormous number of debts which he could never pay off out of his allowance, and he had contracted various commitments, such as his mistress Jeanne Duval, who was

illiterate and improvident and on one occasion asked Baudelaire to support not only herself but her brother. He also declared, out of sheer pride, that he would support his mother, although he could hardly support himself. His diaries are filled with financial calculations. His immaculate appearance suffered: towards the end of his life he could no longer afford to have his hair cut. He turned, fairly rapidly, into the haggard and irascible creature in Nadar's photograph (Fig. 12), although to the end of his life he retained the infinite vulnerability of childhood, a quality which he demanded in all practitioners of the arts and which he called *naïveté*. He was also forced by circumstances to earn his living as a working journalist and translator. The first *Salon*, that of 1845, was written in the same year as the *conseil de famille* that took away his financial independence, and although it is clear that Baudelaire turned to this sort of writing quite voluntarily, it is also clear that he was obliged to persist with it long after his original impulse, and his stamina, had declined.

As a journalist Baudelaire was extremely hard working, as one can judge simply by looking at the index of the volume entitled *Art Romantique*. He was forced to apply himself to anything and everything: reviews, not only of the Salon, but of contemporary literature, volumes of short stories, poems and plays, many of which have sunk absolutely below the surface of the history of nineteenth-century taste. So great was his activity that he never had time to write the two books which he projected on painting, although he managed to use up a great deal of his material, as can be seen in the chapter headings of the *Salon* of 1846 or the marvellously digressive character of the essay on Constantin Guys, *Le Peintre de la vie moderne*. He translated the essays of De Quincey and the poems and stories of Edgar Allan Poe—his English was excellent—and for a time he identified with the tragic, wasted figure of Poe rather more closely than with the apparently impervious Delacroix. He was at the same time writing his volume of poems, *Les Fleurs du Mal*, which was published in 1857 and immediately condemned as obscene by the government. He survived Delacroix, whom he continued to regard as the greatest painter of modern times, independent of any consider-ations of whether Delacroix was in tune with those times; in fact his desire

to impose Delacroix on the nineteenth century leads Baudelaire into some pretty strenuous twisting of definitions. His hero-worship is resurrected in the obituary of Delacroix written in 1863, *L'Œuvre et la vie d'Eugène Delacroix*, and this last blaze of partisanship may account for the curt comments he allowed himself to make on the art of a very much younger friend, Edouard Manet. In 1866, after warnings which he recorded scrupulously in his journal, Baudelaire had a stroke and lost his powers of speech. He survived for thirteen months in a Paris nursing home and died the following year at the age of 46.

This tragic life did not beget unmitigatedly tragic writing, although there is an undertow of tragedy in all Baudelaire's descriptive passages. As he says, he was animated by two diametrically opposed currents of feeling: *horreur de la vie* and *extase de la vie* ('life's horror and life's ecstasy'),[6] and in many of his writings, notably the *Salon* of 1846, the review of the exhibition at the *Musée classique du Bazar Bonne Nouvelle*, and the essays on Guys and Wagner, it is *extase de la vie* that dominates. Baudelaire, in these years, can be brisk, trenchant, and furiously funny. But his *horreur de la vie* gradually engulfs him and as it accounts for his more basic judgements it deserves close examination. One has only to read a few pages of Baudelaire to realize that he is operating against the background of some theological system, some vestigial Catholic programme in which the main accent is laid on sin, guilt, remorse, suffering and expiation. One is constantly coming up against words like *le gouffre*, *l'irréparable*, or *le vieux*, *le long remords* ('the abyss, the irrevocable, long, time-honoured remorse'). In the passages on Delacroix he insists on a quality which he says Delacroix possesses: *la douleur morale*, moral sadness, and this irritated Delacroix to a considerable extent because it seemed to him that in emphasizing the morbid side of his art the critic was misrepresenting him to the general public, and Delacroix, as is well known, was extremely careful of his reputation. Baudelaire felt that the central event of his life—his mother's betrayal of him—could be construed in terms of the original sin to which Eve succumbed in the Garden of Eden, with the same dramatic consequences. The event implanted in him an obsession that nature, or a state of nature, that is to say, the realm of carnal instinct, was something

criminal and menacing, something to be feared and fought on every level. Anything in its natural state was dangerously reminiscent of the concept of original sin.

This obsession was to rule his life, quite literally. It comes through with particular sharpness in his artistic likes and dislikes. For example, so great is the shadow cast by the concept *nature* that Baudelaire will see nothing commendable in the painting of landscape. Although he will appreciate Corot's paintings as paintings, he will none the less object to Corot's serenity in the face of nature and will instinctively prefer Theodore Rousseau whose landscapes give out an almost palpable aura of distress. By the same token, Baudelaire will give much more importance than it perhaps deserves to Delacroix's throwaway remark that nature is only a dictionary from which the artist will select elements for his composition. Similarly, Baudelaire will grow very uneasy when he comes face to face with a portrait by Ingres, for he is quick to sense a replete animal quality which comes dangerously near the heart of his own troubles (Fig. 11). In fact Baudelaire is not at home with any painter who looks at the surface of the world and finds it good, and in this category he puts Courbet and even Raphael, but above all Ingres.

Having accepted the Catholic doctrine of the Fall, Baudelaire sets about finding some form of redemption, and here he is in some difficulty because he claimed that he did not believe in God—or at least not until the end of his life. Like many of his contemporaries, Baudelaire was an avowed Satanist, a position made most explicit in the poem *Le Reniement de Saint-Pierre* which closes with the line, '*Saint-Pierre a renié Jésus; il a bien fait*'. For a time he accepts a negative state of affairs. As the world is intolerable we must find some means to escape from it, some way out, no matter how we arrive there—'*N'importe où hors du monde*'—and in this connection his drug-taking became far more serious than it was in his early days. In the volume entitled *Les Paradis Artificiels* he describes the state of intoxication as a serious alternative to ordinary consciousness. Even when conscious one could to a certain extent outwit the state of nature by cultivating one's own dandyism, which means in effect leaving no detail of one's ordinary life and behaviour to chance, practising the most obvious forms of mastery over nature. It is again a cult,

le culte de soi-même, 'the cult of self'. But none of this is totally satisfactory. Finally Baudelaire returns to a very banal Romantic idea, the idea that the best antidote to nature is art, but characteristically he gives it his own further gloss. He isolates the quality that makes art different from nature, and that quality is Imagination, 'the sovereign faculty', the faculty possessed by all great artists and by Delacroix in particular, the faculty that can transform the elements of the real world into a new synthesis, and in so doing re-enact in some way the magic and holy epic of the original Creation. *Mystérieuse faculté que cette reine des facultés. Elle touche à toutes les autres; elle les excite, elle les envoie au combat. Elle leur ressemble quelquefois au point de se confondre avec elles, et cependant elle est toujours bien elle-même, et les hommes qu'elle n'agite pas sont facilement reconnaissables à je ne sais quelle malédiction qui dessèche leurs productions comme le figuier de l'Evangile. Elle est l'analyse, elle est la synthèse . . . Elle est cela, et elle n'est pas tout à fait cela. Elle est la sensibilité, et pourtant il y a des personnes très sensibles, trop sensibles, peut-être, qui en sont privées. C'est l'imagination qui a enseigné à l'homme le sens moral de la couleur, du contour, du son et du parfum. Elle a créé, au commencement du monde, l'analogie et la méta- phore. Elle décompose toute la création, et avec les matériaux amassés et disposés suivant les règles dont on ne peut trouver l'origine que dans le plus profond de l'âme, elle crée un monde nouveau, elle produit la sensation du neuf. Comme elle a créé le monde (on peut bien dire cela, je crois, même dans un sens religieux), il est juste qu'elle le gouverne.* ('How mysterious is imagination, that Queen of the Faculties! It touches all the others; it rouses them and sends them into combat. At times it resembles them to the point of confusion, and yet it is always itself, and those men who are not quickened by it are easily recognizable by some strange curse which withers their productions like the fig-tree in the Gospel. It is both analysis and synthesis . . . It is that, and it is not entirely that. It is sensitivity, and yet there are people who are very sensitive, too sensitive perhaps, who have none of it. It is Imagination that first taught man the moral meaning of colour, of contour, of sound and of scent. In the beginning of the world it created analogy and metaphor. It decomposes all creation, and with the raw materials accumulated and disposed in accordance with rules whose origins one cannot find save in the furthest depths of the

68

soul, it creates a new world, it produces the sensation of newness. Since it has created the world (so much can be said, I think, even in a religious sense), it is proper that it should govern it.') [Mayne].

This magnificent passage is taken from the *Salon* of 1859 and it is a prelude to one of the standard but never monotonous eulogies of Delacroix. From this passage alone can be judged the quality of writing, the sustained perfection of rhythm, of balance and of fervour which would make of Baudelaire a great prose writer even if he were a much more fallible critic in matters of fact. He is in all events a moral critic even though he uses the fine arts as a vehicle for his morality. Yet add to his almost Manichean system of thought the supreme intelligence and sophistication of a brilliant young man about town in the Paris of the 1840s—Baudelaire was, after all, only twenty-five when he wrote the *Salon* of 1846—and one comes upon the paradox, the enlivening paradox, at the heart of his writings on the fine arts: the moralist and mystic is also a wit, a sceptic, a demolisher of clichés and reputations. He has the inestimable gift, denied to Stendhal and to Zola, of always striking the right note, always finding the key to his subject. So that one must learn to expect and try to follow the alternating currents of feeling in Baudelaire's critical writings: he will begin by attaching himself to the surface of his subject but sooner or later an image, usually by Delacroix, or a concept, usually suggested by a picture by Delacroix, will divert him and he will write himself out in obedience to the inner dialectic that governs his judgements. At the end of his life the system will be turned on its head, so that the essay on Guys consists almost entirely of apparent digressions, and indeed at the end of his life Baudelaire was in such a state of heightened receptivity that an image would immediately set up a chain reaction of associations and memories which he found it essential to set down before they escaped him. This is the method followed in the essay on Wagner.

In a justly famous passage[7] Baudelaire defines the ideal type of criticism as '*partiale, passionnée, politique*', that is, subjective, impassioned, committed. This is, of course, a perfect description of his own method. Perhaps an even better clue to Baudelaire's standpoint is to be found in the essay on Guys, in which he describes that artist as '*un moi insatiable du non-moi*', a self avid for non-self.

69

The imagination eulogized by Baudelaire is in his own case more often than not a synonym for desire or despair. His critical exigencies are, like those of the profoundly sick man that he was, harsh and imperative and illusory in the sense of release temporarily obtained. Yet imagination is also the faculty which gives Baudelaire a royal sense of equality with other creative artists; he uses his status as a poet to boost his activities as a critic, claiming, with total justification in his case, that criticism is a creative affair, a fine rather than an applied art—a very significant departure from the Stendhalian position and one which was jealously questioned not only by practising artists like Delacroix but by orthodox critics like Sainte-Beuve. Only Wagner gave Baudelaire the long-awaited accolade.

Yet there is indeed something royal about Baudelaire's progress from his rather timid beginning in 1845 to the total brilliance and independence of his next *Salon*, that of 1846. In form Baudelaire's writings on art develop with remarkable suddenness from the pattern made famous by Diderot to grandiose aesthetic statements woven loosely around the work and personality of an artist whom Baudelaire particularly admires (Delacroix, Guys). The *Salon* of 1845 is the work of a young man of twenty-four. Its tone is high-spirited and a little brash and the author feels obliged to emulate the manic thoroughness of Diderot and to record an opinion on every single exhibit. His judgement is not quite sure: for example, he overpraises two pictures which have sunk without a trace, Haussoullier's *Fontaine de Jouvence* and Planet's *Sainte Thérèse*. On the other hand he keeps a sharp look-out for anything maudlin, hackneyed or phoney—what he was later to call '*le chic et le poncif*'—and he brings his considerable powers of condemnation to bear on Horace Vernet, who was something of a household word for his affecting military souvenirs. An equally personal and excessive opinion is expressed about Delacroix: *M. Delacroix est décidément le peintre le plus original des temps anciens et modernes*. ('M. Delacroix is emphatically the most original painter of ancient and modern times.') This judgement and the short breathless sentences of the Delacroix passage serve as a prelude to what is to come.

The difference between this piece of journalism and the magnificent philosophical essay which is the *Salon* of 1846 is profound. Baudelaire seems

to have decided once and for all that the business of tramping round a gallery is not for him. The *Salon* of 1846 is published in the form of a book whose chapter headings—*A quoi bon la critique?*, *Qu'est-ce que le romantisme?*, *De l'éclectisme et du doute*, and finally *De l'héroisme de la vie moderne*—are only tenuously connected with the pictures he was sent off to examine. There is in fact every reason to believe that these chapters were written before the Salon opened. The cover of the booklet on the Salon of 1845 had announced that a work by Baudelaire on modern painting was '*sous presse*'. This work never appeared but the form and finish of the *Salon* of 1846 lead one to suppose that the forthcoming book was utilized in this way.

The peculiar excitement of the *Salon* of 1846 comes from the spectacle of a completely original mind proceeding in a completely original manner. Firstly, it marks a break with the critical traditions of the immediate past, the sincere but pedestrian tradition of Delécluze, Thoré, and Planche. Taking his tone from the more frivolous (and generally scurrilous) tradition of anonymous pamphlets that flourished in the eighteenth century, Baudelaire states quite firmly that he will only discuss what appeals to him and he justifies this on the grounds that the only valid criticism is that which is stimulating and agreeable to read ('*amusante et poétique*'), and also that the function of criticism is intimately concerned with enlightenment of a moral order. The critic, as well as the artist, is a witness to the peculiar and irreplaceable quality of contemporary beauty. This leads Baudelaire to enquire whether the Romantic ideal is still valid, and by stretching the meaning of the word Romanticism, which in the first half of the nineteenth century was synonymous with modernity, he defines it as the most recent and up-to-date form of beauty rather than a jumble of literary and historical conceits. The implications of this definition were at least twenty years in advance of their time.

There follows the great passage on Delacroix whom Baudelaire regards as the most modern and singular of the Romantics, *le vrai poète du dix-neuvième siècle*, Delacroix who, according to Baudelaire, expresses so much of modern man's dilemma, notably the melancholy of an exile in an imperfect world. Delacroix is henceforth the standard by which he measures all other painters and again he sharpens his knife on Horace Vernet, stating with enviable

simplicity, *Je hais cet homme*, and going on to give his almost libellous reasons for doing so. Rather more seriously, he expatiates on the fundamental inferiority of all eclectics, because they lack the two basic qualities of passion and imagination. And in the eighteenth and last chapter he returns to his definition of modernity (and it is significant of the rapidity with which he has developed his idea to note that 'modern' is no longer a corollary of 'Romantic' but is taken up as the more important and forward-looking of the two terms) and states that the traditions of the past are no longer valid, that each age must create its own type of beauty, and that the high function of the truly modern artist is to extract from the panorama of contemporary life its eternal and basic values. The artist, with his special power of divination, has only really to see his surroundings to perform his peculiar type of alchemy. The real artist, Baudelaire insinuates, has no need to travel and to copy: his subject matter is what is going on around him.

Between 1846 and 1855, the date of his next *Salon*, Baudelaire was kept busy on literary work, and his hero-worship of Delacroix was supplanted for a time by hero-worship of Edgar Allan Poe, a volume of whose tales he published in translation in 1852, together with a long introductory article. This interval gave Baudelaire an opportunity to develop many of the leading ideas adumbrated in the *Salon* of 1846. Thus, in *Les Drames et les Romans honnêtes* and *l'École paienne*, both published in 1851, he attacks those writers who concentrate on perfection of form at the expense of subject matter and reminds them that the task of the creative artist who possesses the mystical power of imagination is to use it as a bulwark against a further and inevitable Fall. Similarly, in the article on Poe, we find a sharpened attitude to the dualism of Nature and Art. Nature has lost the passive and uninteresting aspect it had in 1846 when it was described as a dictionary and is now seen as something overtly diabolical. Referring to Poe's heredity and more probably to his own, Baudelaire states flatly, *La nature ne fait que des monstres* ('Nature creates nothing but monsters'). But, he goes on to say, Imagination is the divine faculty which, more surely than any philosophy, recognizes the secret relationships, the correspondences and analogies between the phenomena of this world and of the other.

In 1855, when Baudelaire reviewed the great Exposition Universelle, he published only an introductory article and passages devoted to Ingres and Delacroix, both of whom showed a large number of pictures. In this piece of writing Baudelaire is confined within the narrowest limits of his obsessions. The actual pictures have become irrelevant; he states quite frankly that he is liable to appreciate pictures only in relation to the associations they stimulate for him. In this connection the passages on Ingres are far more revealing than those on Delacroix. By his own standards Baudelaire is decidedly unheroic here, for if the paintings of Delacroix seem to him the equivalent of the liberated state of mind one might experience after taking opium, it is apparent in the structure of the sentences that this mental state of grace is now less powerful than the engulfing presence of nature as personified in the deadly realism of Ingres. Confronted with such a picture as the *Jeanne d'Arc*, Baudelaire confesses to feeling uneasy, almost fearful. The saving grace is nowhere in sight: *l'Imagination, la reine des facultés, a disparu* ('Imagination, the queen of faculties, has disappeared'). In a passage of astonishing objectivity he forces himself to see the point of Ingres and succeeds: *Je croirais volontiers que son idéal est une espèce d'idéal fait moitié de santé, moitié de calme, presque d'indifférence, quelque chose d'analogue à l'idéal antique, auquel il a ajouté les curiosités et les minuties de l'art moderne.* ('I would be inclined to believe that his ideal is a sort of ideal composed half of good health, half of a calm which amounts almost to indifference—something analogous to the antique ideal, to which he has added the frills and furbelows of modern art.') [Mayne]. This quintessentially perceptive judgement however denotes no admiration on Baudelaire's part; on the contrary. For in taking a classical ideal and dressing it up in modern accessories Ingres is, in Baudelaire's view, guilty of the same defects as the Parnassian poets, the so-called pagan school which he had attacked in 1851. (It is significant that the only man of letters to admire Ingres in his lifetime was Théophile Gautier.) By the same token the situation of Courbet is unfavourable, for although resolutely modern, he is equally impervious to the demands of imagination.

In 1859, the date of his last *Salon*, Baudelaire's attitude is even more extreme. Having just emerged from the humiliation of hearing his poems indicted for

offences against public decency, he appears to have felt that any obligation to serve the society which had treated him so insensitively was at an end. This article appears to have been written more from the catalogue than from the works themselves and it is marked by a polemical, almost bad-tempered note. Baudelaire, reacting against the squalor of his recent court case, affects the disdain of the fastidious amateur. He combines his own ideal of the dandy with the archaic politeness of the previous century, and the *Salon* of 1859 is written in the form of letters to a friend, much as Diderot wrote to Grimm. '*Mon cher M.*', he begins, 'M.' being Jean Morel, the editor of the *Revue Française* in which this *Salon* was published, and he goes on to condemn the state of modern painting which is now convicted of the crime of realism. Not only is Imagination in abeyance, the doctrine of fidelity to nature is everywhere gaining ground. One has only to look at landscape painting, that *genre inférieur*, for evidence of this terrible fact. Corot and Millet are swept aside; even Rousseau, for whom he once made special claims, has become a bit of a bore. The only practitioners of this genre whom he admires are Meryon, who confines his attention to cities (a city being, comparatively speaking, a work of art) and Boudin. Again, at the formal and metaphorical heart of the article, there is another panegyric on Delacroix, and Baudelaire's great generosity of spirit is once again apparent in the amplitude and acuteness of his descriptions and the extraordinary graciousness of his praise. Voluminous and fascinating passages follow on portraiture and sculpture but in the conclusion the mask of disdain is sharply reassumed. Baudelaire admits to leaving out a great deal, but, after all, *tout ce qui n'est pas sublime est inutile et coupable* ('all that falls short of the sublime is useless and reprehensible'), as the few kindred spirits of any distinction to whom he addresses himself will agree. Among these, *mon cher M.*, please count yourself. *Votre trés-dévoué collaborateur et ami etc.*

One aspect of the structure of these *Salons* must be examined. So much has been written about Baudelaire's debts to Diderot, to Stendhal and to Delacroix himself that it is important to see these debts in their true perspective. Baudelaire's first *Salon*, that of 1845, is unlike any other that he wrote. It is obviously the work of a beginner: the sentences are uncharacteristically short,

the turns of phrase somewhat archaic—he speaks, for example, of '*notre méthode de discours*'—and the coverage exhaustive. He is in fact emulating Diderot, in which he shows his usual excellent judgement. Certain of Diderot's *Salons* had been published by Naigeon in 1798 but they appear to have been little read, or at least to have had little effect. But in 1831 fragments of the *Salon* of 1763 appeared in the magazine *l'Artiste*, and in 1845, the year of Baudelaire's début, Diderot's *Salon* of 1759 was published in the same journal. Diderot's *Salon* of 1759 is by no means characteristic, and as Baudelaire was only ten years old in 1831 we cannot safely assume that he applied himself to the much more mature *Salon* of 1763. It is more likely that Baudelaire's attention to Diderot is an independent affair, a serious and responsible attempt on the part of an enlightened novice to follow in the steps of the undoubted master of Salon criticism. Baudelaire does not persist in this exercise, but he retains the exhilarating energy of approach, the essential amateurishness and the unashamed subjectivity that Diderot brought to the business.

By 1846 he has changed his model. He is now far more concerned with abstract ideas, particularly with the idea of Romanticism, and in order to tackle this particular problem he has recourse to the most fearless and eminent writer on this subject, Stendhal. It is perhaps relevant to note that Delacroix was a great admirer of Stendhal, and one may suppose that in their discussions Delacroix had praised Stendhal's writings to Baudelaire. With this in mind, a short cut can be found to Section II of the *Salon* of 1846, the section entitled, '*Qu'est-ce que le romantisme?*' because this cannot be understood without reference to Stendhal's *Racine et Shakespeare*. *S'appeler romantique et chercher systématiquement le passé, c'est se contredire. Ceux-ci, au nom du romantisme, ont blasphémé les Grecs et les Romains: or on peut faire des Romains et des Grecs romantiques quand on l'est soi-même.* (To call oneself a romantic and to look systematically at the past is to contradict oneself. Some blasphemed the Greeks and the Romans in the name of romanticism: but you can only make Greeks and Romans into romantics if you are one yourself.) [Mayne]. These sentences are so Stendhalian that they almost jump off the page. Even more striking in this connection is Baudelaire's adoption

of Stendhal's dictum: *Il y a autant de beautés qu'il y a de manières habituelles de chercher le bonheur*. ('There are as many types of beauty as there are habitual ways of seeking happiness.') [Mayne]. Now *le bonheur* is not a concept which figures largely in Baudelaire's aesthetic system—very much the opposite— but it is one of the most captivating of Stendhal's preoccupations. Again: *le romantisme ne consistera pas dans une exécution parfaite mais dans une conception analogue à la morale du siècle*. ('Romanticism will not consist in a perfect execution, but in a conception analogous to the moral climate of the times.') [Mayne.] And again, *Qui dit romantisme dit art moderne* . . . In the section on Delacroix, Baudelaire even follows Stendhal in referring to *Les Pestiférés de Scio*, as if to show how much of the older writer he has taken into account.

All this is quite explicit. Baudelaire, by leaving in Stendhal's key words, does not attempt to mislead us. But he does not leave it there, for all Stendhal's ideas are given a new gloss, are moved slightly forward to correspond to a changed set of circumstances and to the changed position of the artist. While re-stating Stendhal to the extent of saying that Romanticism lies not in choice of subject or exact truth but *in a way of feeling*, Baudelaire adds this rider: 'they looked for it outside themselves but it is only inside that it can be found', that is to say, he emphasizes the autonomous inner life of the artist, a concept that Stendhal would have found marginal and misleading. Similarly, he re-states Stendhal when he says, *Qui dit romantisme dit art moderne*, but adds, as ingredients of modernity: *intimité, spiritualité, couleur, aspiration vers l'infini*, all the qualities, in fact, which Baudelaire brought to his poetry and Delacroix to his painting. If one applies this much-quoted definition of Romanticism only to the work of Delacroix, the point will be partly lost for it is of course a perfect description of *Les Fleurs du Mal*. Here, at the height of his confidence, Baudelaire sees both himself and Delacroix as representatives of the new Romanticism; he recognizes, quite correctly, that both of them have a modern sensibility which, even when applied to traditional subject matter, isolates them from the *tristes spécialistes* who are all around. Moreover, he is very delicately implying the parity of the painted and the written statement. One must remember that Baudelaire was exceptionally modest about his own work. He never commits the vulgarity of referring to it, and even when

he quotes one of his own poems he does so in the most anonymous manner possible. But in 1846 he is very close to his literary background, as can perhaps be seen both in his reliance on written sources, on other men's opinions, as well as in his praise of Balzac right at the end of this very long and magnificent essay.

Again, another slight change of emphasis given to a remark of Stendhal—and this time a very significant one—occurs in Section XVIII of this *Salon*, the section entitled *De l'héroisme de l'art moderne*. Here is the Stendhalian statement: . . . *puisque tous les siècles et tous les peuples ont leur beauté, nous avons inevitablement la nôtre*. ('. . . since all centuries and all peoples have had their own form of beauty, so inevitably we have ours.') Then Baudelaire adds, off his own bat, *Toutes les beautés contiennent, comme tous les phénomènes possibles, quelque chose d'éternal et quelque chose de transitoire*. ('All forms of beauty, like all possible phenomena, contain an element of the eternal and an element of the transitory.') [Mayne]. The high function of the modern artist is to apply his mind to the distinction between the profound and the merely picturesque, realizing that both modes have their values but that these values are not interchangeable. This section can be read as a prelude to the later essay on Guys, *La Peintre de la Vie moderne*, in which Guys is seen as the master of the superficial aspect ('*le transitoire*'). Delacroix was, of course, for Baudelaire, always the master of the profound aspect of modernity or Romanticism, and the section on Delacroix in the *Salon* of 1846 contains some of Baudelaire's finest sentences, notably the descriptions of the *Romeo and Juliet* and the *Femmes d'Alger*, in which the beauty of the words almost elbows the images out of the way. The whole *Salon* is a triumph of intelligence, of sensibility and of divination. Its elaborate scheme was originally dictated by the book which Baudelaire had half written. The only difficulty which might arise from it is not knowing whether the various definitions of beauty and Romanticism should be applied to Delacroix. The answer, perhaps, is that they apply primarily to Baudelaire himself, for his poems reconcile the two aspects of Romanticism, *l'éternel* and *le transitoire*, which he found isolated in the painters of his election.

So much for Baudelaire's debts to Diderot and to Stendhal, neither of

them more than incidental. But what of his debts to Delacroix himself? This is a little more problematic, as indeed is the whole question of the relationship between the two men.[8] It can be stated, with almost total justification and abundant circumstantial evidence, that the section in the *Salon* of 1846 entitled *De la couleur* is the fruit of discussions with Delacroix. It would have been impossible for a young writer, with no studio background, to have possessed such complete technical knowledge. Moreover, the lines have a disconnected, aphoristic character, as if they had been written up from odd notes hastily made while the painter was talking. So far, so good. But there is more to it than this. Baudelaire's description of Delacroix's working method presupposes a more intimate knowledge of the man than in fact existed. We know that after a time, possibly after 1846, Delacroix got tired of Baudelaire with his wild enthusiasms, his emphasis on the sick aspect of his pictures. 'This Baudelaire is beginning to annoy me,' he is reported to have said, and he was concerned to keep him at arm's length. He never answered his letters, he made very few references to him in the *Journal*, and above all he made it clear that although he was glad that someone had the wit to see what he was about he did not appreciate the interpretation that Baudelaire relayed to the general public. There are several reasons for this. Delacroix had already had the unpleasant experience of having his words taken down and used out of context, for in 1837 Balzac published an amplified and dramatized version of *Le Chef-d'œuvre inconnu*, for which he applied to Delacroix for technical instruction.[9] In Balzac's story Delacroix's general theories on art are given to a mythical painter, Frenhofer, who is not only a recluse and a misogynist but is, in addition, quite demonstrably insane. The significance of this was overlooked by Balzac, but not by Delacroix. Secondly, the note struck by Baudelaire when writing of Delacroix's works, a note not only of careless social intimacy but of equal professional dignity, vexed Delacroix for the reason that it was the one he used himself when writing about other painters. Here is an amazing sentence, a very powerful and haunting sentence describing a painter mortally sick of the demands of imagination: *Il lui arrivait de regarder sa montre pour voir s'il était temps de déposer, avec sa palette, le fardeau de l'inspiration.* ('He was apt to look at his

watch to see if it was time to lay down his brushes and the burden of in-spiration.') This is not, as might be thought, Baudelaire on Delacroix, but Delacroix on Gros.[10] It is one of the main weaknesses of Delacroix that, with all his literary friendships, his assiduous visits to literary salons, he could never appreciate Baudelaire as an independent writer. To Delacroix, Baudelaire was a plagiarist, and, what is worse, a plagiarist who perfected his, Delacroix's, method. He was, in addition, a morbid fantasist who examined with embarrassing profundity the states of soul of the protagonists in pictures like *Sardanapalus* and *Les Femmes d'Alger*. It is a little chilling to reflect that there is no mention in Delacroix's *Journal* of the publication of *Les Fleurs du Mal*.[11]

One must assume that Delacroix very much resented Baudelaire's whole-hearted annexation not only of his works but of his intentions. Delacroix hated to be interpreted or to have his motives uncovered. When Baudelaire said that Delacroix was a dandy, he was for once demonstrably correct; in everything but his pictorial imagination, Delacroix was a recluse and an ascetic. 'The mask is everything' is a phrase—and a sentiment—which recurs in the *Journal*. And something of this control, the control of the highly evolved social animal, is reflected in his works. An *Odalisque* by Ingres (Fig. 13) is insistently solid and sensual and may be seen to represent '*la nature*' as against '*l'imagination*' (these being Baudelaire's synonyms for evil and good). A similar subject by Delacroix, *Les Femmes d'Alger* (Fig. 15), is impregnated precisely with the kind of reticence which Delacroix considered so desirable a quality in real life. Baudelaire, commenting on this picture, expresses his admiration in a stupendous sentence that manipulates Delacroix into an overtly moralistic position: *Ce petit poème d'intérieur, plein de repos et de silence, tout encombré de riches étoffes et de brimborions de toilette, exhale je ne sais quel haut parfum de mauvais lieu qui nous guide, assez vite, vers les limbes insondées de la tristesse.* ('That little poem of an interior, all silence and repose, crammed with rich stuffs and knick-knacks of the toilet, seems somehow to exhale the heady scent of a bordello which quickly enough guides our thoughts towards the fathomless limbo of sadness.') [Mayne].[12] The melancholy of *Les Femmes d'Alger*, implicit in Delacroix's treatment, becomes explicit in Baudelaire's exegesis, and Baudelaire imprudently assumes that

both interpretations stem from a common moral source. To one of Delacroix's fastidious and somewhat miserly temperament, these accolades from Baudelaire for having expressed that particular sadness contingent upon the condition of original sin must have been a nightmare. Delacroix did his best to ignore them, and pretty well succeeded. At the end of his life the scales fell from Baudelaire's eyes and he recorded in a letter his final judgement on Delacroix: 'un grand égoiste'.[13]

This raises the further point of the validity of Baudelaire's criticism of Delacroix. Baudelaire did not 'discover' Delacroix, who had been protected and supported by various important and discreet agencies since the early 1820s, but Baudelaire did possess a quality of empathy, a fantastic insight into certain states of mind, which literally threw new light onto Delacroix's works. A case in point is the *Death of Sardanapalus* (Fig.14) of 1827, accepted by the more liberal-minded critics of the day as a poem of destruction. But the *Sardanapalus*, as Baudelaire is constantly hinting, is not about destruction, but about *ennui*, about *spleen*, about the inability to feel no matter how violent the stimulus. So overwhelming is the impression that Baudelaire receives from this picture that he turns it into a poem, and few would argue with the interpretation as it is set out, slightly symbolized, in one of the poems from the sequence entitled *Spleen*:

> *Je suis comme le roi d'un pays pluvieux,*
> *Riche, mais impuissant, jeune, et pourtant très vieux,*
> *Qui, de ses précepteurs méprisant les courbettes,*
> *S'ennuie avec ses chiens comme avec d'autres bêtes.*
> *Rien ne peut l'égayer, ni gibier, ni faucon,*
> *Ni son peuple mourant en face du balcon.*
> *Du bouffon favori la grotesque ballade*
> *Ne distrait plus le front de ce cruel malade;*
> *Son lit fleurdelisé se transforme en tombeau,*
> *Et les dames d'atour, pour qui tout prince est beau,*
> *Ne savent plus trouver d'impudique toilette*
> *Pour tirer un souris de ce jeune squelette.*
> *Le savant, qui lui fait de l'or, n'a jamais pu*

De son être extirper l'élément corrompu,
Et dans ces bains de sang qui des Romains nous viennent,
Et dont sur leurs vieux jours les puissants se souviennent,
Il n'a su réchauffer ce cadavre hébété
Où coule au lieu de sang l'eau verte du Léthé.

('I am like the king of some rainy country, rich but impotent, young and yet senile, who, despising the toadyings of his tutors, is bored with his dogs and with other creatures. Nothing can amuse him, neither game nor falcon, nor the sight of his people dying beneath his balcony. His favourite jester's grotesque ballad can no longer relax the brow of this cruel invalid; his couch, adorned with fleurs-de-lys, is turning into his tomb, and the ladies in waiting, for whom all princes are attractive, are at a loss to find the immodest dress which might draw a smile from this young skeleton. The learned alchemist who makes gold for him has failed to extirpate the corrupt element from his being, and in those blood-baths which come down to us from the Romans, to which men of power resort in their last days, in vain he has tried to rekindle this benumbed corpse in which flows, not blood, but the green waters of Lethe.')

The reasons for Baudelaire's hero-worship of Delacroix, which Delacroix could only see as dangerous misrepresentation, lie deep in Baudelaire's personality, and have already been mentioned. There is no doubt, however, that Baudelaire is the most illustrious celebrant of Delacroix's pictures, and this for a very special reason. The works of Delacroix represent, for Baudelaire, an *invitation au voyage*, an opportunity to live exclusively in the only element in which Baudelaire was comfortable, his imagination. Indeed, when faced with certain pictures by Delacroix, Baudelaire lays down his critical arms and surrenders to the extraordinary happiness of the journey; certain famous passages have a solemnity which is a little child-like, but the perception remains so acute that one can almost understand Delacroix's distaste at being tracked down by this specialist in emotional subtleties. The interpretations, particularly in the great obituary of 1863, inevitably bring us closer to Baudelaire than to Delacroix, yet Baudelaire prepares and defends even this position in his definition of beauty: *quelque chose d'ardent et de triste*

... *laissant carrière à la conjecture* ('something ardent and sad ... leaving the field free to conjecture').[14] The element of conjecture, which Baudelaire occasionally abuses in his passages on Delacroix, is nevertheless so apposite that not even the most clinical and detached student of Delacroix can afford to dispense with the critic's interpretation.

Having canalized his ardour and admiration for Delacroix, Baudelaire is inevitably led to criticize Ingres. Ingres was not only the official opponent of Delacroix; his pictures made Baudelaire feel physically ill because they tied him down to the here and now, they were finite statements, they did not *laisser carrière à la conjecture*. There were many additional reasons for Baudelaire's instinctive dislike of Ingres, the champion, in Baudelaire's eyes, of an unspiritual, materialist, academic canon of beauty. Ingres was that despised animal, an eclectic. He was not a Romantic because he painted Greeks and Romans without giving them a modern application. As a person, he was boring, dogmatic, and not at all *dandy*. He had no imagination, using the word in the almost magic sense in which Baudelaire habitually uses it. Above all, Ingres was a famous man, whereas Delacroix, in Baudelaire's view, was ignored, despised and rejected—a curious Romantic fallacy in which, for once, Delacroix concurs. For these reasons, Baudelaire adopts a very different critical stance towards Ingres; he brings to the task of judging him not the humility and deference lavished on Delacroix but those qualities which make him superior to Ingres as a man of the world: wit, polish, sophistication, even a certain savagery. Yet so great is Baudelaire's integrity that he struggles with his dislike for Ingres and out of this struggle is born the most amazing objectivity. Baudelaire is the first critic to note that Ingres's temperament and style are made up of various irreconcilable strains which he, by a gigantic effort of will, manages to blend. Baudelaire's perception of this phenomenon dates from the *Salon* of 1846. In the *Salon* of 1855, which contains his longest essay on Ingres, Baudelaire actually names Ingres's sources: Titian, the quattrocento Florentines, Poussin and the Carracci, Raphael, the Nazarenes, and the arts of the Near and Far East. This alone is extremely far-sighted of him, particularly when one reflects that Baudelaire was entirely self-taught and that he hardly ever left Paris. He goes on to analyse Ingres's tastes and

methods with far greater accuracy than he usually devotes to Delacroix. Ingres is really outside Baudelaire's experience; there is no possibility of identification, and therefore Baudelaire is forced to exercise his eye, his curiosity, his need to understand this paradoxical but paradoxically modern figure. Baudelaire is, equally, the first critic to see Ingres as an essentially modern painter, and in this connection his essay should be read as a corrective to all the older standard biographies.

All this is of great historical and intellectual importance. Yet undoubtedly Baudelaire's most memorable utterance on the business of painting is *Le Peintre de la Vie moderne* in which painting is hardly mentioned at all. This is nominally a report on the work of Constantin Guys, referred to throughout as 'M.G.' out of deference to Guys's desire for anonymity. The device serves Baudelaire well for it enables him to take over Guys's work in a way that he was never quite permitted to do with Delacroix. It is significant that in this study one reads through pages of dazzling description without ever feeling the need to refer to an actual image by Guys, for Baudelaire does it all so much better. The essay is about life—and only incidentally about modern life—by someone who is already sick and has always regarded himself as disabled. The images of the Child and the Convalescent are dominant. Only the sick man, or the artist, clings so desperately to the surface of life, values its trivia, tries to catch, as if by contagion, its vitality. Only the child, or the artist, is capable of such surrender to sensations of noise, light, excitement, appetite. These qualities, on which Baudelaire expatiates, are in fact his credentials for belonging to the Happy Few; they demonstrate what he himself calls in another context his impeccable *naïveté*. Apart from its intrinsic beauty, this essay occupies an absolutely central position in the development of nineteenth-century painting and literature. The brothers Goncourt were to base their method on a study of *petits-maîtres* as recommended in the first section. Zola was to reproduce in his novels the sense of being immersed in a tide or flux of humanity, like Baudelaire's aching appetite for *la foule*, while the images of the Child and the Convalescent are vital for Proust. Moreover it is possible that the Impressionists of the 1860s and early 1870s, whose work is so intensely Parisian, regarded this text as something of a

signpost and strove to become painters of modern life in a sense that made Courbet appear almost academic.

The keynote of Baudelaire's attitude to art and artists is generosity. In fact, despite the rigidity and apparent exclusivity of his system, painters fared well in Baudelaire's pages. Delacroix, of course, owes his fame as much to Baudelaire as he does to himself. But Daumier too got powerful encouragement when Baudelaire said that he was one of the greatest draughtsmen of the nineteenth century, perhaps greater than Delacroix himself. Both Baudelaire and Courbet had a reciprocal antipathy for each other's ideas but Baudelaire declined to attack Courbet in print. Millet was condemned for his sentimentality, which is understandable, but not praised for his draughtsmanship, which is curious. Guys was over-praised, largely for his subject matter, but a painter who had virtually no subject matter at all, such as Boudin, was accurately assessed. It is perhaps a little disappointing that Baudelaire does not express a more coherent attitude to Manet. There is no doubt that Manet was in many ways a disciple of Baudelaire, but of Baudelaire the poet rather than Baudelaire the critic. The two met fairly regularly in the early 1860s and Manet's *La Musique aux Tuileries* (Fig. 16) is an image of *la foule* in the sense in which Baudelaire used the term in relation to Guys. But when the two were friendly, Manet was young and ambitious and Baudelaire was already a very sick man, for whom objectivity was an almost impossible task. His most prophetic words on modern art, as opposed to Romantic art, had already been lavished on the person of Constantin Guys. Moreover, in 1863 Delacroix died and this was a great emotional shock for Baudelaire because it meant the end not only of a great man but of great art. In Baudelaire's eyes, the poetic vision of Delacroix could only be followed by anti-climax, by a general decline in ability to measure up to such high and exacting standards. Hence his rather cruel remark to Manet, *Vous n'êtes que le premier dans la décrépitude de votre art.* ('You are only the first in the degeneration of your art.')[15] Does he sense in Manet the inception of art without a moral dimension? This is, although formulated in different terms, the objection of Zola, for however unlike Baudelaire and Zola are as people, both have a heightened awareness of the solemn and marvellous

significance of life, *la saveur amère ou capiteuse du vin de la vie* ('the bitter or heady taste of the wine of life'). Baudelaire wrote no art criticism after 1863, so one must piece together his attitude to Manet from letters and one published sentence in *Peintres et Aquafortistes*, in which Manet and Legros are briefly commended. Baudelaire's main criticism of Manet was the latter's desire to arrive and be accepted, a quality very far removed from the detachment of the true dandy. It is Manet's despair at the rough treatment he received in the Salon that incites Baudelaire to this outburst in a letter of May 1865: 'Do you think you're the first man this has ever happened to? Are you a greater genius than Chateaubriand or Wagner? People made fun of them but they didn't die of it. *Vous n'êtes que le premier dans la décrépitude de votre art.*' He obviously felt considerable remorse for having spoken so harshly, because three days later he wrote to a mutual friend, Mme Paul Meurice, praising Manet's qualities, his *'facultés si brillantes et si légères'*. He adds, *Jamais il ne comblera absolument les lacunes de son tempérament. Mais il a un tempérament, c'est l'important.* ('He will never entirely fill the gaps in his temperament. But he *has* a temperament, and that is the important thing.') This is an extremely significant statement. The word *tempérament* will be used and abused by Zola. It is not much appreciated by Baudelaire, but at the very end of his life he sees that the new generation of artists will have to be judged by different standards, by standards of temperament, that is to say, a revised version of *la manière de sentir*, 'a way of feeling'.

So that Baudelaire would seem to have spanned, pretty exhaustively, a range of attitudes that at first sight might have appeared deceptively simple, commonplace or well-worn Romantic attitudes to which he gave back their original freshness, as well as a profundity that they did not always possess in the first instance. Baudelaire is a living justification of the art of criticism; he is in a sense the critic beatified, and for a very singular reason. It is a cliché of the Romantic legend—it is in fact an indispensable item of nineteenth-century mythology—that the artist, whether he be painter or poet, inevitably suffers at the hands of the uncomprehending critic. Like all clichés, this one is perhaps ninety per cent true. But in the case of Baudelaire we have an interesting reversal of this cliché: we have an example of the critic suffering

at the hands of the uncomprehending artist, for Baudelaire is of a temperament even more rare and of a historical and moral sense even more acute than any of the four heroes whose fame he chose to propagate, Delacroix, Guys, Wagner and Edgar Allan Poe. What makes Baudelaire's quality as a critic so rare is that he is always operating as an artist rather than as a patron, and of course for Baudelaire the artist always has moral obligations. Historically, Baudelaire belongs to the age of Romantic disillusionment, to the age which sees the withdrawal of the artist from the social context. Yet for Baudelaire these difficulties exist only to be overcome. He is the great master of aesthetic and moral counter-attack, one of the few undoubted heroes of the nineteenth-century literary scene.

NOTES

1. Alfred de Vigny, *Servitude et Grandeur militaires*, 1835.
2. *Salon* of 1846.
3. *Mon coeur mis à nu*, LXIX.
4. *Fusées*, XVIII.
5. Enid Starkie, *Baudelaire*, Gollancz, n.d.
6. *Tout enfant, j'ai senti dans mon coeur deux sentiments contradictoires: l'horreur de la vie et l'extase de la vie. C'est bien le fait d'un paresseux nerveux.* ('As a small child I felt two antithetical feelings in my heart: life's horror and life's ecstasy. This is certainly the result of laziness and bad nerves.') (*Mon coeur mis à nu*, LXXIII.)
7. *Salon* of 1846.
8. See Gita May, *Diderot et Baudelaire critiques d'art*, Geneva, Droz, 1957; P. Jullian, *Baudelaire et Delacroix*, Gazette des Beaux-Arts, December 1953; J. P. Revel, *Delacroix entre les anciens et les modernes*, l'Œil, May 1963; Lucie Horner, *Baudelaire critique de Delacroix*, Geneva, Droz, 1956; François Fosca, *De Diderot à Valéry*, Paris, Albin Michel, 1960; George Mras, *Eugène Delacroix's Theory of Art*, Princeton University Press, 1966.
9. The story first appeared in *l'Artiste* in 1831.
10. Delacroix, *Gros* in Revue des Deux-Mondes, 1.9.1848. In *Œuvres, Littéraires*, Paris, Bibliothèque Dionysienne, 1932, vol. ii.
11. Although he does acknowledge a copy sent to him by Baudelaire in a letter of 17.2.1858.

12. *Salon* of 1846. I am indebted to the Editor of the Burlington Magazine for allowing me to reprint this passage from my article *Art Historians and Art Critics VII: Charles Baudelaire*, Burl. Mag., June 1964.

13. Letter to Jules Troubat, 5.3.1866.

14. *Fusées*, XVI.

15. Quoted N. G. Sandblad, *Manet: three studies in artistic conception*. Translated by W. Nash. New Society of Letters Publications 46. Lund, 1954.

ZOLA

Zola

ÉMILE ZOLA HAS ALWAYS had a bad press from painters and art-historians, both in his own time and since his death. Great efforts have been made by literary historians to emphasize the unusually fearless stand he made in defence of Manet and the Impressionists before moving on to other battles and defending more important causes. While literary historians do this, art historians tend to concentrate on Zola's apostasy, i.e. his abandonment of Manet and the Impressionists in the later years of the movement's history, his failure to defend Cézanne, and above all, the evidence of his novel *L'Œuvre*. It is only too easy to point out that Zola is an imperfect critic, and that the man is far greater than the sum of his works. It is equally easy to point out that his taste was not only fairly rudimentary but behind that of the times in which he lived. But having said this, one must then add that Zola's ideal was always the greatest good of the greatest number, and that minorities were only of interest to him as long as they were under attack or being victimized or without a voice to speak for them. Zola is at no stage a critic in the traditional sense of the word; he is a journalist, the greatest journalist of the nineteenth century. And as a journalist he takes the stand that has become so debased in our own time: that of the fearless investigator, the public conscience. He was seen by his contemporaries to be a vulgarian, and his literary reputation was always coloured by this fact. He was also an arch-combatant, a moulder of public opinion: tiresomely candid friend and ultimately invincible foe. Baudelaire, speaking as an unassimilated individual, could virtually ignore Manet in public and toss out a slighting phrase in private without anyone being any the worse off for it. But Zola, writing in a mass-circulation weekly, could not describe Cézanne as 'a great painter who miscarried' (*un grand peintre avorté*) without setting off storms of partisan-ship which have still not died down.

It would be possible to describe Zola's career as a triumph of journalism over literature, of appeal to the mass over individual taste, but one is always brought up against Zola's activities as a human being. Anatole France's words at his funeral—*Il fut un moment de la conscience humaine*—provide the correct standard by which to judge him. Zola does not simply write about the heroism of everyday life; he exercises and promotes it, in spheres as

widely different as painting and politics. With Zola, therefore, a slight but essential mental adjustment has to be made. His writings on the arts, which are relatively copious, must be put into a wider social context. We are in the presence of a moralist of the left, and seen from this point of view, the hurt feelings of Monet and Cézanne become less important than is generally recognized in histories of the Impressionist movement. It is in any case absurd to concentrate on the break-up of the friendship between Zola and Cézanne without taking into account the quality of the thirty-year intimacy that preceded it. It is equally absurd to read Zola's last *Salon*, that of 1896, without remembering the heartfelt letters of admiration from Monet and Pissarro on the occasion of the Dreyfus affair. In fact Zola's relations with the painters of his time take us out of the narrow confines of textual criticism or art history and situate us in the middle of a vast Romantic epic of friendship, such as Zola himself described in *L'Œuvre*, a novel too often read for partial or didactic reasons.

One of the many small tragedies of Zola's life—small only because he was great enough to surmount them—lay in his knowledge that his work as a critic could not co-exist with his ideal of friendship. In May 1866 Zola dedicated his first victorious critical campaign to Cézanne with these moving words: *Il y a dix ans que nous parlons art et littérature. Nous avons habité ensemble—te souviens-tu?—et souvent le jour nous a surpris discutant encore, fouillant le passé, interrogeant le présent, tâchant de trouver la vérité et de nous créer une religion infaillible et complète.* ('For ten years we have been talking art and literature. We have lived together—do you remember?—and often day-break came when we were still discussing, ransacking the past, questioning the present, seeking the truth and trying to create for ourselves a complete and infallible religion.') This solidarity was not to last. In an essay on Sainte-Beuve, published first in the Russian journal *Vestnik Evropy* or *Messager de l'Europe* and reprinted with other literary essays in book form in Paris in 1881, i.e. five years before the publication of *L'Œuvre*, Zola indicates that the original alliance has already broken down: *C'est qu'il faut un véritable courage pour dire la vérité en tout et partout. On est sûr d'abord d'être accusé de brutalité, d'envie ou d'orgueil. Mais le pis est qu'on doit renoncer à toute camaraderie . . .*

('Real courage is needed to speak the truth everywhere and in everything. You can be sure to be accused at first of violence, envy or of pride. But the worst is having to give up all friendship . . .') From the idyllic friendships of his youth Zola proceeded to greater and greater isolation in the cause of his understanding of the truth, until he suffocated in his own bed, with his sick wife beside him, from a blocked chimney, perhaps the handiwork of a political or social enemy. It would be possible to interpret his entire career as a continued conflict between friendship and duty to the truth, and there is sufficient evidence to suggest that this is how Zola himself saw it.

To many people Zola's isolation was obscured by the fact that he spoke for the masses and therefore gave the impression of being a robust and positive character surrounded by an army of fervent supporters. Nothing was further from the truth, a truth perceived by the clinicians of the rue S. Georges, the brothers Goncourt, writing in their *Journal* on 14 December 1868. 'Our admirer and pupil Zola came to lunch today. It was the first time we had ever seen him. Our immediate impression was of a worn-out *normalien*, at once sturdy and puny, with Sarcey's neck and shoulders and a waxy anaemic complexion . . . The dominant side of him, the sickly suffering, hypersensitive side, occasionally gives you the impression of being in the company of a gentle victim of some heart disease. In a word, an incomprehensible, deep, complex character; unhappy, worried, evasive and disquieting.' This is deeply perceptive. Although written in 1868, before Zola's fortunes were really consolidated by the vast success of *L'Assommoir*, it already departs in every respect from the popular notion of the bluff fearless warrior who had made Manet famous and lost his own livelihood in the process. This standard view of Zola tended to harden as the years went by until he was accepted, in the 1880s, as the archetypal middlebrow, popular with the average reader, having capitalized on the 'new' scientific principles of Claude Bernard, and put into practice Guizot's hated maxim, *'Enrichissez-vous'*.

There is a grain of truth in this simplistic reading of Zola's progress. Zola is not an ironic commentator like Stendhal or a dandy like Baudelaire; he writes for a wide public and he is basically a member of that public. He bears a certain resemblance not only to Balzac, whom he so greatly admired, but

also to Hugo, of whom he disapproved. All three are concerned with the production of an epic, and all three had the staying power to accomplish it. But there is perhaps a closer comparison to be drawn between Zola and Hugo, for both have the Messianic faculty well developed, both create literary miracles of sustained greatness interspersed with large slices of banality, and, most important of all, both are Romantics. *Je trempe dans le romantisme jusqu'à la ceinture* ('I am steeped in Romanticism up to the hilt'), confessed Zola in 1882.[1] It is significant that his own literary contemporaries, notably Flaubert and Maupassant, also saw him as a Romantic. Leaving aside for a moment the exact nature of Zola's Romanticism, it could perhaps be suggested that his personal loneliness was in part due to the fact that he had outraged some widely shared primitive conviction by being a Romantic who not only obtained popular success but also made a great deal of money out of it. Like Hugo, Zola frequently made his contemporaries wince; he had, without being altogether aware of it, the gift of setting teeth on edge, of upsetting prejudices, but unlike Hugo, who revelled in the ensuing uproar, Zola never fully understood it. It is as if he repressed whole areas of self-examination and comprehension, not out of crudeness but out of fear. He was not unaware of this deeply secret operation although he tried to confine it within purely literary limits. *Bon courage et bon succès*, he wrote to Huysmans on the publication of *A Rebours* in 1884. *Moi, je tâche de travailler le plus tranquillement possible mais je renonce à voir clair dans ce que je fais, car plus je vais et plus je suis convaincu que nos œuvres en gestation échappent absolument à notre volonté.* ('As for me, I am trying to work as quietly as possible, but I give up trying to understand what I am doing, because the further I go, the more I am convinced that the works germinating inside us are entirely beyond the control of our will.') Our destiny also escapes the operations of our will, as Zola, flushed with determinism, would agree. But at the heart of the matter, determinism is not enough. It cannot explain the melancholy of Zola, a melancholy all the more poignant for being played down; it cannot explain his fear of death, which made his love of life so dynamic; it cannot explain his peculiar relationship with what was later to be known as the collective unconscious. In his most personal works, the brisk explanations of Claude

Bernard are transmuted into the darker and more ancient concept of fatality.[2] This is surely the message of *L'Assommoir*, *La Joie de Vivre*, and above all *Germinal*, and art historians, transfixed by the fiery gaiety of the *Salon* of 1866, or the almost peevish disappointment of that of 1896, may merely be judging without the dimension of experience which occasioned Huysmans to pronounce when he had read *Germinal*, . . . *ça dégage une sacrée, une sacrée tristesse* . . . ('what appalling sadness emerges from that book').[3]

Art historians are accustomed to read Zola's life as a sort of shadow accompaniment to that of Cézanne, although Cézanne's life is virtually free of incident and that of Zola packed with high drama. Zola was born in Paris in 1840, the son of a French woman and a father of mixed blood, part Greek, part north Italian. The father was a civil engineer and in 1842 the family moved to Aix-en-Provence where François Zola was given the important job of canalizing the city's water supply. He died in 1847 before he was able to complete his task, and an aura of failure hung over the whole Aix enterprise, particularly as the authorities refused to pay any compensation to the widow. Much litigation and recrimination took place, which makes it easy to understand why Zola later became interested, to the point of obsession, in the power and money nexus of Second Empire society, particularly in a small town, the town he calls Plassans in his novels. The mother was forced to work to keep her son at school. Meanwhile, Zola was enjoying himself in and around Aix with his friends Cézanne and Baille, and biographers of both Cézanne and Zola have emphasized this idyllic moment in their friendship. Zola himself has described it in lyrical terms in his article on Musset.[4] The friends had predictably Romantic tastes, wrote poetry and envisaged a career in the arts, and at this stage Zola was very much the leader, Cézanne the pupil. In their youth the two men were astonishingly alike, linked, in particular, by a rather lurid, old-fashioned Romanticism coloured by precocious erotic yearnings which neither of them was in a position to canalize profitably. If there is to be any comparison at all, it must be on the basis of their early experiments, e.g. Cézanne's murder and rape scenes with Zola's hectic 'black' novels, *La Confession de Claude* and *Thérèse Raquin*. The comparison, however, must end there. Cézanne abandons this style

completely for one of increasing purity. Zola retains it, and to the end of his life remains the celebrant of the primary emotions.

In 1858 the free country happiness ended for Zola. He and his mother moved to Paris, where they lived in extreme poverty. Zola tried to pass his examinations and failed, and it may be legitimate to blame his lack of what is now called further education for his critical acceptance of the popular scientific theories circulating at the time, notably Darwin's *Origin of Species*, translated into French in 1862, and Claude Bernard's *Introduction à la Médecine expérimentale*, which appeared in 1865. By 1860, Zola was working in a warehouse and supporting his mother, which he continued to do until her death in 1880. He suffered from hunger, from cold, and eventually from a severe illness; he suffered above all from loneliness, and he wrote to his friends urging them to join him in Paris as they had originally planned. By 1862 he was working in the packing department at the publishing house of Hachette. By titanic efforts he got himself transferred to the publicity department, and there Zola the Romantic turned himself into Zola the careerist. He began to make friends with editors, publishers and men of letters by sending out free samples of books published by Hachette. He had already started to publish a few stories and reviews, notably of Doré's illustrations to *Don Quixote* and the *Bible*, which appeared in the *Journal populaire de Lille* and the *Salut publique* of Lyons in 1863, and by 1865 he was writing a regular gossip column entitled *Les Confidences d'une Curieuse* for *Le Petit Journal*. It was in 1865 that his first novel, *La Confession de Claude*, was published. In view of the fact that 'Claude' was to become something of a fetish-name, that Zola signed his 1866 Salon articles in *L'Événement* 'Claude' and that the hero of *L'Œuvre* is called Claude Lantier, this work has an importance beyond its literary merit. It also occasioned, almost fortuitously, a change in Zola's life. An air of immorality hung over it and although this was dispersed by the Procureur-Général after suitable enquiry, the publicity was considered undesirable by Zola's employers at Hachette. Zola resigned, determined to 'me consacrer entièrement à la littérature.'[5]

More important publications, however, were seeing the light of day at that time. In 1865 the Goncourts published *Germinie Lacerteux*, which they

described in a resounding preface as the first truly working-class novel. Also in 1865 came Taine's important but now little read *Philosophie de l'Art*, which propounds the general thesis that schools of art are the product of a set of circumstances dominated by heredity, environment and moment in time ('*race, milieu, moment*'). This determinist explanation, eagerly adopted by Zola, is coloured by Darwin's theories and gained great currency in this age of popular science. The idea that man was descended from the apes rather than the angels, that he was the product of his heredity and environment rather than a highly individualized entity trailing clouds of glory, was to produce a deep division in belief, desolating some and consoling others with a vision of science as the great living force of progress which would inevitably bring about the bravest of new worlds. In aesthetic terms, the conflict took the shape of two opposed ideologies: that of *le vrai* and that of *le beau*. For all Zola's adolescent yearnings, he is firmly on the side of *le vrai*. Indeed his entire intellectual platform is that of naturalism, of which the classic description has been provided by Professor Harry Levin:[6] 'a term belonging to the vocabulary of French philosophy, designating any system of thought which accounts for the human condition without recourse to the supernatural and with a consequent emphasis on material factors.' As an art critic, however, Zola's role is more traditionally that of a realist, in the sense in which the term was used by Duranty in 1856–7: on the side of the here and now, for the individual, against the school. This was the position of Stendhal, the position of Baudelaire, the original Romantic position that forms the link between these three great writers.

In 1866 several things happened. On 1 February, Zola was taken on as a book reviewer by the newspaper *L'Événement*. In the same month Cézanne returned to Paris, his third or fourth visit, resolved to submit a work to the Salon. Zola now had four of his boyhood friends in Paris: Cézanne, Baptistin Baille, Numa Coste and Philippe Solari. They met on Thursdays at Zola's home, and Cézanne brought his friend Camille Pissarro. They talked of their personal ambitions and of the forthcoming Salon. In May came the news that the Salon Jury had rejected Cézanne's works. Cézanne wrote to the Directeur des Beaux-Arts, the Comte de Nieuwerkerke, to

97

demand the re-establishment of the Salon des Refusés, that annexe to the official Salon, held in 1863, for works on which the Jury had been unable to agree. His letter was not answered. A second letter, slightly more militant in tone, met with the same fate. Cézanne then appealed to Zola to print something about all this in his newspaper, and the result was the series of articles in *L'Événement*, most of which were axed by the editor in response to the protests of his furious subscribers but eventually published separately by Zola as a short book called *Mon Salon*. This appeared in May 1866 and was dedicated to Cézanne.[7]

It is clear that Zola undertook these articles as an act of friendship. Basically, he considered painting to be a limited activity, to which he had a limited attachment. He believed, as he said, in the present and the future, but beyond this fact he was better acquainted with painters than with paintings, and he would certainly not at this point have considered himself a professional art critic. However, he was a journalist and he knew how to make an article. At any time after 1863 and before 1870 there was one foolproof way of writing a review of the Salon: one attacked the Jury, which was a symbol of reaction, and one demanded the re-establishment of the Salon des Refusés. Zola proceeded along these lines but he did so with passion. His attack on the members of the Jury, written before the Salon opened, was so actionable that the editor was eventually forced to suspend him, but the method, which Zola found congenial, served him as well in 1866 as it did thirty years later when he attacked, in exactly the same manner, those members of the military and government commission which had convicted Captain Dreyfus. Secondly, Zola not only demanded the re-establishment of the Salon des Refusés, he devoted his fourth article to the arch-*refusé* himself, Édouard Manet, whose pictures *Le Fifre* and *L'Acteur Tragique* had been rejected by the Salon of 1866. He did this out of sympathy but also because to do so symbolized a fight against censorship and reaction—most of the phrases in the *Salon* of 1866 have a political ring to them. Nevertheless Zola made an honest attempt to rationalize his enjoyment of Manet's paintings. It may even be that *Le Fifre* was perhaps his ideal picture: a man of the south, Zola appreciated strong colours, simple shapes and black outlines. He also performed an immense

service to the general public which, if it cared to, could read an article on controversial contemporary painting which dispensed with the jargon of criticism. The results surpassed all expectations. Zola won a moral victory for himself and wide publicity for his friends. Above all, he achieved something relatively new in the history of nineteenth-century aesthetics: the integration of the critic into a new artistic movement. It has even been suggested that Zola's championship of Manet was responsible for the formation of a group—Manet being considered as *chef d'école*—and that Zola 'was the first combatant of this circle'.[8]

The tone of the *Salon* of 1866 is militant and republican. After making the point that the Jury is not elected by universal suffrage, Zola asserts his own understanding of this matter: *Pour moi, un Salon n'est jamais que la constatation du moment artistique . . .* ('for me a Salon is only an account of the artistic moment . . .'), and says that to accept Manet one year and reject him the next is an absurdity. He goes on to define his own theory of the 'artistic moment', although artistic theory is not something one instinctively connects with Zola's name. (Yet is it not his theory that carries him from an objective to a subjective view of Manet and the Impressionists?) *Ce que je demande à l'artiste, ce n'est pas de me donner de tendres visions ou des cauchemars effroyables; c'est de se livrer lui-même, cœur et chair, c'est d'affirmer hautement un esprit puissant et particulier, une nature âpre et forte qui saisisse largement la nature en sa main et la plante tout debout devant nous, telle qu'il la voit . . . Donc, une œuvre d'art n'est jamais que la combinaison d'un homme, élément variable, et de la nature, élément fixe. Le mot réaliste ne signifie rien pour moi, qui déclare subordonner le réel au tempérament. Faîtes vrai, j'applaudis; mais surtout faîtes individuel et vivant et j'applaudis plus fort.* ('What I expect from the artist is not to give me tender visions or appalling nightmares; but to give himself body and soul, and boldly to declare himself a powerful and individual mind, a just and strong nature who can grasp life broadly in his hands and set it whole before us as he sees it . . . Thus a work of art is never anything but the combination of a man, the variable factor, and of life, the unchanging factor. The word Realist means nothing to me, since I proclaim reality subordinate to temperament. When you paint the truth, I shall applaud; but when you paint what is

living and individual I shall applaud even louder.') His article on Manet is an attack on the ignorant public rather than a defence of the artist, although he does mention three works in detail, the *Déjeuner sur l'Herbe*, the *Olympia* and the *Fifre*. His simple summing-up is that Manet's canvases put the whole Salon out of joint, underlining the insipidity of the popular favourites. He winds up, *La place de M. Manet est marquée au Louvre, comme celle de Courbet, comme celle de tout artiste d'un tempérament fort et implacable.* ('M. Manet's place is marked out in the Louvre, like Courbet's, like that of every artist with a strong and unrelenting temperament.') His identification with Manet does not on this occasion invalidate his appreciation of the artist. In his section on the realists he singles out Monet and goes on to make his famous statement, *Une œuvre d'art est un coin de la création vu à travers un tempérament* ('a work of art is a corner of the creation seen through a temperament'), which is not so very different from Baudelaire's admittedly more subtle evaluation of Constantin Guys. He ends with a profession of faith to which he will never prove unequal: *J'ai défendu M. Manet, comme je défendrai dans ma vie toute individualité franche que sera attaquée. Je serai toujours du parti des vaincus.* ('I have defended M. Manet, as I will always in my life defend every honest form of individuality under attack. I shall always be on the side of the defeated.')

This ideal situation persisted throughout 1867 and 1868. In 1867 Zola again made his sympathies quite clear by reviewing the Exposition Universelle, i.e. the official artistic manifestation, in one paper, *La Situation*, and a selection of works by Manet in another, *La Revue du dix-neuvième siècle*. The Salon fares badly, as Zola concentrates on its more popular representatives, Meissonnier, Cabanel, Gérôme, and Rousseau, who had incurred Zola's ire because he had fallen into a predictable method which did not conform to Zola's standards of truth. This is a short article because Zola had the tact not to drag it out; in any event he preferred a short clean fight to a prolonged smear campaign. The article on Manet, entitled *Une nouvelle manière en peinture*, is by contrast elegant, carefully written, and almost certainly based on Baudelaire's essay on *Le Peintre de la Vie moderne*, or if not based on it, at least inspired by it. It contains, in addition, a certain amount of studio

parlance which may remind one of Baudelaire sitting at the feet of Delacroix in 1846. Zola makes a noteworthy attempt to judge Manet *ni en moraliste, ni en littérateur: on doit le juger en peintre* ('neither from the point of view of the moralist nor of the man of letters: he should be judged from the point of view of the painter'). This procedure is so contrary to Zola's normal method —or even to that of Stendhal and Baudelaire—that it merits attention. He notes the similarity between Manet's paintings and *images d'Épinal* and Japanese prints, refutes the suggestion that he was influenced by Baudelaire's poems, and sums up his manner, memorably, as '*une brutalité douce*'. Also on this rare occasion Zola undertakes to criticize '*la foule*' for its lack of understanding, yet at the same time tries to explain the artist to the public in such a way that those with no aesthetic responses at all will be able to understand him. There is no doubt that this article marks the peak of Zola's achievement as an art critic.

1868 was an even more triumphant year. Manet, Monet, Renoir, Bazille and Pissarro were accepted by the Salon Jury, and in reviewing the Salon of that year Zola concentrates on them almost to the exclusion of other painters. There is no mention of Cézanne, but then Cézanne is still, on his own admission, a virtual beginner. In 1868 Zola's first campaign ends. The *naturalistes*, the *actualistes*, as he calls them, have won the day—they are hung in the Salon. Zola the fighter is almost disappointed at the ease with which the victory has been achieved. Now, he feels, the campaign must be waged by the painters themselves; it is up to them to justify the claims he has made for them, and made at the risk of compromising his own livelihood. *J'interroge l'avenir*, he says, *et je me demande quelle est la personnalité qui va surgir assez large, assez humaine, pour comprendre notre civilisation et la rendre artistique en l'interprétant avec l'ampleur magistrale du génie.* ('As I look to the future, I wonder whose personality will emerge broad and human enough to understand our civilization and to make it artistic by interpreting it with the magisterial breadth of genius.') This sentence is a virtual paraphrase of Baudelaire's conclusion to the Salon of 1845: *Celui-là sera le peintre, le vrai peintre, qui saura arracher à la vie actuelle son côté épique, et nous faire voir et comprendre, avec de la couleur ou du dessin, combien nous sommes grands et*

poétiques dans nos cravates et nos bottes vernies. Puissent les vrais chercheurs nous donner l'année prochaine cette joie singulière de célébrer l'avènement du neuf. ('That man will be the painter, the true painter, who manages to snatch the epic side from modern life, and to make us see and realize, by means of colour or draughtsmanship, how great and poetic we are in our cravats and polished boots. May the true seekers give us next year that rare delight of greeting the advent of novelty.') But Zola's phrase contains a warning which was over-looked by the painters themselves. Zola knew that he had other things to do, that he was not to be permanently on hand to promote an artistic revolution, that his own career, in fact, was a matter of equal importance. Yet in 1868 Zola was known to the public mainly as the critic who defended Manet, and there is evidence that Manet and his group continued to think of Zola in this light despite the passage of the years. Manet's portrait (Fig. 18), painted in the winter of 1867–8, is not devoid of complacency, for Zola is seen as an attribute of the painter along with the engraving after Velazquez' *Los Borrachos* and the Japanese print and screen. But for the time being, all was well. Zola was delighted with the portrait and in 1868 dedicated his novel *Madeleine Férat* to Manet. Other painters paid homage to their champion. Cézanne portrayed his father reading *L'Événement* (Fig. 17); the newspaper figures largely in the riverside restaurant in Renoir's *Le Cabaret de la Mère Anthony*, while a young, solemn and virtuous Zola peers out of the gloom of Fantin-Latour's *Groupe des Batignolles* (Fig. 19), perhaps the most touching evocation of this moment of friendship and solidarity.[9]

This early and intoxicating unity, which might have cooled considerably had the situation remained static, was brought to a much more natural con-clusion by the war of 1870 which caused the protagonists to leave Paris and pursue their individual interests without being dominated by any form of group consciousness. Zola, exempted from conscription because he was the only son of a widowed mother, went to Marseilles with his wife and mother and tried to start a new periodical. When this failed, and his return to Paris was blocked, he went to Bordeaux where he acted as secretary to a minor minister in the Gambetta administration. His interest in painting, which had always been an affair of warm personal sympathies rather than an objective delight, faded quite naturally from his mind. His own career as a serious writer,

sacrificed to circumstances so many times since he decided to free-lance in 1866, was once again menaced because at this juncture Zola's publisher went bankrupt and the serialization of his new novel, *La Fortune des Rougon*, was suspended. This event, in reality a minor setback for a man of Zola's energy and determination, took on a more serious aspect. *La Fortune des Rougon* is the first of those twenty novels which represent Zola's major literary under-taking, the novels that were to rival Balzac's *Comédie Humaine*, and to pro-vide a complete survey—sociological, psychological, phenomenological—of Second Empire France. To Balzac, avarice and ambition are the main-springs of human conduct; to Zola, human conduct is determined in advance by heredity and environment, the thesis, in fact, of Darwin and Claude Bernard adapted to a literary purpose. In his twenty novels Zola constructs an elaborate dynasty, the issue of two unpromising families, Rougon and Macquart, injects into this dynasty two hereditary weaknesses, alcoholism and syphilis, and works out the ravages that these inherited tendencies inflict on his characters and on the society in which they live.

This titanic undertaking has been gently but mercilessly characterized by Henry James. 'If we imagine him asking himself what he knew of the "social" life of the Second Empire to start with, we imagine him answering in all honesty: "I have my eyes and my ears—I have all my senses; I have what I've seen and heard, what I've smelled and tasted and touched. And then I've my curiosity and my pertinacity; I've libraries, books, newspapers, witnesses, the material, from step to step, of an *enquête*. And then I've my genius—that is, my imagination, my passion, my sensibility to life. Lastly I've my method, and that will be half the battle. Best of all perhaps even, I've plentiful lack of doubt." '[10]

There is, of course, more to it than this. Although Zola had a completely genuine belief in determinism as the precipitating factor in human behaviour, he was not a sublimated policeman, as James seems to imply, or a frustrated scientist, and the task of creating a family—a task which he was denied in his own life until very late on—developed a faculty in his make-up which had so far been inadequately exercised: his imagination. The weakest of the Rougon-Macquart novels are those in which the formula is predictably

worked out, and in this category one must place the novel which was to have such vast consequences for Zola's personal life, *L'Œuvre*. The strongest are those in which it is possible to forget the original formula altogether or to attach it to some other basic cause, as in *L'Assommoir*, *La Joie de Vivre*, *Germinal* and *La Terre*. These novels were to carry Zola to heights of literary fame and fortune. The most sensational of them, *Nana*, published in 1880, ran into ninety editions in one year. Zola's prodigious output says much for his own heredity and environment, and one marvels at his ability to start another book almost as soon as one was finished. His paper family became more real to him than his publisher and his readers and translators and admirers in France, England and Russia. Zola's real communion was with his documentation, his notes, his '*ébauches*', many volumes of which are now in the Bibliothèque Nationale in Paris and the Bibliothèque Méjanes in Aix. These notes are characterized by an extraordinary vivacity of tone which indicates that writing, even at such length, never became journeyman's work for Zola.

Nevertheless, it was Zola's method of documentation that now began to embarrass his friends. As Henry James had indicated, Zola placed great value on the evidence of his senses. His idea of creativity was very close to a heroic concept of paternity; he was, as he had called Courbet, '*un faiseur de chair*'.[11] For the actual details, he was dependent on a number of helpers, either voluntary or involuntary, and the figure of Zola walking the streets of Paris with his notebook, interrogating porters, market workers, laundresses, and department store sales assistants, is a familiar and slightly ridiculous one in literary history. For the local colour in *Nana* he was obliged to write to a friend for information, adding, by way of excuse, '*Moi, je suis un chaste*'. Slightly less ridiculous, and in fact totally impressive in human terms, is the sight of Zola taking his notebook down the mines to write *Germinal* or actually riding on the platform of an express train in order to write *La Bête Humaine*. And although these activities may reveal him, once again, as the journalist turned novelist, they were to have surprising results, because when Zola came up from the mine or away from the goods yard, he was so engrossed in conditions of labour, in matters of social justice, that the man of letters began to give way to the practical philanthropist. A letter to a Dutch

correspondent, Jacques van Santen Kolff, written in June 1886, contains the key sentence, *Toutes les fois que j'entreprends une étude maintenant, je me heurte au socialisme.* ('Every time I begin a study now I run up against Socialism.') It is surely impossible to read *Germinal* or *La Débâcle* without feeling that in comparison all previous nineteenth-century literary or artistic creeds have been puny and self-interested. If one now re-reads the art criticism one perceives that Zola had from the start carried within him the two faculties that expand to such heroic proportions in the novels: a natural socialism, which made him demand equal representation for the Impressionists in the Salon of 1866, and a form of paternalism which led him to believe that, given the right circumstances, creative spirits could contribute to the life of their times in terms of strength and clear-sightedness, and *mutatis mutandis*, that artists had obligations towards society, not merely towards themselves.

The novels reveal Zola as a writer of genius, a writer with an extraordinary visual sense. Because of his crushing work programme, it is usually his opening chapters which are the freshest, although the great set-pieces of description have a kind of orgiastic energy which is not easily forgotten. In particular it is the descriptions of Paris which are so vivid and these have been used, wrong-headedly, to underline the natural affinity between Zola and the Impressionists. This is a claim one might be able to make for the Goncourts, but not for Zola, because Zola was a man committed to words, not one, like Baudelaire, who could feast on images. Perhaps this is why Zola tired of painting and of painters' problems. Conversely, it was becoming clear to Zola that although Monet might be able to capture the picturesque aspect of the Gare Saint-Lazare, he was in no way able, or even anxious, to convey the crippling strain of the man in charge of the train. From being a favour done for friends, criticism, for Zola, became a more general moral responsibility. As far as he himself was concerned, he had fought the Impressionist fight by 1868; now other causes, notably those of the workers, awaited him. The painters, having with his help stormed the citadel of the Salon, had only to make good their victory by taking it over. If they wished to prolong their sectarianism by holding separate exhibitions, that was their affair. Zola the critic opts out of the sphere of aesthetics, where

the recompenses for total commitment are small, for that of human activity, where they are all-rewarding. As he became more of a revolutionary himself, Zola began to lose patience with those earlier and smaller revolutionaries, Manet, Monet, Pissarro and Cézanne.

The novels also made Zola extremely rich, and in 1878 he was able to buy himself a villa at Médan. This also produced a widening of the breach between Zola and his former friends because in furnishing his villa Zola revealed himself to be in possession of the most dubious natural taste. His ideas of decoration were in fact entirely typical of the Second Empire. Both Maupassant and Edmond de Goncourt have left descriptions of the stained glass windows, the Japanese armour, the fake medieval reliquaries, the Turkish carpets, and the tapestries, on which were hung his eleven Cézannes and his pictures by Manet, Monet and Pissarro. In this villa, which Cézanne visited, painted and stayed in several times, Zola could give full vent to his paternalism, to the occasional discomfiture of his guests. Meals were gargantuan; Zola's appetite was, predictably, huge. One gets very good food in his novels. One of these banquets is described in *L'Œuvre*, when the writer Sandoz, who is Zola thinly disguised, feasts his former friends. To the host's consternation, the guests, perhaps inflamed by the conjunction of caviare, red mullet, roast beef, truffles and ice cream, behave very badly; instead of being impressed by this abundance of worldly delights, which Zola himself enjoyed enormously, they turn up in their working clothes, ignore Madame Sandoz, smoke their pipes, and discuss the next Salon. We may assume that this situation was repeated many times in real life; the more fallible aspects of Zola's triumphant success were ironically appraised by the trained eyes of his former companions, and the tiny seed of potential resentment which occurs towards the end of the *Salon* of 1868 grows to something more sizeable and more truculent.

Yet in the 1870s, when editors of French papers were reluctant to employ him, Zola continued to plead for his friends, although they were now committed to a policy of which he could not approve: that of holding independent exhibitions. Zola was one of those moralists who are obsessed with vindication. The original miscreants must be seen to eat their words; those

who denied Manet a place in the Louvre must be shot down at their official posts, not overcome, in the fullness of time, by a subtle outflanking movement. Nevertheless, Zola, writing for the Russian paper *Vestnik Evropy* in which he has to give a broad picture of the French artistic scene, continues to bring the names of Manet and the Impressionists to the notice of the public, even if it means dragging in an allusion to the Impressionist exhibition in the rue Le Peletier which had already closed a month earlier than the official Salon (that of 1876) he was purporting to review. The writing of these Russian articles, of 1875 and 1876, is much more sober in tone than the extremely radical reviews of the 1860s, but Zola is constant in his opinions. He has been won round again to Manet by the sight of that most literary of pictures, *Argenteuil* (Fig. 20), in the Salon of 1875, but he refuses to believe that this is the last word on the subject of what he had formerly hailed as a revolution. Here he comes curiously close to Baudelaire, whose admiration for Manet was always tempered by his memory of the standards set by Delacroix. In 1875, with a note of unmistakable emotion, Zola restates this position: *Hélas, avec quelle joie ardente je me livrerais à l'enthousiasme pour quelque maître. Mais je ne puis qu'évoquer les grandes ombres de Delacroix et d'Ingres, ces génies obstinés, disparus du monde sans avoir trahi leur don. Ces géants n'ont pas laissé d'héritiers, et nous attendons toujours les génies de l'avenir. Courbet, vieilli, chassé comme un lépreux, s'en va déjà à leur suite dans l'histoire. Lui aussi appartient dès aujourd'hui aux morts, aux artistes dont les tableaux seront éternels par leur force et leur vérité. Parmi les vivants, à peine un ou deux s'efforcent de se hausser au rang des créateurs.* ('Alas, with the most passionate joy I would give myself over to enthusiasm for some great artist. But I can only evoke the shades of Delacroix and Ingres, those stubborn geniuses who vanished from the world without betraying their secrets. Those giants have left no posterity and still we await the geniuses of the future. Courbet, aged and driven out like a leper, is already following their steps into history. From now on he too belongs with the dead, with the artists whose pictures will last eternally by their power and truth. Among the living, there are barely one or two who strive to raise themselves to the level of the creators.')

It is at this point that Zola's contribution to art criticism can be fully

appreciated. From the first, he has joined the honourable company of Stendhal and Baudelaire in proclaiming the necessity of contemporaneity, of fidelity to, and enjoyment of, the times in which one lives. Although rudimentary and untutored, his taste is strong enough to condemn the outworn formula and to delight in the new vision. His entirely general response is in fact correct in a surprising number of cases, although his journalistic formation and his positive temperament have led to a slight impoverishment of the vocabulary of art appreciation, a factor for which the Goncourts will more than compensate. To Zola, the critic was not an aesthete so much as an essential witness: . . . *je dirai que chaque génération, chaque groupe d'écrivains a besoin d'avoir son critique, qui le comprenne et qui le vulgarise.* ('. . . I believe that every generation and every group of writers needs its critic who will understand it and popularize it.')[12] This function of spreading the word was one which Zola took very seriously. Through the purest motives of friendship, he had done much to establish an artistic movement in the eyes of the general public against the greatest possible opposition and at severe personal inconvenience. It was one thing to carry off a moral victory by getting the sack from *l'Événement* in 1866; it was quite another to be boycotted by French newspapers in the mid-1870s. Now Zola begins to tire. Like Baudelaire, he allows his obsessions to take over. Where is the great creative personality, the Courbet of the new generation? Why do the Impressionists not improve and concentrate their original formula? In his article of 1879, again written for the Russian paper, Zola permits himself to take an independent line. He criticizes Manet for his sketchiness, implying that it is easy enough to be a pioneer but that a more sustained effort is necessary for total victory. The Impressionists, he says, are too easily satisfied. They are wrong to break so completely with the past; a solidly composed masterpiece would not do them any harm. (Ironically enough, a similar conviction was held by Cézanne, who wanted to make of Impressionism *quelque chose de solide et de durable comme l'art des musées*).[13] Zola, bearing in mind the crushing fatigue that went into the composition of his own novels and indeed suffering from that fatigue, resented the rapidity with which the Impressionists painted their pictures. Again the solemn warning is issued: *La place est balayée pour*

le génie de l'avenir ('the place is swept clean for the genius of the future').

This Messianic note was built into Zola's make-up, and it would be a serious mistake to suppose that he confined his strictures to the art of painting.[14] Utopia, or the Millennium, is clearly postulated in *Germinal* and *La Débâcle*, although in general terms of man's humanity to man. But in his article on *La Critique contemporaine*, Zola quite specifically looks for the Messiah of criticism and does so in almost flagrantly religious terms, although he may well have been unaware of the overtones. *Le critique attendu se produira, il faut l'espérer, et il fera la lumière sur notre situation, il mettra chaque chose à sa place, reculera le passé dans l'ombre et posera debout la présent dans une grande lueur de vérité et de justice.* ('The awaited critic will arrive, let us hope, and he will shed light on our own situation, and put everything in proper perspective; he will place the past back in the shadow and will stand the present upright in the great radiance of truth and justice.')[15]

From the height of a conviction such as this, the plight of the Impressionists must have seemed a minor problem. So that when Cézanne, in 1880, once again enlisted Zola's help on behalf of Renoir and Monet, it was a rude shock to read in *Le Voltaire*, to which Zola had been reinstated, what looked like an attack but was in fact a revision, in slightly stronger terms, of Zola's argument of 1879, with the addition of one very significant word: '*impuissance*'. It is now no longer a question of what the Impressionists will not do; Zola begins to feel that they are unable to do it. *Le grand malheur, c'est que pas un artiste de ce groupe n'a réalisé puissamment et définitivement la formule qu'ils apportent tous, éparse dans leurs œuvres. La formule est là, divisée à l'infini; mais nulle part, dans aucun d'eux, on ne la trouve appliquée par un maître. Ce sont tous des précurseurs, l'homme de génie n'est pas né. On voit bien ce qu'ils veulent, on leur donne raison; mais on cherche en vain le chef d'œuvre qui doit imposer la formule et faire courber toutes les têtes. Voilà pourquoi la lutte des impressionistes n'a pas encore abouti: ils restent inférieurs à l'œuvre qu'ils tentent, ils bégayent sans pouvoir trouver le mot . . . On peut leur reprocher leur impuissance personnelle, ils n'en sont pas moins les véritables ouvriers du siècle . . . Ils ont bien des trous, ils lâchent trop souvent leur facture, ils se satisfont trop aisément, ils se montrent incomplets, illogiques, exagérés, impuissants; n'importe, il leur suffit de travailler au naturalisme*

contemporain pour se mettre à la tête d'un mouvement et pour jouer un rôle considér-able dans notre école de peinture. ('The great misfortune is that not one artist of this group has given powerful and definitive expression to the formula which all of them bring diffused throughout their works. The formula is there, but split up ad infinitum; nowhere, in none of them, does one find it applied by a master. They are all precursors, the man of genius has yet to be born. People see clearly what they are looking for and give them credit for it; but in vain one seeks the work of art which will make the formula accepted and bow all heads in admiration. This is why the struggle of the Impressionists has not yet reached its term: they remain inferior to the attempted work, they are stammering and cannot find the right words . . . They can be criticized for personal sterility, but they are still the true workmen of the century . . . They have many gaps, they are often careless in execution, too easily satisfied, unfinished, illogical, exaggerated, sterile; nevertheless, they only need work at contemporary Naturalism in order to put themselves at the head of a movement and to play an important part in our school of painting.') Thus, in the article of 1880 is adumbrated the theme of *L'Œuvre*, a novel about artistic impotence. This was precisely the factor that so wounded Cézanne and brought the long friendship between the two men to an end.

Zola, however, had his own worries. The publication in book form of his masterpiece *L'Assommoir* in 1877 had brought him literary supremacy in France, a fact unacceptable to another associate of earlier times, Edmond de Goncourt, who claimed that Zola had stolen his method. Zola's fantastic industry can be judged by the output of his novels. The ninety editions of *Nana* in 1880 might have satisfied a lesser man but Zola refused to relax. In 1882 he published *Pot-Bouille*, in 1883 *Au Bonheur des Dames*, in 1884 *La Joie de Vivre*, in 1885 *Germinal*, in 1886 *L'Œuvre*, in 1887 *La Terre*. There is a reason for this phenomenal record. In 1880 Zola's mother died, and Zola, to whom the idea of death was a nightmare, went through a prolonged nervous crisis, with hallucinations of the kind suffered by Baudelaire before his stroke. The Zolas were childless, a circumstance particularly painful to a man whose idea of creativity was associated with the natural reproductive process. Zola's

compulsive productivity begins to strike a harsh note. *La Joie de Vivre* is an ominous book about frustration, while *Germinal*, with its terrifying black symbolism, is taken from the month in the Revolutionary calendar which indicates new growth and is the equivalent of April, here very definitely perceived as the cruellest month. In addition to these internal pressures, Zola was beginning to suffer professionally. After the publication of *La Terre*, there appeared on the front page of *Le Figaro* an attack on the novel's alleged obscenity signed by five of Zola's former disciples who thus signified their break with naturalism. This *manifeste des cinq*, inspired, one imagines, by Edmond de Goncourt, who denies all responsibility, merely reinforced earlier failures like the theoretical works Zola had published on the naturalist novel and the naturalist drama in 1879 and the early 1880s. Zola was no theorist; he was, moreover, by the 1880s, somewhat out of date. The symbolist movement was well under way while Zola was still trapped in the coils of his epic celebration of determinism. Moreover, the idea that had fertilized his early writings, particularly on painting, the idea of the value of individual temperament,[16] had been replaced by his increasing preoccupation with collective undertakings, particularly on a democratic level. This explains why *Germinal*, which deals with the struggle of the workers against a corrupt mine owner, is a novel of passion and genius, and why *L'Œuvre*, a Romantic, even sentimental, study of a painter working in isolation, is a failure.

L'Œuvre, published in 1886, is the least successful of the Rougon-Macquart novels and the most personal. It tells the story of Claude Lantier, a painter first met with in *Le Ventre de Paris*, who hangs himself when he cannot complete the masterpiece that will vindicate his entire career by being hung in the Salon. In fact he hangs himself because his heredity is so disastrous that the cards are stacked against him: Claude is first and foremost the son of the wretched Gervaise of *L'Assommoir* and her ponceing lover Lantier, and therefore a prime example of the negative effects of determinism. However, Claude also bears a sinister resemblance to Cézanne—in the notes for the novel he is described as '*un Manet, un Cézanne dramatisé, plus près de Cézanne*' —and although one of his pictures is very close to Manet's *Le Déjeuner sur l'Herbe*, it is easy to see that the hirsute and unsociable character of Claude is

based physically on Cézanne, particularly as he purports to come from a Provençal town which Zola calls Plassans.[17] It was on this level that the novel gave such offence to Cézanne, although fellow writers were quick to seize the inference that Lantier represented a fair slice of Zola's own experience. Claude was the name adopted by Zola when he wrote his articles in *L'Événement* in 1866 and when he was known to the public simply as 'Monsieur Claude'. In a sense Zola is present throughout *L'Œuvre*. He is not only the healthy, 'arrived' journalist, Sandoz; he is the depressed struggler of twenty years earlier in time, timid, poor and shy, Claude Lantier, in fact. Edmond de Goncourt took the point right away. Writing in the *Journal* on 10 April 1886 and evidently reporting a conversation he had just had with Zola, he notes, '. . . I added that in my opinion he had made a mistake in introducing himself into the novel in the characters of both Sandoz and Claude . . .'

The book is disappointing in practically every respect, except for the reminiscences of Aix-Plassans, the brief idyll enjoyed by Claude and his mistress Christine in the country at Bennecourt, and the clumsy homage paid by Zola to the great painter of the day, a thinly disguised portrait of Courbet, whose qualities are contained in his name: Bongrand. On the whole, Zola's painters do not otherwise appear in an attractive light and one can understand the anxiety of Monet and his friends when the book appeared. Pissarro, whose judgement was always more disinterested than that of his fellow painters in the Impressionist group, remarked, correctly, that it was merely a bad novel. And here he shows himself to be perceptive, for *L'Œuvre* is essentially a literary creation, and the actions turn on events which are by no means the exclusive property of the Impressionists. In fact, Claude Lantier has a distinguished ancestry both in fact and fiction. The idea of the painter committing suicide is based on a real circumstance, for in May 1866 a painter named Jules Holtzapfel shot himself because the Salon jury refused his picture, an event which inspired some of the generous indignation which Zola manifested in print in his articles in *L'Événement*. Perhaps more telling in this context is an anecdote told by Zola himself in his article on Gautier: *On raconte que le peintre Flandrin, après de longs silences désespérés devant ses*

tableaux, levait parfois ses mains tremblantes, en murmurant: 'Ah! si j'osais, si j'osais!' Quel superbe cri d'impuissance, quelle cruelle conscience d'un artiste capable de comprendre et incapable de réaliser! ('It is said that the painter Flandrin, after long despairing silences in front of his pictures, sometimes used to raise his trembling hands and groan: "Oh! If only I had the courage, if only I had the courage!" What a magnificent cry of impotence, what terrible awareness in an artist capable of understanding and yet incapable of creating.')[18] Over and above this, the idea of the painter's masterpiece being a jumble of colours and shapes intelligible only to the painter himself, is lifted straight from another story, Balzac's *Chef d'Œuvre inconnu*, which Cézanne knew and admired.[19] But Balzac's painter, Frenhofer, although mad, is given the benefit of his genius throughout, whereas Claude Lantier suffers from a form of spiritual impotence, and Cézanne applied this stricture to himself. Zola sent him the novel, as he sent him all his books, and Cézanne acknowledged it. They never spoke or wrote to each other again.

No overt mention of disloyalty was made but an atmosphere of unspoken accusation and counter-accusation prevailed. Perhaps it is in this context that one should look back, as Zola does both in *L'Œuvre* and in his last *Salon* of 1896, to younger days. Zola's blistering experience of early poverty in Paris was absorbed by the optimism of youth. He saw no discrepancy in urging a life of art and high endeavour on his friend Cézanne, the banker's son, or in losing his first important job as an independent journalist over Manet, the lawyer's son, but at some point in middle life, when his own gigantic labours had finally brought him the kind of security essential to himself and his two female dependants, some memory of that early inequality took possession of him and would not easily be shaken off. Zola was a transparently courageous and heroic man but he had a certain fear of his own feelings. He never fully worked out his attitude to Cézanne but it was surely coloured by the fact that Cézanne represented failure in worldly terms, and Zola felt literally menaced by him, much as Baudelaire had felt menaced by a roomful of works by Ingres. For Zola, the person, not the painting, was the symbol. That is why Claude Lantier is half Cézanne, half Zola himself, or rather a projection of Zola's anxieties. Again, Zola was a political animal. When he defended the

Impressionists in 1866, he did so because he wanted equality of opportunity for them; he was not interested in turning their equality, once acquired, into a form of privilege. This point the Impressionists were unwilling to concede. So that Zola must be allowed a certain amount of edginess and vulnerability. He had been a risk-taker in the Stendhalian sense, but there is evidence that the Impressionists considered him mainly as a useful property. If there is any personal animosity in *L'Œuvre*—and what there is is largely unconscious—it must surely stem from these factors.

It is with these considerations in mind that one should consider Zola's last *Salon*, published in *Le Figaro* in May 1896. And what a piece of writing it is! In histories of painting, this *Salon* is dismissed or ridiculed as final evidence of Zola's philistinism because it refers to Cézanne as *un grand peintre avorté*, because it bemoans the invasion of the Salon by artists painting in the manner of the Impressionists but without that primal vigour that the original group possessed, because it seemed to Zola that he had been waging a paper war on behalf of an inferior army. And it is true that at this point his indignation has something comic about it: *Eh quoi! vraiment, c'est pour ça que je me suis battu? c'est pour cette peinture claire, pour ces taches, pour ces reflets, pour cette décomposition de la lumière? Seigneur, étais-je fou? Mais c'est très laid, cela me fait horreur!* ('What, is that really what I fought for? for that bright painting with its spots and reflections and decomposed light? God, was I mad? But it's so ugly, I loathe it!')

In fact, this *Salon* is only marginally about painting. It is, in essence, the lament of a great Romantic, surveying the battles he fought and won in earlier and more candid days, and it is impossible to read the conclusion without experiencing some kind of revelation about the true nature of Romanticism and the Romantic temperament. It deserves to be quoted in full. *Non, j'ai fait ma tâche, j'ai combattu le bon combat. J'avais vingt-six ans, j'étais avec les jeunes et avec les braves. Ce que j'ai défendu, je le défendrais encore, car c'était l'audace du moment, le drapeau qu'il s'agissait de planter sur les terres ennemies. Nous avions raison parce que nous étions l'enthousiasme et la foi. Si peu que nous ayons fait de vérité, elle est aujourd'hui acquise. Et, si la voie ouverte est banale, c'est que nous l'avons élargie, pour que l'art d'un moment puisse y passer.*

Et puis, les maîtres restent. D'autres viendront dans des voies nouvelles; mais tous ceux qui déterminent l'évolution demeurent, sur les ruines de leurs écoles. Et il n'y a décidément que les créateurs qui triomphent, les faiseurs d'hommes, le génie qui enfante, qui fait de la vie et de la vérité. ('No, I've done my duty, I've fought the good fight. I was twenty-six and I was on the side of the young and the brave. What I defended then I should defend now, for it was the daring of the moment, the flag which had to be planted on enemy territory. We were right because we had enthusiasm and faith. Whatever little truth we created is accepted today. And if the path we opened up has become well-trodden, that is because we widened it for the art of a moment to pass freely. Now we have the great masters. Others will come along new paths; but all those who will determine future evolution remain over and above the ruins of their schools. Decidedly it is only the creators who triumph, the creators of men, only the genius who begets life, who creates life and truth.')

It has been suggested, by Henry James among others, that Zola spent his life gravitating towards the defence of Dreyfus, the Jewish army officer wrongly convicted of passing documents to German army headquarters. Certainly the *Salon* of 1866 can be read as a blueprint for his journalistic campaign, *J'accuse*, and the *Salon* of 1896 as the regret of a fighter who found all his earlier battles to be of insufficient stature. Zola's five articles demanding a re-trial of Dreyfus, who was already serving his sentence on Devil's Island, are the crowning achievement of a lifetime; they turned the author into a kind of folk hero whose lustre remained undimmed in Europe until the outbreak of the first World War and was resurrected in the 1930s.[20] The writing is of a peculiarly inspired kind, as if Zola has at last found the cause worthy of his energy. It is curious to reflect that while the brothers Goncourt, through their passion for the eighteenth century, had evolved a style of writing as precious and as delicate as that of their favourite period, Zola, concerned purely with the circumstances of his own time, manages instinctively to recapture the spirit of the rhetoric of 1789, or perhaps to put on the mantle of Voltaire in his defence of the Calas family. Zola took no money for these articles and was rewarded with a heavy fine and a year's exile. It is touching to know that with the whole of Europe to choose from, Zola made

straight for those old Impressionist haunts, Norwood, Sydenham, and Penge. He even made a brief and, to him, baffling stay at a temperance hotel in Tulse Hill, before retiring to wear out his year in Surrey.

Zola died in 1902 in extremely unusual circumstances. Returning to their Paris apartment from Médan, Zola and his wife woke in the night of 28 September unable to breathe. Madame Zola stumbled to the bathroom and managed to clear her lungs but Zola was dead by the morning. The cause was found to be a blocked chimney, and the fire which Zola had lit in the bedroom proved fatal. Foul play was immediately suspected and indeed has never been disproved. Zola's disappearance was regarded as a national tragedy, his funeral cortège was immense, his position as moral leader universally acknowledged. Retrospectively, one can see that art criticism was the least of his activities, yet as an art critic he is not unimportant. He operates at a practical and emotional level rather than at an intellectual one, but his ideas are in the honourable tradition of Stendhal and Baudelaire. The words with which he concludes his *Salon* of 1879—*La place est balayée pour le génie de l'avenir*—are in fact a reprise of the lesson of Stendhal and Baudelaire who spend a great deal of their time looking for the ideal painter who will justify their predictions. Zola is the last of the Romantic idealist critics who place their hope in some unspecified painter of the future. The next development is a regression, an inversion; idealism will be projected back into the past. The masters of this particular phase are the Goncourts and Huysmans. Yet it is appropriate to mark a pause here and to recognize the accuracy and the importance of Zola's prophetic instinct. In 1860, as a very young man, he wrote to Cézanne, rallying that more inhibited spirit to action. *J'ai fait un rêve l'autre jour. J'avais écrit un beau livre, un livre sublime que tu avais illustré de belles, de sublimes gravures. Nos deux noms en lettres d'or brillaient, unis sur le premier feuillet, et dans cette fraternité de génie, passaient inséparables à la postérité.* ('I had a dream the other day. I had written a beautiful book, a sublime book which you had illustrated with beautiful, sublime prints. Side by side on the first page, our two names shone in golden letters and in this fraternity of genius came down inseparable to posterity.')[21] Posterity may have arranged the details a little differently but in essence the prophecy was fulfilled a hundredfold.

NOTES

1. Letter to G. Giacosa, 28.12.1882.

2. See F. W. J. Hemmings, *Émile Zola*, The Listener, 21.4.1966; also Hemmings, *Émile Zola*, Clarendon Press, 1953; and *Émile Zola, Salons*, recueillis, annotés et présentés par F. W. J. Hemmings et Robert J. Niess, et précédés d'une étude sur *Émile Zola critique d'art* de F. W. J. Hemmings. Geneva, Droz, 1959.

3. Letter of March 1885, quoted Lambert and Coigny, *J. K. Huysmans. Lettres inédites à Émile Zola*, Geneva, Droz, 1953.

4. Zola, *Documents Littéraires*, Paris, Charpentier, 1881.

5. Zola to Valabrègue, Paris, 6.2.1865.

6. In his marvellous book, *The Gates of Horn*, Oxford University Press, 1966.

7. Henri Mitterand, *Zola journaliste*, Paris, Armand Colin, 1962, says July.

8. Ima Ebin, *Manet and Zola*, Gazette des Beaux-Arts, 27, 1945.

9. These examples are quoted by John Rewald, whose book, *Cézanne et Zola*, Paris, Sedrowski, 1936, is the standard account of the relationship between the two men. The present writer, however, cannot agree with Rewald's evaluation of Zola as a critic.

10. Henry James, *Selected Literary Criticism*, edited by Morris Shapira with a preface by F. R. Leavis. A Peregrine Book, Y. 73. N.d.

11. *Courbet est le seul peintre de notre époque; il appartient à la famille des faiseurs de chair.* ('Courbet is the only painter of our times; he belongs to the family of the creators of flesh.') *Proudhon et Courbet*, 26.7.1865.

12. 'La Critique contemporaine', in *Documents littéraires, op. cit.*

13. Quoted Rewald, *op. cit.*

14. Pierre Coigny (in Lambert and Coigny, *op. cit.*) speaks of Zola as *animé de la foi des fondateurs de religion* ('moved by the faith of the religious pioneers').

15. *Documents littéraires, op. cit.*

16. *Une œuvre d'art est un coin de la création vu à travers un tempérament.* ('A work of art is a corner of the creation seen through a temperament.') *Proudhon et Courbet, op. cit.*

17. For other derivations, see R. J. Niess, *Zola, Cézanne and Manet. A study of l'Œuvre.* Ann Arbor, University of Michigan Press, 1968.

18. *Documents littéraires, op. cit.*

19. 'Frenhofer, c'est moi!' Quoted Rewald, *op. cit.*

20. Henri Barbusse, *Zola*. Translated by M. B. Green and F. C. Green. J. M. Dent and Sons Ltd, 1932.

21. Zola to Cézanne, 25.3.1860. Quoted Rewald, *op. cit.*

THE
BROTHERS
GONCOURT

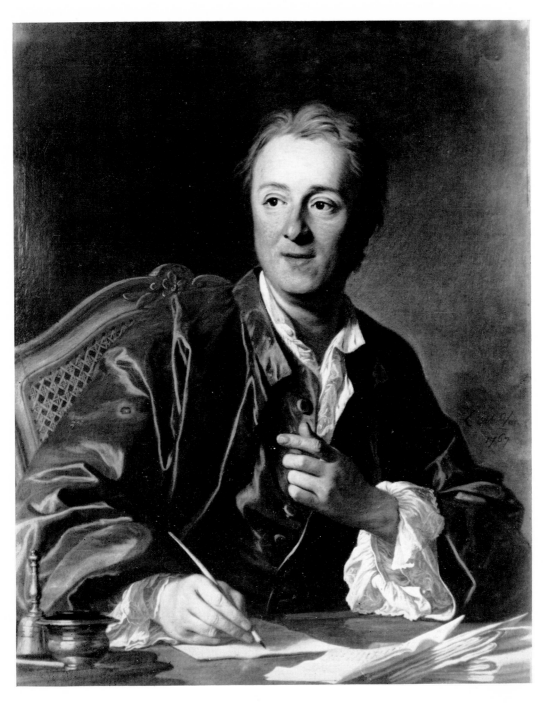

1. VAN LOO: *Portrait of Diderot*

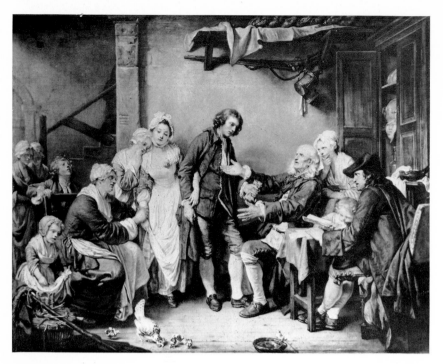

2. GREUZE:
*L'Accordée de
Village*

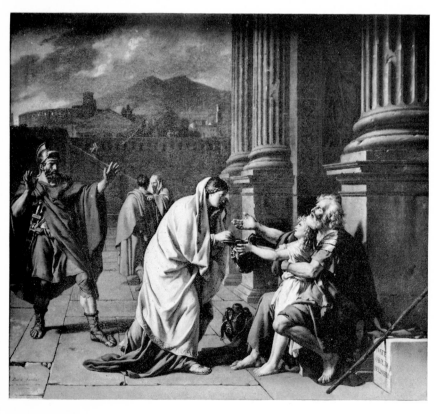

3. DAVID:
Belisarius

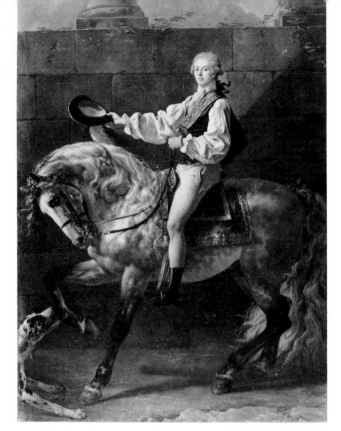

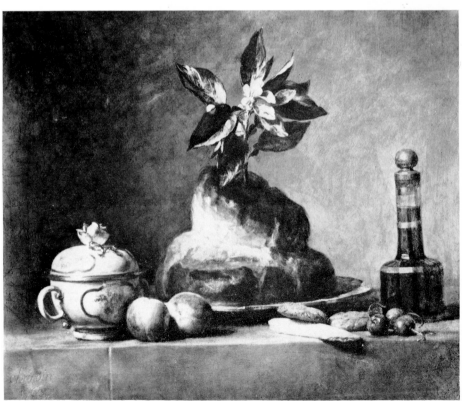

6. *Portrait of Stendhal*
by an unknown artist

7. PAJOU:
Turenne

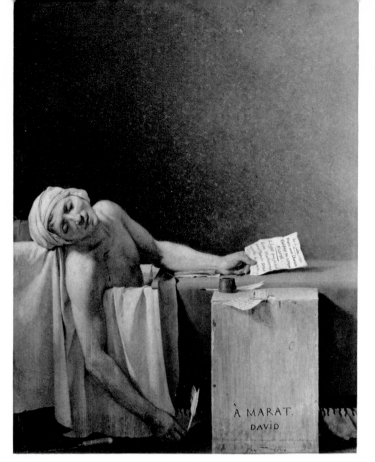

8. DAVID:
Death of Marat

9. DELACROIX:
*Scenes from the
Massacre at
Chios*

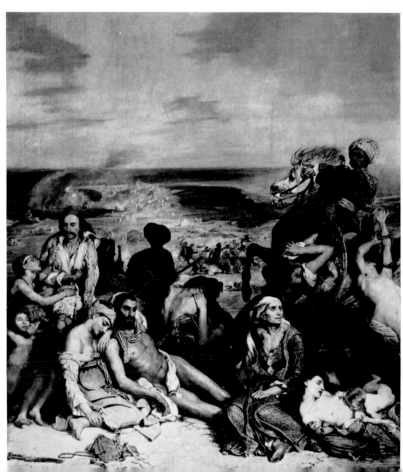

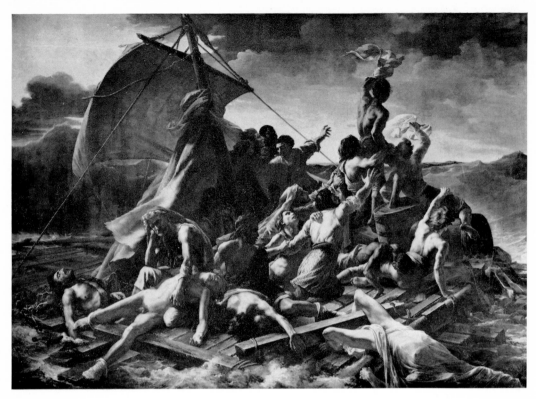

10. GÉRICAULT: *Raft of the Medusa*

11. INGRES: *Portrait of Mme Moitessier*

12. NADAR: *Baudelaire*

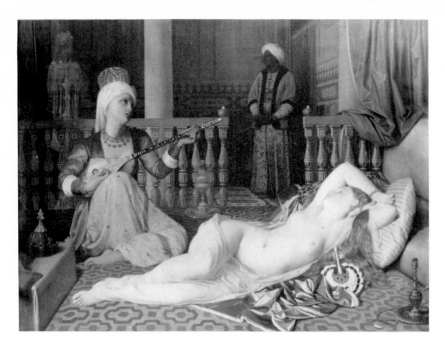

14. DELACROIX: *Sardanapalus*

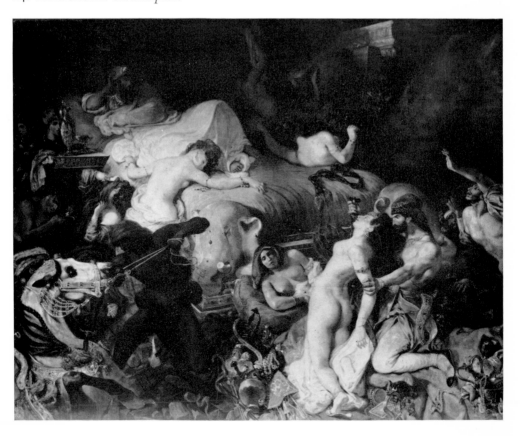

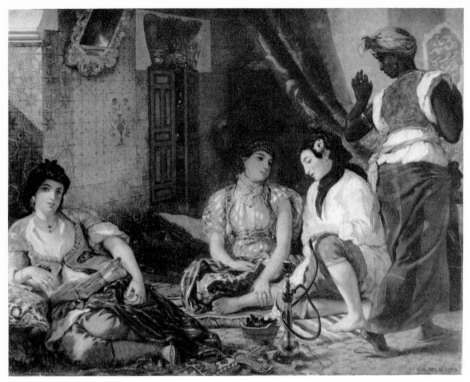

15. DELACROIX: *Les Femmes d'Alger*

16. MANET: *La Musique aux Tuileries*

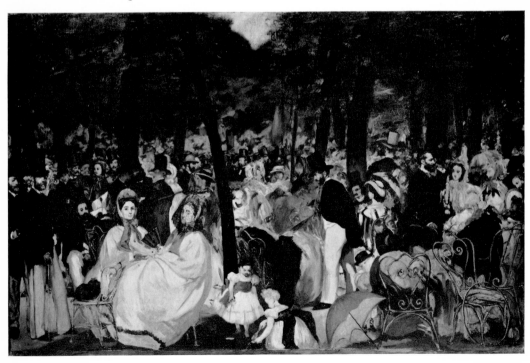

17. CÉZANNE:
Louis-Auguste
Cézanne
reading
L'Événement

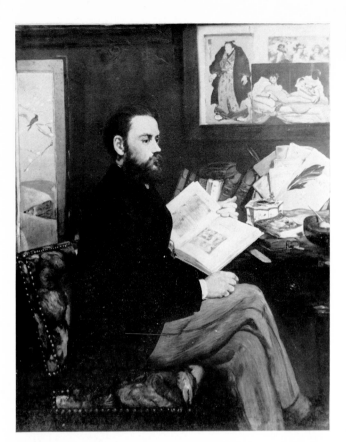

18. MANET:
Portrait of Zola

19. *(below)* FANTIN-LATOUR:
Le Groupe des Batignolles

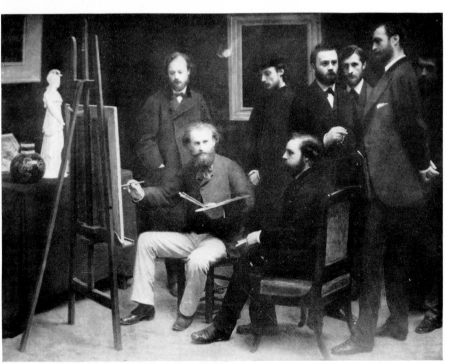

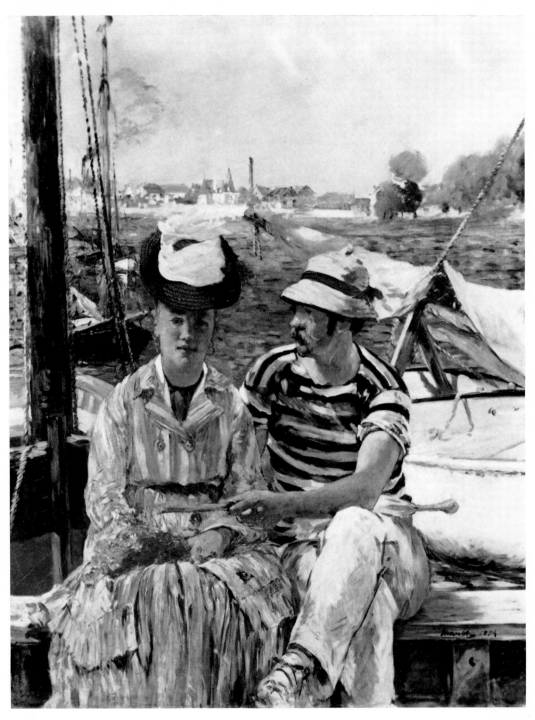

20. MANET: *Argenteuil*

21. LA TOUR:
Mlle Fel

22. J. DE GONCOURT:
Italian watercolour

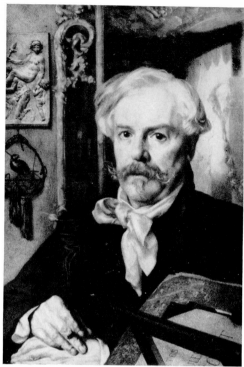

23. *Jules de Goncourt*

24. BRAQUEMOND: *Portrait of Edmond de Goncourt*

25. WATTEAU: *Pilgrimage to Cythera*

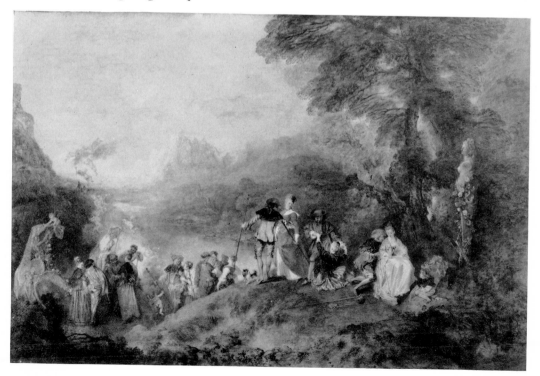

26. *Joris Karl Huysmans*

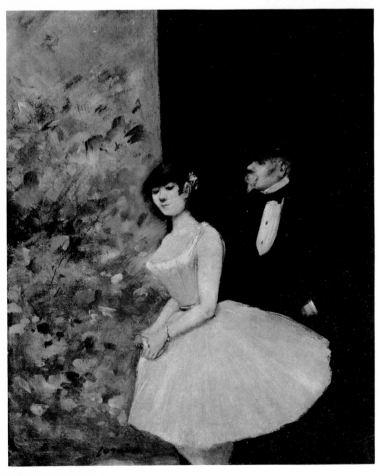

27. FORAIN:
Behind the Scenes

28. BIANCHI DI FERRARI:
*Virgin and Child
with Saints*

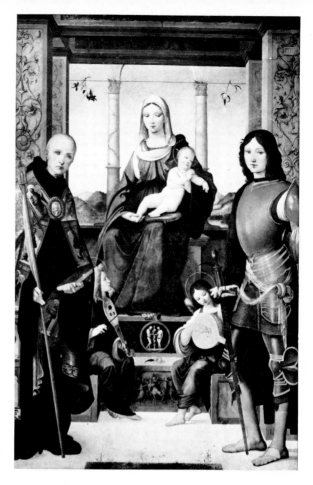

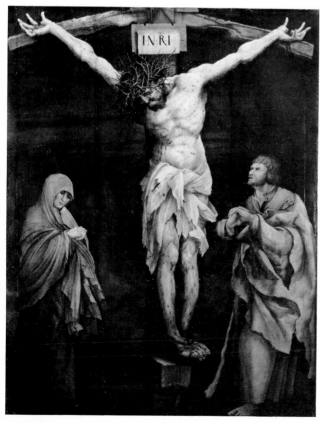

29. GRÜNEWALD:
Crucifixion

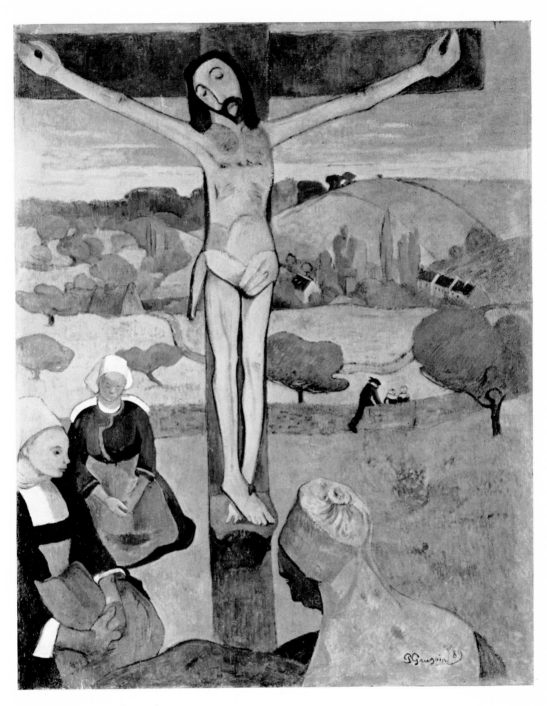

30. GAUGUIN: *Yellow Christ*

The Brothers Goncourt

ART HISTORIANS HAVE always had a certain amount of difficulty in defining their attitude towards the brothers Goncourt. The latest appraisal of their book *L'Art du dix-huitième siècle* suggests that it should be judged almost as a work of poetry,[1] a proposal which marks a sharp contrast with the traditional attitude—and with that of the Goncourts themselves—that it should be regarded as the first and finest of all the source-books. It is still required reading for students of eighteenth-century French painting, but attitudes towards it range from admiration to sharp dissatisfaction, according to the degree of sympathy that exists between the personality and tastes of the reader and those of the writers. They themselves occupied an ambiguous position in contemporary literature and the anomaly has survived the passage of time, although it can now be seen that continuous lines of development relate both their novels and their historical exercises to the work of certain of their predecessors.

Something of the dissatisfaction, or rather the discomfort, which they inspire, has to do with the fact that in the case of the brothers Goncourt the lines of demarcation between professional and amateur enterprises almost entirely disappear. The heady element of risk-taking, so apparent in Diderot, Stendhal, Baudelaire, and Zola, has vanished, or rather is replaced by an autocratic desire to *faire école*. In one sense, all the Goncourts' activities are amateur because they were not obliged to earn their living and consequently never had to conform to standards other than their own. But they saw themselves in a very different light: they saw themselves as professional men of taste. And they saw taste as an abstract quality almost in the same category as genius, and conferring quite as much prestige on the possessor.

This fact alone has much to do with the paradoxical position which the brothers Goncourt occupy in the history of aesthetics. They are responsible for many innovations, some genuine and impressive, as in the case of their novels, some curiously inverted, as in the case of their work on the eighteenth century. This particular inversion is easy to sense but hard to define: it is in some way bound up with an excessive pride taken in taste, their taste, for the objects of the past, considered not only as things in themselves but as vehicles for the emotional associations and sensual connotations they brought

in their wake. The Goncourts thought that their particular brand of taste, which they cultivated to excess, was the crowning achievement of their lives, their passport to immortality. In the eyes of posterity, however, it appears, on many occasions, to verge on hysteria, or perhaps, more properly speaking, to contain a large element of hysteria, of that cerebral lechery of which Huysmans was to become so aware. With the brothers Goncourt we are almost in the realm of the professional aesthete, poised somewhere between dandyism and decadence, but retained on the brink of the abyss by a remarkable kind of Romantic scholarship. When reading their books, particularly their books on painting, one will search in vain for any abstract pronouncements on the nature of styles; one will miss, quite consciously, the moral strictures of Baudelaire, the humanitarian breadth of Zola, or the apparently irrelevant but so enlightening generalizations of Stendhal. In fact one will always be slightly worried, when reading the Goncourts, by their apparent lack of desire to relate taste to action, and by their overwhelming need to widen the gap between art and life, a gap which Zola had done so much to close.

The brothers Goncourt have, moreover, a kind of split aesthetic personality. They operate on a selection of periods and subjects which at first appear to be irreconcilable: the fine and applied arts of the *ancien régime* in France, the fine and applied arts, of almost any period, of Japan, and the drab and frequently distressing world of contemporary Paris. They are Romantic in their view of the eighteenth century, realist in their view of the nineteenth century, and scholarly, in the best sense of the word, in their love of Japanese art. Far from being disturbed by the irreconcilability of their enthusiasms and their attitudes, they felt a strong temperamental need to balance one style, one period, against its direct opposite, and would turn from a particularly clear-sighted piece of contemporary observation to a hectic and over-written description of an eighteenth-century picture or object, a description so emotional that it occasionally borders on fantasy. Edmond, in fact, noted in the *Journal* that they had spent one morning at a hospital watching a Caesarian operation, dashing off immediately afterwards to the auction house to bid for a lot of Gravelot drawings. This *modus operandi*, in which they took

immense pride, is not very attractive, and it must be said that basically the Goncourts are not a lovable pair. Their way of tackling artistic matters held the seeds of both naturalism and decadence. In a figurative sense, the Goncourts begat both Zola and Huysmans, a fact which Edmond spent the rest of his life lamenting.

The brothers Goncourt have left so many definitions of their own originality, so many justifications of their literary and social worth, that the simple reader may be led to wonder why they do not figure more prominently in his own consciousness. They are, of course, their own worst enemies, and their statements about themselves, made either in the *Journal* or in those prefaces which the elder and surviving brother, Edmond, wrote to every new edition of their works, are somewhat embarrassing and occasionally uproarious. A random selection of such statements sets the general tone. In the *Journal* for 23 March 1878, Edmond writes, 'The critics may say what they like about Zola, they cannot prevent us, my brother and I, from being the Saint John the Baptist of modern neurosis.' In a much-quoted letter to Zola, Edmond states, 'Our entire work, and this perhaps is what constitutes its originality, is built on nervous illness.' In a letter to Flaubert, of October 1866, Jules pronounces, 'We three, with Gautier, form the entrenched camp of art for art's sake, of the morality of beauty, of indifference in political matters, and of scepticism with regard to the other nonsense, I mean religion.' Edmond again, writing in the *Journal* on 1 June 1891: 'I gave the complete formula for naturalism in *Germinie Lacerteux*, and *L'Assommoir* (that is to say, Zola's novel) was written from beginning to end on the lines laid down in that book. Later, I was the first to abandon naturalism . . . because I considered that the genre . . . in its natural form was worn out . . . Yes, I was the first to abandon naturalism for what the young writers are now using to fill its place—dreams, symbolism, satanism, etc. when I wrote *Les Frères Zemganno* and *La Faustin*, for in these books I, the inventor of naturalism, tried to dematerialize it long before anyone else thought of doing so.' And perhaps the best-known claim of all is the one contained in the preface to Edmond's novel *Chérie* of 1884, in which Edmond recalls a conversation he had with his brother Jules just before the latter's death, in which Jules said

proudly, 'The search for truth in literature, the resurrection of the art of the eighteenth century, the victory of Japonism are the three great literary and artistic movements of the second half of the nineteenth century, and we initiated them all. Well, when you've done that, it's very difficult not to count for something in the future.'[2] So great was Edmond's desire to vindicate the Goncourt reputation that he went so far as to claim that his brother died of services to literature, a martyr to fine writing—a notion to which the generous and compassionate Zola also subscribed—whereas everybody knew that poor Jules' mental collapse was due to syphilis, the most lethal malady of the nineteenth century and one to which men of letters seem to have been particularly prone.

Now all these claims can be disproved by a conscientious historian, but perhaps they require a little explanation. The brothers Goncourt laid down their lives, not for any humanitarian ideal, but for art, and not simply Art with a capital A but for *their* Art. They lived a life of what their contemporary Paul Bourget has called voluntary illness,[3] in order to sharpen their sensibilities and refine their nervous systems. They lived in a state of withdrawal from the world, looked after by their nurse, Rose Malingre, who was later turned into fiction as Germinie Lacerteux; they took little exercise, and virtually no interest in the outside world, comfortably accepting their aversion to Jews, foreigners, politicians, modern art as represented by Manet, and most men of letters who did not pay them homage. Their favourite excursion was to auction houses or antique dealers, where they amassed their superlative collection of eighteenth-century French drawings, bronzes, prints and bibelots, or to shops specializing in goods from the Far East, such as *La Porte Chinoise* or Bing, where Edmond amassed an equally amazing collection of Japanese objects of art and virtu. They were, as can be gathered from their remarks, exceedingly jealous and occasionally small-minded and they were driven to demand compensation from the world for the undoubted agonies they underwent at the writing table. They certainly suffered from a communal neurosis, although there was nothing specifically modern about it. Paul Bourget described it as lack of moral energy and '*affaiblissement de la volonté*'; it is, in fact, a tardy manifestation of our old friend *le mal du siècle*,

or, to use a more precise eighteenth-century definition of the same pheno-
menon, *le mal de vivre*. The Goncourts belong to the school of sick Roman-
ticism, Romanticism as disability, whereas Zola is the last of the healthy
Romantics, representing Romanticism as energy. The Goncourts suffered
from their scepticism, but they also cultivated it, so that in 1863 they were
able to make this statement: 'No cause is worth dying for, any government
can be lived with, nothing but art may be believed in, and literature is the
only confession.'[4] This attitude resulted not only in some of the finest and
most highly personal descriptive prose of the second half of the nineteenth
century, but also, and not too indirectly, in complacent acceptance of the
condemnation of Captain Dreyfus. As to the claim set out in the preface to
Chérie—that they were pioneers of realism, eighteenth-century scholarship,
and the Japanese taste—this is a vexed matter but one which cannot be
ignored if the Goncourts are to attain their rightful place in the hierarchy of
nineteenth-century connoisseurship.

The brothers Goncourt lived monumentally uneventful lives, the even
tenor of which was shattered by the painful death of the younger brother,
Jules, in 1870. They were well born and well off. Their father had been a
general in Napoleon's armies; he retired with a pension after Waterloo and
died in 1834. Their mother lived until 1848, by which time Edmond had
reluctantly started on a career at the Ministère des Finances. With the death
of their mother came an inheritance which was to keep them comfortably for
the rest of their lives. They were then faced with the problem of how to
spend their time. Jules, who appears to have been the more sympathetic of
the two, wrote to a friend, Louis Passy, on 29 September 1849, 'My mind is
made up; I shall do absolutely nothing.'[5] Both agreed to devote their lives
to art and letters, although their decision to be the writers they eventually
became was not spontaneous. Jules had a talent for watercolour, and although
neither of them had received more than rudimentary instruction, they em-
barked, in 1849, on a tour of France as aspirant artists. They got as far as
Algeria, no doubt stimulated by a late Romantic enthusiasm for that country
or perhaps by the example of Fromentin. From this journey, and from one
made to Italy in 1855, date a number of very attractive watercolours now in

the Louvre, precise and highly coloured and not noticeably amateur (Fig. 22); back in Paris, Jules, who was trying to complete one of these and not succeeding, jotted down, with his brush, a description of what he was trying to paint. And this highly significant transposition marks not only the inception of the Goncourts' literary career but the explanation of their literary method. It is, in fact, a prolongation of Théophile Gautier's *transposition d'art*, an essentially plastic and chromatic approach to the use of words, and it leads to the cult of the word picture at the expense of narrative or argument or even continuity. The Goncourts were aware of this and took some pride in it. Their career *manqué* as painters signified to them a right to speak on artistic matters with as much authority as other painters and infinitely more than most critics. They defined their particular prose style as *écriture artiste*, and when Edmond wrote his book describing the collection of works of art in his house at Auteuil, he entitled it, not, as one might expect, *La Maison d'un Collectionneur*, or *La Maison d'un Amateur*, or even *La Maison d'un Homme de Lettres*, but *La Maison d'un Artiste*. Curiously enough, contemporaries saw no significance in this, which may explain the note of grievance struck so continuously in the prefaces and the *Journal*.

Their literary career took some time to get under way. They were beguiled by the theatre and spent far too much time writing plays, some of which were performed but none of which were successful. Very early on, perhaps too early, they tried their hand at art criticism of the orthodox variety, with reviews of the Salons of 1852 and 1855. These reviews were very obviously the work of two comparatively young and inexperienced writers, although in 1855 they strike a note of robust common sense which betokens a fairly accurate appraisal of the average reader rather than any state of soul they themselves experienced. The *Salon* of 1855 is chiefly memorable for the fact that in it the Goncourts place Decamps very much higher than either Delacroix or Ingres, and this preference for a minor painter is entirely characteristic of the Goncourts at any stage of their lives. They remain singularly blind to the qualities of both Ingres and Delacroix whom they acknowledge simply as '*deux grandes renommées*'. Of the marvellous drawings of Ingres they isolate . . . *un crayon appliqué, laborieux, peiné, expert en raccourcis, mais asservi au terre-*

à-terre des figurations d'ici-bas . . . ('. . . a pencil sketch, studious, conscientious and laboured, cleverly foreshortened, but enslaved to the earthbound nature of everyday representation . . .'). They deplore his *'peinture porcelainée'* ('china-ware painting'), and also, curiously enough, a fault of which they themselves were also guilty, *l'excessive curiosité de l'accessoire*. They follow Baudelaire in awarding him the mention of a *'talent avare'*, and they anticipate Huysmans with the judgement, *Sa naïveté est un souvenir, son caractère un archaisme* ('his candour is recollected, his character an archaism'). On the other hand the genius of Delacroix is seen as a matter of 'convulsions'. Of his gifts as a colourist, on which his originality rested, they make the surprising and much-quoted remark, *Coloriste, M. Delacroix est un coloriste puissant mais un coloriste à qui a été refusé la qualité suprême des coloristes: l'harmonie*. ('As a colourist, M. Delacroix is a powerful colourist but one who has been denied the supreme quality of colourists: harmony.') Like Baudelaire, they acknowledge Delacroix's position as the only great monumental painter of the day but they turn with relief to Couture and Decamps, on whom they lavish excessive praise. They find their most characteristically vivid adjectives when they describe a wall painted by the latter as *calciné, lézardé, grenu, poreux, suant des micas, rougi par des esquilles de briques, émeraudé par d'humides suintés, les pieds roux de fumier . . . Decamps est le maître moderne, le maître du sentiment pittoresque* ('. . . burnt, cracked, granular, porous, exuding mica, reddened with chips of brick, green with damp oozings, its base stained by the russet-colour of manure. Decamps is the modern master, the master of picturesque feeling').

It is clear from the passages quoted that the Goncourts feel the need to talk down, to denigrate, anything to which they themselves cannot respond, and by the same token to exaggerate the importance of anything to which they can respond. This method would be perfectly acceptable were their method to be relied on, but even as early as 1852 their responses tend to drift in one direction. They are deeply uneasy in the presence of great art; they are unable to rise to Delacroix or to Ingres; they prefer the small, the appealing, the fragmentary, the collectible. The reasons for this must go very deep and are perhaps bound up with feelings of inadequacy for which they spent their

lives compensating. On a more superficial level, several rationalizations may be proposed. One must remember their original skill in watercolour, an essentially miniature medium; one must remember their distaste for the civilization of their day, their scepticism, their coldness towards abstract ideas, their apparent lack of all the major appetites. Their form of the nostalgia from which everyone in the nineteenth century seemed to suffer was turned inwards, towards a kind of sentimental codification of the past, rather than outwards in an attempt to galvanize the present. One must remember, above all, their vulnerable snobbishness, which made them literally unable to share the tastes of the majority in any sphere whatever. In order to operate success-fully, the Goncourts had to feel superior to their material. The great dreams of Delacroix, the piercing candour of Ingres, made them feel petty and irri-table, threatened with annihilation by the superior visions of superior men. It is surely instructive that the artists who became their friends—and never have two *artistes* like the Goncourts known so few painters personally—were men of inferior capabilities such as Gavarni, Raffaelli, Helleu. In the *Journal*, the great painters of their own time, Manet, Monet, and Degas, are spoken of briefly, slightingly, or simply referred to as social acquaintances. Compare this with their treatment of Gavarni, for whom they felt an altogether exag-gerated admiration and on whom they wrote a monograph which was published in 1873. This monograph is their equivalent of Baudelaire's *Peintre de la Vie moderne*; their style here is in fact strongly reminiscent of that of Baudelaire with that recognizable emphasis on the ugliness of the modern frock-coat as a fitting subject for contemporary painting. The Goncourts, characteristically, would like this to have both a contemporary appearance and one reminiscent of the Old Masters. As they remark in the *Journal*, on 12 November 1861, *L'avenir de l'art moderne, ne serait-ce point du Gavarni brouillé avec du Rembrandt, la réalité de l'homme et de l'habit transfigurée par la magie des ombres et des lumières . . .?* ('May not the future of modern art be a mixture of Gavarni and Rembrandt, the reality of man and dress transfigured by the magic of light and shade?')

The Goncourts' most important books, with the exception of *La Maison d'un Artiste* of 1881, were written before the death of Jules in 1870. This has

led many people to the conclusion that Jules was the greater writer of the two, but in fact the mental processes of the brothers were so close that they were complementary, the vivacity of the one simply regulated by the method of the other, like the two heroic acrobats in *Les Frères Zemganno*, a poorish novel which is nevertheless valuable as a testimony. Together, the brothers give the impression of a nervous energy so intense that it may occasion a feeling of discomfort in the reader; alone, Edmond is a slower and wearier man, for the experience of Jules' last illness was so shattering that Edmond's life was reduced and maimed by it and he became comparatively wordless as a result of it (Fig. 24). Be that as it may, there can be no doubt that the books written by the two brothers before 1870 are very brilliant indeed: *Manette Salomon*, the novel about painters, and *Renée Mauperin* are certainly to be counted among the finest French novels of the second half of the nineteenth century. These novels were written concurrently with their study of certain eighteenth-century painters and engravers, misleadingly entitled *L'Art du dix-huitième siècle*, which is, nominally at least, the subject under discussion here, but it is their novels, to which the words Realist, Impressionist and Naturalist were later attached, which count as the more durable of their achievements. Disregarding early exercises and those later written by Edmond alone, these novels are six in number: *Charles Demailly*, which deals with the disastrous influence of a stupid woman on a young writer of great promise: *Sœur Philomène*, the story of a young nun who works at the hospital of La Charité; *Renée Mauperin*, the story of the decline of a bourgeois family; *Germinie Lacerteux*, the story of a servant—their own servant, in fact—who goes to the bad; *Manette Salomon*, the story of a group of painters and their misfortunes; and *Madame Gervaisais*, the story of a religious conversion.

In their very different ways, these novels are deeply original. To begin with, although they have a strong story line, they are not (with the exception of *Renée Mauperin*, the most traditional in style) written in narrative form. The subject is attacked in a series of descriptive passages of mounting virtuosity, a method which is a severe test of literary skill, but a literary skill based on an astounding and highly developed visual sense. *Manette Salomon*, for example, which has a complex cast of characters, consists of 155 short

chapters, some of which deal with people, some with inanimate objects, some with atmosphere, some with states of soul. It is a cinematic style, which demands total passivity from the reader, and which perhaps forces the note of sheer brilliance and occasionally becomes rather taxing. On reading *Manette Salomon*, one begins to wonder whether certain virtuoso passages might not indeed have contributed to the death of Jules, particularly when one remembers that before sitting down to grind out, first separately and then in collaboration, such passages, the two brothers had spent the day, so to speak, in the field, taking notes for their descriptions of working life, charity funerals, operations and diseases of all kinds. The cult of note-taking is characteristic of French novels at this period[6] and perhaps the best-known practitioner is Zola. The Goncourts naturally regarded themselves as pioneers, conveniently overlooking Flaubert, to whom they owe so much, and subsequently blaming Zola for stealing their method. What can be claimed on their behalf is that they were the most heroic note-takers of all time. Flaubert, the doctor's son, rather enjoyed his visits to the dissecting room: Zola, after all, had the sort of energy to drive an express train, but the Goncourts made themselves ill for weeks out of sheer devotion to the truth. Nor did they present their usually distressing facts in such a way as to shock or disgust the reader. The very rare quality of their fiction can be appreciated in passages such as those describing the death of Germinie Lacerteux or the growing mental confusion of Madame Gervaisais, in which one's admiration is equally divided between the clinical accuracy of the diagnosis and the tenderness and delicacy of the narrative.

As for the brilliant and moving *Manette Salomon*, a jumble of pronouncements on 'modernity' borrowed from Stendhal and Baudelaire, and descriptions of fictitious pictures exhibited in the Salon which reveal the authors' inability to come to terms with contemporary painting, this is, properly speaking, a novel about the loss of youth rather than the world of art, and, as such, a masterpiece. This sad story about painters in Paris bears a strong superficial resemblance to Murger's *Vie de Bohème*, except that one is aware very early on that the Goncourts have condemned their characters to an unrewarding end, and that love, friendship, human emotion, are dire and

dangerous elements that can never compensate for the comfort of a well-run life. The novel gets off to a tremendous start as Anatole, drop-out, anti-hero, rotten painter, and the most sympathetic character ever created by the Goncourts, goes through his paces at the Jardin des Plantes. Anatole's endless clowning has something theatrical about it: he is the element of continuity in what is essentially a collection of episodes; he entertains us in front of the curtain while the novel's scenery is being shifted. The official hero is Coriolis, a languorous and sensitive painter of Creole extraction whose spirit is gradually broken by the exigencies of his mistress, the beautiful Jewish model, Manette Salomon. Manette's crime is to demand marriage from her lover and to import a number of her fearful Jewish relatives into his house, thereby forcing Coriolis to turn his hand to paintings of low degree in order to support them all. The Goncourts are quite convinced—and expect us to be convinced—that the minute Coriolis' steps are turned towards the Mairie the artistic virtue goes out of him. On one level the story is absurd. On another, it makes deep and bitter sense, for the alliance of Coriolis and Manette is a determinist conspiracy to which both submit. This is how Zola would have understood it. In fact a Coriolis plotted by Zola would have exclaimed, *J'assiste à la ruine de ma volonté* ('I am a witness to the ruin of my own will-power') rather than lay the blame for his decline unfairly and squarely at the feet of a Jewish *femme fatale*.

The supporting cast consists of fellow painters, critics and archetypes, the strongest of whom is the country painter, Crescent, a composite Barbizon figure who remains uncorrupted by the life of the monster Paris. His wife eventually arranges Anatole's salvation by getting him a job as attendant at the Jardin des Plantes. These people, roughly speaking, represent the conventional idea of good. The arch-villain of the piece, whose name is never in fact mentioned, is Courbet, described in many a spluttered outburst by one or other of the côterie and condemned not because he was the advocate of ugliness but because he was a vulgarian. (This, incidentally, was also the view of Delacroix.) It is interesting to compare Zola's benevolent earth-father, Bongrand, with the miscreant whom the Goncourts shrilly condemn for being *common: Ah! cette question-là, la question du moderne, on la croit vidée,*

parcequ' il y a eu cette caricature du Vrai de notre temps, un épatement de bourgeois: le réalisme! . . . parce qu'un Monsieur a fait une religion en chambre avec du laid bête, du vulgaire mal ramassé et sans choix, du moderne . . . bas, ça me serait égal, mais commun, sans expression, sans ce qui est la beauté et la vie du Laid dans la nature et dans l'art: le style! ('Oh, that question, the question of modernity, people think it's settled because in our day we have had that caricature of Truth which only tries to shock the bourgeois: Realism! Because a certain gentleman made his private religion of crass ugliness, of an ill-assorted un-selected heap of vulgarity and modernity . . . ugh! I shouldn't mind all this so much, but it's so common, expressionless and without any of the quality which gives beauty and life to ugliness in nature and in art: Style!')

Many pronouncements on modern art are made and these can be traced without difficulty to the writings of Stendhal and Baudelaire. As if to demonstrate their inability to come to terms with the art of their generation, the Goncourts compose two 'modern' pictures for submission by their characters to the Salon. One is called *Le Conseil de Révision* and the other *Un Mariage à Saint-Germain des Prés* and they are described in some detail. They are sentimental anecdotes painted large and they lead one to wonder whether the ideal modern painter for the Goncourts might not have been Meissonnier. Nevertheless, the reader should not be gulled into thinking that *Manette Salomon* is about art. It is, as Henry James so subtly put it, about 'the simple breakdown of joy'.[7] The scene describing Anatole in the café, all set for an evening's roistering yet unable to find any of his former companions because, he eventually realizes, he is no longer a student but a man of thirty-nine, is one of the most painful vignettes in nineteenth-century French fiction.

In the preface to *Germinie Lacerteux* the Goncourts claimed that they had brought something new to the novel, that they were the first to write objectively about the working classes. This is in essence true, but they could never accept the fact that there were bound to be imitations or adaptations of their method. When Zola's novel *L'Assommoir* appeared in 1876-7, they accused him of plagiarism. When Huysmans published *Marthe, histoire d'une fille*, he judged it politic to write to Edmond that it was mere coincidence, that he had no desire to copy the latter's *La Fille Élisa*, which tells substantially the

same story. But although the Goncourts' method was to pass into the history of literature, their style is a slightly more rarefied affair and is of course the link between their novels and their more objective works like *L'Art du dix-huitième siècle*, in which it rises to enormous gas-filled heights. Although this style is unique, it is not all that difficult to imitate. Huysmans managed a plainer and more dyspeptic version of it; Zola, who was not as thick as his friends liked to think, gave a by no means ineffectual parody of it in *L'Œuvre* when the music-loving Gagnière suddenly unleashes a great deal of enthusiasm, expressed in short breathless sentences, heavily interspersed with exclamation marks, when he talks about a concert he has just attended with one of the guests at Sandoz' ill-fated dinner party. The principle behind this *écriture artiste* is the use of uncommon or unfamiliar words which will automatically lift the meaning out of the popular category and impress upon the reading public the fact that the authors are rare spirits addressing themselves to those who are similarly endowed. Despite their claims to have 'invented' a literature of the working classes, the Goncourts write out of a kind of contempt for the general public; they are aristocrats, pursuing essentially aristocratic sensations, and this is another strong link between the novels and the essays on painting.

One more point remains to be made. Historians of literature remark on the extremely visual aspect of the Goncourts' descriptions, which can be appreciated from the Sunday outing in *Germinie Lacerteux*, or the first and last chapters of *Renée Mauperin*. Such passages have been called Impressionist, as indeed they are in the widest and most general sense of the term. But this connection is little more than coincidence. The Goncourts had no love for Impressionist painting; in fact, they despised it, lamenting the demise of small highly finished fragments, gleaming with the thin light golden varnish used in the eighteenth century. They hated the chalky quality of Manet,[8] and although they commended Degas for having a modern temperament, they do not appear to have thought highly of his pictures. Their extraordinary prose, therefore, is their own creation, although it owes a debt to Flaubert; it has nothing to do with modern painting and one can even see that it is overlaid with Romantic preciosity, as indeed is that of Flaubert himself.

Romantic preciosity is probably the most striking feature of *L'Art du dix-huitième siècle*, which was published in instalments from 1859 to 1875. The earliest article—the one on Watteau—which was printed in embryonic form in *L'Artiste* in 1856, provides a further insight into the curious Goncourt method of working, for it consists of a thoroughly subjective general essay allied with scrupulous research into contemporary documents which are published in the form of notes. All modern Watteau scholarship has followed this pattern of an interpretative essay, backed up by the early biographies of Jullienne, Gersaint and Caylus. The Watteau essay is of course a justly famous piece of writing; it is the only essay on painting which is about more than painting, and it is undoubtedly the best-known section of this book, which never lives up to its title. *L'Art du dix-huitième siècle* would seem to promise a general survey of the entire period, but what is provided is a series of essays on the lighter aspects of French painting and engraving in the eighteenth century. Certain major figures are there—Watteau, Boucher, Fragonard, Chardin, La Tour and Prudhon—but painters who take the world seriously, who do not conform to the nostalgic image of the period as a kind of lost paradise of gaiety, wit and charm, are rigorously excluded. Instead, therefore, of Subleyras, Restout, Perronneau, Dumont le Romain, Vernet and David, we get extremely minor figures like Cochin and Debucourt and Gravelot and Moreau le Jeune and Eisen. It is only fair to say that a chapter on the school of David had been planned but was abandoned on the death of Jules. It nevertheless remains significant that David himself was excluded, although in terms of painting he was far more clearly the heir to the eighteenth-century tradition than, for example, Prudhon. But David was a republican, David was a regicide; his inclusion in this company would be tantamount to a lapse of social taste.

The Goncourts' attitude to the eighteenth century was in fact selective, subjective, exclusive, and based on the Romantic fallacy that the past is better than the present. They had been drawn to the period since their youth, possibly because their grandmother, who had been a rather sparkling social figure in the later years of the reign of Louis XVI, seemed to them to possess so many admirable qualities, notably gaiety and elegance, that had vanished

from the society of their own day. This almost Proustian causation led them to make themselves historians of the period as early in their career as 1854, when they published their important *Histoire de la Société française pendant la Révolution*, and throughout the 1850s and 1860s they had written a number of extremely irritating monographs on royal mistresses and famous courtesans of the *ancien régime*—irritating because their scrupulous scholarship could and should have been turned on to something weightier. But again this can be explained by their desire to feel superior to their material. To the brothers Goncourt, the only good woman was a dead one: once dead, she could be dealt with nostalgically. Sophie Arnould, one of the more scandalous and abrasive characters of the eighteenth century, must have turned in her grave when she was elected candidate for the Goncourt treatment in 1857.

This nostalgia for eighteenth-century high life had been one of the motive forces behind their own collection, which is described at length by Edmond in *La Maison d'un Artiste*. Here again the title is misleading, for in their search for eighteenth-century bibelots the Goncourts operated as historians, attaching as much value to fragments like dressmakers' bills, menus, bulletins describing the state of the king's health, and contemporary lives of painters as to the works of the painters themselves. This documentary approach was indeed very far-sighted and it is odd that they do not list it with their other claims to originality, for it marked the inception of a serious and scholarly approach to a period which was viewed with excessive sentimentality and indulgence. Their claim to have unveiled the art of the eighteenth century to an ignorant world is manifestly untrue. Watteau in particular had been a cult name since the beginning of the nineteenth century when the painter Auguste had owned one half of the great *Enseigne de Gersaint*, Watteau's supreme late work, and Ingres had explained the beauties of Watteau's landscapes to his pupils. Those other great collectors of eighteenth-century drawings, Eudoxe and Camille Marcille, cannot be discounted in this connection. If anything, the Goncourts err on the side of vulgarity in their attitude to Watteau in their preliminary article in *L'Artiste*, in which their tone is pretty close to that of popular writers like Arsène Houssaye and the various contributors to women's magazines who are content to sigh dramatically over the glories of

a vanished past. In its final form, however, the Watteau essay is both more serious and more tragic, for the intensity with which the brothers reach out for this other world proves conclusively that they cannot reach it. Their highly subjective view of Watteau's *Cythera* (Fig. 25) contains obvious qualities of ardour and frustration, particularly evident in their description of the felicity of Watteau's characters: . . . *des yeux sans fièvre, des enlacements sans impatience, des désirs sans appétits, des voluptés sans désir, des audaces de gestes réglées pour le spectacle comme un ballet, et des défenses tranquilles et dédaigneuses de hâte en leur sécurité; le roman du corps et de la tête apaisé, pacifié, ressuscité, bienheureux; une paresse de passion dont rient d'un rire de bouc les satyres de pierre embusqués dans les coulisses vertes* . . . ('. . . looks have no fever in them and embraces no impatience; there is desire without appetite and pleasure without desire. There are audacious gestures, but their audacity is measured, designed to be seen, as if for a ballet; and there are feminine ripostes, but of the same nature, tranquil and disdainful of haste in their assurance. It is the becalmed romance of pacified bodies and heads, restored to life and blessed. And the stone satyrs, ambushed in the verdant wings of this theatre, laugh with a goat's laugh at this passion which is all idleness.') This is no longer the imaginary journey of Baudelaire but an imaginary experience, and the great sentence is orchestrated in such a way that it moves like a funeral cortège, a token of bitter loss.

The Goncourts' choice of artists for this work is, as has been noted, very personal. Greuze and Prudhon, for example, retain their attention because their careers were adversely affected by malicious or hysterical wives, a circumstance very close to the Goncourts' own preoccupations and the theme of two of their novels, *Charles Demailly* and *Manette Salomon*. Other painters are made to symbolize eighteenth-century humours and are slightly distorted in the process. A case in point is that of La Tour, whose pastels seem to embody the humanitarian candour of the *philosophes* (Fig. 21). These the Goncourts describe very beautifully without, however, relating them in any way to the society of their time. La Tour was certainly an innovator in that he divested his sitters of their mythological and allegorical trappings, as the Goncourts point out. But they fail to add that this innovation had been

brought about by humbler painters, like Aved, and that in fact the whole trend of eighteenth-century portraiture was towards greater naturalism. Again, La Tour was a difficult, cranky, and anti-social personality, which makes the equilibrium of his works even more remarkable. The Goncourts give a rosy account of his eccentricities and completely mask the total insanity to which La Tour succumbed in his later years. Similarly, Boucher and Fragonard are made into roguish lightweights whose more serious efforts are passed over, and here the style takes on a sort of waggishness which is not always to the point. Of Boucher's pastorals, we read, *Bergères adorables, bergers délicieux! Ce n'est que satin, pompons, paniers, mouches au coin de l'œil, colliers de rubans, joues fardées, mains faites pour broder au tambour, pieds de duchesses échappés de leurs mules, moutons de soie, houlettes fleuries* . . . ('These delightful shepherds, these adorable shepherdesses are all satin, paniers, beauty spots, necklets of ribbon; their cheeks are painted, their hands fit only for embroidery and their feet, escaping from their slippers, are the feet of duchesses; their sheep are silken and their crooks flowered . . .') And of his drawings of nude women: *Quoi de plus charmant que ces académies de femmes de Boucher! Elles amusent, elles provoquent, elles chatouillent le regard. Comme le crayon tourne au pli d'une hanche! Quelles heureuses accentuations de sanguine mettant dans les ombres le reflet du sang sous la peau! Quel dessin gras, facile, lutinant la chair!* . . . *Et quelle variété, quelle diversité de postures, renouvelant sans cesse ce poème de la nudité agaçante! Le corps de la femme joue sous son crayon comme dans le paravent de glace d'une alcove!* ('What could be more charming than Boucher's female life-studies! They amuse, provoke, titillate our eyes. How well his pencil hollows the fold of a thigh! What felicitous accentuations of red chalk suggesting, in the shadows, the reflection of blood beneath the skin! What rich, facile draughtsmanship, seeming to tease the flesh!— And with what a variety and diversity of attitude this tantalizing poem of nakedness is constantly renewed! Female forms move and change at his touch as though in the mirror screen of an alcove.') Yet the Boucher chapter is possibly the best in the book and to this day no one has improved on it. One would wish that the chapters on Clodion and the school of David, which were included in the original plan, had been written, particularly the one on

the school of David, which would seem, at first glance, so at war with their own taste. Possibly they would have stuck to their original method and rooted out the more obscure and decorative of David's followers, presenting them to the public with a flourish as their own discoveries.

L'Art du dix-huitième siècle is a Utopian work, written by two would-be eighteenth-century sceptics, amateurs and aristocrats who felt themselves to be living in an age without intellectual subtlety or finesse of perception. In their attitude to their own times the Goncourts somewhat resemble Delacroix or, indeed, Delacroix's putative father Talleyrand, who laid what amounts to a highly decorated headstone on the old century while casting aspersions on the new one: *On avait de la débauche autrefois, mais on avait de la grâce. On était coquin avant la Révolution mais on avait de l'esprit. Maintenant on est débauché grossièrement et coquin platement.* ('In those days you were debauched, but you were elegant. Before the Revolution you were a scoundrel, but you were witty. Now the debauched are coarse and the scoundrels insipid.')[9] In their manner of writing about eighteenth-century artists they somewhat resemble Diderot. In fact they kept very quiet about their interest in Diderot which must have been strong, for Anatole, the anti-hero of *Manette Salomon*, bears a strong resemblance to Diderot's *Neveu de Rameau*, a work for which they had the greatest admiration. The Goncourts do not bear much resemblance to the critics already included in this study, for they are not interested in that abstraction called style or in the morality of beauty. They are interested in effects rather than causes, and for this reason they cannot work far from the object, unlike Baudelaire, who was able to write a whole *Salon* after one quick turn round the gallery.[10] Robin Ironside has remarked on their 'botanizing' approach to works of art,[11] and it is true that they give the impression that they are viewing paintings and drawings through a very powerful microscope. But this sympathetic concentration on the work itself, which is described with an appetite, an excitement, that makes a powerful, possibly disagreeable impression on the reader, is in fact salutary, although the cult of personality is not entirely absent from it. *L'Art du dix-huitième siècle* is the work of amateur historians, amateur collectors, but it remains one to which the professionals are still obliged to refer.

The question should now be asked, what have these gentlemen-amateurs to do with the development of art criticism as represented by Stendhal, Baudelaire and Zola? A great deal, so long as it is understood that Stendhal, Baudelaire, Zola and the brothers Goncourt all represent different facets of Romanticism which is, in France, the dominant aesthetic movement of the entire nineteenth century. In fact, a study of these four writers is recommended to hard-core art historians who may have the impression that Romanticism died in 1848 when painting entered upon its realist phase. In literature, the boundaries between Romanticism and realism are more difficult to trace. Romanticism survived in its original form far longer in literature than in painting, and literary Romanticism is capable of many mutations, mainly because it does not rely so much on standard imagery. For Stendhal, Romanticism had to do with liberated energy and speculation; this attitude was inherited by Zola who added elements of altruism and of regret. For Baudelaire, Romanticism represented the kingship of the imagination, as indeed it did for Delacroix. With the brothers Goncourt we arrive at the final phase of the Baudelairean attitude, in which the realm of art in general and the cult of images in particular signify consolation, compensation for the ills of contemporary life, a sublimation of human appetites, and theirs is a Romanticism of a highly literary cast which links up with the Parnassianism of Gautier and Flaubert. For Zola, beauty was synonymous with life; for the Goncourts, beauty was the antithesis of life. Had they not been so resolutely pagan in outlook, the Goncourts might have pursued the standard Romantic escape routes into drugs, or the lure of the East, or Catholic mysticism. Their tremendous fight to sustain a contemporary realist position holds them back from the brink of total withdrawal. It was left to their successor, Huysmans, the last great amateur of the nineteenth century, to complete the last stage of the Romantic journey.

Having said this, one is obliged to discuss their most flamboyant claim to originality, the one stated in the preface to *Chérie*: 'the search for truth in literature, the resurrection of the art of the eighteenth century, the victory of Japonism are the three great literary and artistic movements of the second half of the nineteenth century, and we initiated them all.' Note that they

state the stronger position—the pursuit of truth in literature—first, and the least defensible—the victory of Japonism—last; the resurrection of the art of the eighteenth century sits uneasily somewhere in the middle. All claims are substantially untrue. Their claim to have initiated the pursuit of truth in literature seems to be based entirely on their documentary approach and on the fact that *Germinie Lacerteux* is a genuine proletarian case history. This, in their eyes, gives them the right to say that they have launched the realist novel, which in turn became the naturalist novel, for which Zola was given, and indeed took, all the credit. Now the weakness of this argument is that the Goncourts rely on too close a definition of the word 'truth', which to them means taking notes, working from documents: the procedure followed by Flaubert in *Madame Bovary*. The originality of the Goncourts in this respect lies rather in having created documentary novels without heroes, or rather, in turning the heroes into case-histories. It is, after all, still possible to identify with Mme Bovary, as indeed her author did (*Madame Bovary, c'est moi!*); nobody in the world could identify with Germinie Lacerteux or Madame Gervaisais, because the intention behind these novels is to impress the reader, as if the Goncourts were not so much simple story tellers as consultant physicians. It was left to Maupassant, in the preface to *Pierre et Jean*, to rebuke the Goncourts for foisting such an imposition on the reader. Edmond, who only understood morality in aesthetic terms, was content to define his method as 'a scrupulous study of reality in prose that speaks the language of beauty'.[12]

As to their claim to have rediscovered the eighteenth century, this was widely accepted until as late as 1964, when an American scholar, Seymour Simches, published a book proving that a taste for the eighteenth century was widespread in France in the period 1800–60 and citing a lot of names that the Goncourts had found it convenient to ignore, notably Auguste, Ingres, Balzac, Gérard de Nerval, Musset, and the Empress Eugénie.[13] Simches presents his evidence very persuasively, and the case against the Goncourts is proved, or perhaps, here again, they merely mis-stated their claim. They did not 'discover' the eighteenth century; they did unearth a great deal of documentary information about it and thus make possible a true historical reassessment of the period.

With their claim to have brought about the victory of Japonism, they are on very shaky ground indeed, particularly when they stress that they were the first to succumb to the attraction of Japanese objects and works of art. The history of the Japanese taste in nineteenth-century French painting still remains to be set out in water-tight chronological form. Credit for the taste is generally, and rightly, given to the painters Bracquemond, who picked up a volume of Hokusai drawings in 1856, Monet and Whistler. Baudelaire wrote to Arsène Houssaye in 1861: *Il y a longtemps que j'ai reçu un paquet de japonaiseries.* ('I received a parcel of Japanese things a long time ago.')[14] Further research will no doubt establish the first wave of Japanese enthusiasm as earlier even than this. By 1868, after the sensational impact of the Japanese pavilion at the Exposition Universelle of the previous year, the taste had become so widespread that the Goncourts judged it wise to stake their claim as pioneers, and we find an entry to this effect in the *Journal* for 29 October of that year. There can be little doubt that this claim is a bit of wishful thinking, and entirely characteristic of their jealous struggle to make themselves part of history. Edmond, however, does have certain rights in this connection, partly for his very sincere love of such Japanese objects, partly for his admirable self-training in this field, and partly for the enormous collection he built up under the tutelage of the Japanese Hayashi, who came to Paris to pack up the Japanese section of the Exposition Universelle of 1878 and who opened a shop in the Rue d'Hauteville in 1884. And for an appreciation of the scope of this collection, the reader is referred to Edmond's extraordinary account of it in *La Maison d'un Artiste.*

The challenge was flung to posterity but one faithful contemporary shouldered the burden of answering it. *Vous dites avec raison que vous avez ouvert la voie au roman peuple, amené le dix-huitième siècle et le Japon dans la société actuelle,* writes Huysmans. *Oui, mais, eh bien et la langue? . . . Il me semble que c'était là un assez beau fleuron que vous aviez droit de revendiquer, comme les trois autres, car c'est un fait indiscutable et que personne au monde ne pourrait nier, vous avez été des ouvriers de la langue exceptionnels dont l'influence est énorme sur nous tous.* ('You say rightly that you pioneered the working-class novel, introduced the eighteenth century and Japan into contemporary

society. Yes, but what about the language? . . . It seems to me that you had there a fine enough feather to add to your cap with the three others, for it is an undeniable fact—which nobody would attempt to deny—that you have been outstanding craftsmen of the language whose influence on all of us is enormous.')[15] The influence of their triturated style was certainly enormous on Huysmans but hardly on any other writer of note. Today we should advance as their major claim to fame the whole ardour of their aesthetic response, their constant awareness of the beauties of things seen, whether famous or infamous. It is somehow only fitting that they should have admired the pictures of Vermeer ('Van der Meer') some five years before this totally unknown artist was discovered by Thoré-Burger.[16]

Although the Goncourts professed to believe that Romanticism was dead, there is something eminently Romantic about the character of their own *ennui* and revolt against contemporary ugliness, their search for *'une nature plus belle que la nature'*. It is perhaps unusual to find the Romantic search for happiness or the infinite diverted to, and concentrated on, a selection of comparatively minor works of art, and this is perhaps the major reason for one's residual dissatisfaction with a book like *L'Art du dix-huitième siècle*. But there is no doubt that the work of art itself had the ability to change the Goncourts' rancour and loneliness into expansive and positive energy. Edmond sums up his situation with the sobriety of a historian although with an obvious class bias: *Oui, cette passion devenue générale, ce plaisir solitaire, auquel se livre presque toute une nation, doit son développement au vide, à l'ennui du cœur, et aussi, il faut le reconnaître, à la tristesse des jours actuels, à l'incertitude des demains, à l'enfantement, les pieds devant, de la société nouvelle, à des soucis et à des préoccupations qui poussent, comme à la veille d'un déluge, les désirs et les envies à se donner la jouissance immédiate de tout ce qui les charme, les séduit, les tente: l'oubli du moment dans l'assouvissement artistique.*

Ce sont ces causes . . . et incontestablement un sentiment tout nouveau, la tendresse presque humaine pour les choses, qui font, à l'heure qu'il est, de presque tout le monde des collectionneurs et de moi en particulier le plus passionné de tous les collectionneurs. ('Yes, this passion which has become universal, this solitary pleasure in which almost an entire nation indulges, owes its wide following

to an emotional emptiness and ennui; but also, it must be recognized, to the dreariness of the present day, to the uncertainty of tomorrow, to the labours of giving birth to a premature new society, and to worries and anxieties which, as on the brink of a deluge, drive desire and envy to seek immediate satisfaction in everything charming, appetizing and seductive: to forget the present moment in aesthetic satiety.

'These are the causes . . . together with what is undeniably a completely new emotion, namely the nearly human affection for objects, which at the present day make collectors of practically everyone and of me, in particular, the most passionate of all collectors.')[17]

NOTES

1. See Goncourt, *L'Art du dix-huitième siècle*. Edited by J. P. Bouillon, *Miroirs de l'Art*, Paris, Hermann, 1967.

2. These extracts are taken from *Pages from the Goncourt Journal*. Edited, translated and introduced by Robert Baldick, Oxford University Press, 1962.

3. Paul Bourget, *Essais de Psychologie contemporaine*, 1885.

4. Quoted H. Levin, *The Gates of Horn*, Oxford University Press, 1966.

5. Quoted R. Ricatte, *La création romanesque chez les Goncourt*, Paris, Colin, 1953, and P. G. Castex, *La critique d'art en France au XIXe. siècle* (Les Cours de Sorbonne), Paris, 1958.

6. A. W. Raitt, *Life and Letters in France. The Nineteenth Century*. Nelson, 1965.

7. Henry James, *Selected Literary Criticism*, edited by Morris Shapira with a preface by F. R. Leavis. A Peregrine book, Y. 73. N.d.

8. *Blague! blague! blague que cette exposition Manet. Ça vous met en colère, ce montage de coup. Qu'on aime ou qu'on n'aime pas Courbet, il faut lui reconnaître un talent de peintre, tandis que Manet . . . c'est un imagier à l'huile d'Épinal.* ('Farce, pure farce—that's what that Manet exhibition is. This charlatanry is really infuriating. Whether you like Courbet or not, he must be granted a painter's talent, whereas this fellow Manet . . . he's only a dauber from Épinal.') *Journal*, 19.1.1884.

9. Reported in a letter from Mérimée to Stendhal, 19.1.1833.

10. Letter to Nadar, 16.5.1859: *J'ai fait une visite, une seule, consacrée à chercher des nouveautés, mais j'en ai trouvé bien peu; et pour tous les vieux noms, je me confie à ma vieille*

mémoire, excitée par le livret. ('I made one visit, one only, in search of something new, but I found very little; and for all the old names I rely on my old memory, stirred by the catalogue.')

11. *French eighteenth-century painters, by Edmond and Jules de Goncourt.* Translated with an introduction by Robin Ironside. Phaidon Press, 1948. See also J. P. Richard, *Littérature et sensation*, Paris, 1954.

12. *Journal*, 25.1.1876.

13. S. O. Simches, *Le Romantisme et le goût esthétique du XVIIIe. siècle.* Paris, Presses Universitaires de France, 1964.

14. Baudelaire to Houssaye, quoted Sandblad, *Manet; three studies in artistic conception.* Lund, 1954.

15. Huysmans to Edmond de Goncourt, 21.4.1884.

16. Bouillon, *op. cit.*

17. *La Maison d'un Artiste.*

HUYSMANS

Huysmans

THERE ARE MANY reasons why art historians should annexe for their private study the figure of Joris-Karl Huysmans, who wrote art criticism both of a professional and an amateur variety throughout his working life. Huysmans' name occurs in most manuals of the history of nineteenth-century French painting, although for the slenderest of reasons: he was one of the first critics to speak favourably of Gauguin, when the latter exhibited his *Nude sewing* in 1881, and he gave a rousing send-off to the Decadent movement in 1884 with his novel *A Rebours*, which contains, among other fancies, highly coloured eulogies of Gustave Moreau and Odilon Redon. These factors have contributed greatly to the latter-day notoriety of Huysmans as a critic, making him appear as something of a trail-blazer, although nothing could be farther from the general pattern of his evolution. To literary historians, of course, Huysmans has a different reputation, and to Catholic apologists yet another, and it is perhaps the latter group which is most entitled to claim him as its own, for Huysmans is above all the executant and apologist of a form of conversion not much advertised today. Conversion, or reversion, is in fact the constant that binds his various activities together. The naturalist pilgrim accomplishes a return to the faith that inspired the builders of Gothic cathedrals; the sharp-witted admirer of Degas eventually melts before the humble simplicity of Fra Angelico; the canny recruit to Zola's group at Médan finally founds his own school of devout artistic practitioners —rather in the line of the Lucasbund or the Pre-Raphaelite Brotherhood—at Ligugé, an enterprise which, like most of those undertaken by Huysmans, contained several built-in practical impossibilities. Now in all these matters Huysmans' progress is anti-historical; it is, quite literally, *à rebours*, of which the best translation is 'against the current' or 'against the grain'. So wholehearted is Huysmans' withdrawal from the rigorous nineteenth-century moment in which he was condemned to live, so devout his desire to embrace earlier, simpler, more subjective doctrines, that one begins to wonder whether his famed conversion was to Catholicism or whether it was in fact to Romanticism. There is, of course, enough evidence to enable one to argue either view to a more or less water-tight conclusion.[1]

The situation is further complicated by the fact that even in his search for

God Huysmans continues to operate as an art critic, or rather as a critic of the arts. The series of novels which are in essence his autobiography all contain their significant passages of description and appreciation, and these are written not only by a wordsmith of fantastic if rebarbative talent, but by a dandy, a literary, artistic and liturgical dilettante, whose nerves are as easily bruised by a badly sung motet or a corrupt Italian altarpiece as they once were by too physical an image of Parisian life. Huysmans, or Durtal as he calls himself in *En Route*, the most impressive of the novels of the conversion, sets down in all honesty the fact that he cannot say his prayers in Saint-Germain-des-Prés because of the vulgarity of the ambiance. He cries, and this is a cry from the heart: 'To be able to transport here, instead of this boring chapel, the apse of Saint-Séverin, to hang on the walls pictures by Fra Angelico, Memlinc, Grünewald, Rogier van der Weyden, Bouts, interspersed with fine pieces of sculpture like the portal of Chartres or wooden retables like those in the Cathedral at Amiens!' Similarly, when making a choice of books to take with him to La Trappe, he falls into a series of intellectual poses which show that the old Adam, or rather the old Des Esseintes, is far from vanquished. It is as a dilettante of the faith—of any faith—that Huysmans is at his most impressive, and this is a cruel judgement on a man whose desire and ability to believe were so far above the norm. It may go part of the way to explaining his sincere respect for Zola, who lived so magnificently the life of the *homme moyen sensuel*. Huysmans had no simple faith, just as he had no robust conviction, but whatever the objects of his search, his journeyings were parallel: from the age of scepticism to the age of faith; from observer of modern life to an oblate's retreat; from disciple of Zola to biographer of the Blessed Lydwine of Schiedam.

Huysmans is the least sympathetic of the great nineteenth-century personalities so far included in this study. Nervous, thin-blooded, and fidgety, he seems from his earliest days to have suffered from several forms of malnutrition which caused his aesthetic temperature to rise and fall in peaks of admiration or contempt, only rarely coming to rest at the equivalent of 98·4. His judgements on his contemporaries are not unlike the humours of an invalid, his view of the world as highly subjective as that of a patient in a

hospital bed, which is precisely where Huysmans began his literary career. Georges-Marie-Charles Huysmans began his life in 1848 in Paris, although he was later to emphasize his northern descent and even to change the forms of his Christian names. His father was Dutch and purported to come from a long line of fairly humble artists and craftsmen. Huysmans made enormous capital out of this fact, which had great emotional importance for him, to such an extent that he embraced and identified with all things northern—he does indeed seem to inhabit some kind of emotional north—and there is a touch of paranoia in his hatred of southern exuberance which gradually extends to Italian art, with the single honourable exception of Fra Angelico. (In fact, he had exactly the same admixture of foreign blood as Zola.) His mother was French, and after his father's death in 1856 she remarried fairly speedily, thus duplicating the behaviour of Mme Aupick, formerly Baudelaire. Huysmans' early life was a chronicle of brutal discomforts—the first significant autobiographical intrusion into his fiction is the account of his terrible schooldays which we read in *En Ménage*, the novel of 1881—and these discomforts, in some mysterious way, seem to have been prolonged throughout his life, so that he never found an adequately heated room or a digestible, let alone an enjoyable, meal. He became a law student but simultaneously began work at the Ministry of the Interior in 1868, and remained there until 1898 when he retired with the Légion d'Honneur for meritorious service. His working day was short and thus did not interfere with his literary career, which began in 1874 with an extremely slim volume of prose poems entitled *Le Drageoir à Épices*. These are consciously Baudelairean, extremely sentimental, very 'charming' with an occasional 'robust' intrusion, e.g. a description of a Flemish Kermesse, after Rubens, to remind the reader of the author's northern origins. They are not, one would say, the work of a natural writer, and in a sense Huysmans never became one; they were, moreover, written shortly after Huysmans had quitted the bed of a military hospital in Évreux where he had been suffering from an obstinate case of dysentery. They were written, therefore, *à rebours*. Two years later, in 1876, the publication of his first novel, *Marthe, histoire d'une fille*, brought him into contact with the literary lions of the day, Edmond de Goncourt and Émile Zola.

Contact with Goncourt was in fact uncomfortably close, for the latter was about to publish his story of a prostitute, *La Fille Élisa*, and Huysmans, by dint of rushing his story to Brussels, managed not only to avoid censorship laws but to scoop the market. Goncourt, who characteristically believed that Huysmans had milked an earlier novel, *Germinie Lacerteux*, for most of his working-class details, wrote a slightly repressive letter of congratulation. Zola, on the other hand, received him warmly into the naturalist fold, and this is equally characteristic, for Zola, with his devotion to any form of pro-creation, liked to think of his characters giving birth to others, and if Marthe were modelled on Gervaise, in *L'Assommoir*, so much the better. Huysmans' attitude to these two early mentors is fairly consistent and he pays public homage to them, notably in *A Rebours*. At this stage of his career he remains very close to them, particularly to Edmond de Goncourt, although closeness was a state which neither of those two solitaries could tolerate. To a certain extent Huysmans is that 'sick man with high ideals' which the Goncourts claimed collectively to be. He inherits from them not only the bleakness of their Parisian vision, dominated by the pathos of the working class suburb, but the gamey quality (*faisandage*) needed to arouse their interests and his. In addition, Huysmans was to study, to digest, and occasionally to reproduce the pattern of Edmond's greatest non-fiction work, *La Maison d'un Artiste* of 1881, that marvellous perambulation of a collector's home, which provides the justification for those endless descriptions of Des Esseintes' trendy villa in the suburbs, and eventually the cataloguing approach to the cathedral of Chartres.

Huysmans' connections with Zola are nobler and more straightforward, and are expressed very directly in four articles on Zola and *L'Assommoir* published in the Belgian review *L'Actualité* (25 March–1 April 1877), in the dedication of *Les Sœurs Vatard* of 1879, and their correspondence.[2] It is possible that Huysmans saw in Zola and his work something of the robust health and warmth that he admired in Rubens and those quasi-mythical Dutch ancestors of his, yet he also admired him as a writer, singling out for his particular approval *La Faute de l'Abbé Mouret*, one of Zola's less memorable stories which tells of a young priest seduced by a half-wild girl, Albine,

who has grown up in the ruins of a magnificent domain called Le Paradou. Their affair, if one can so call it, is a very simple paraphrase of the Fall and Expulsion from the Garden of Eden, but hindsight enables us to see why Huysmans so admired the novel. Firstly, the many descriptions of Albine's fabulous garden are breathtakingly exotic; they proceed according to the naturalist formula for such matters, i.e. as if the author were reconstructing a gigantic seed catalogue, but Zola's passion and energy transform this catalogue, as Huysmans says, into a Hindu poem. Secondly, *La Faute de l'Abbé Mouret* is an extremely devout book, although the cult celebrated is that of nature, in which the created world conspires to bring two human beings to full knowledge of themselves. The lines in which Zola describes the feelings of Serge and Albine when they have succumbed to the lure of the garden are undeniably solemn and splendid, and there is no doubt that Huysmans was impressed by the conviction of Zola, which he nevertheless—and quite rightly—saw as completely alien. Zola, for his part, considered Huysmans as a disciple, used him as occasional researcher for his novel *Pot-Bouille*, reproved him for his taste for abstruse words, drafted him into the École de Médan, and finally, after the publication of *A Rebours*, reproached him for his disloyalty to the cause of naturalism. Zola's more lasting gift to Huysmans, however, was an object lesson or blueprint of how to be an art critic.

Les Sœurs Vatard, published in 1879, brought Huysmans to the notice of the public and revealed him as a man who could paint word-pictures which put earlier practitioners like Gautier and Edmond de Goncourt in the shade. Although Cézanne and Pissarro preferred the seedier, more humorous *En Ménage*, it is in *Les Sœurs Vatard* that Huysmans reveals a very striking affinity with modern painters. The novel is a story of two working-class sisters, but the main protagonist is Paris, suburban Paris, the Paris of railway stations, cheap restaurants and *café-concerts*. Action is subordinated to description, and the passages that describe the music-halls and crowds of the Avenue du Maine and the Boulevard Saint-Michel, or the railway yard seen from the back window of the sisters' bedroom, have a visual immediacy, and, moreover, a kind of energy, a force of personality, which are utterly unusual in Huysmans' work. Although Huysmans was to write the much

more characteristic *En Ménage*, before devoting himself to art criticism proper, one can sense a strong line of continuity between *Les Sœurs Vatard* and the theme of the painter of modern life which Huysmans celebrates in the various reviews of *L'Art Moderne*.

These reviews, devoted both to the Salon and the exhibitions of the Indépendants, were published in *Le Voltaire*, *La Réforme*, and *La Revue littéraire et artistique*, before being issued in book form in 1883. In a sense they are the most pleasing of Huysmans' writings and the most traditional. As an art critic, Huysmans had inherited a position of great freedom. Stendhal had demanded '*une âme à la peinture*'. Baudelaire had completely established a poetic subjective approach to painting, claiming that the creative writer was in a sense specially qualified to translate the painter's intentions. Zola, the man of revolutions, had drawn the vital distinction between the official Salon and the breakaways, i.e. those who opposed the hegemony of the established rule in painting, and had celebrated the first artist whom he considered the equivalent of the new naturalism in literature: Manet. The Goncourts, although quite fallible in their attitude to contemporary art, had added enormously to the documentation of modern Parisian life and had therefore furnished circumstantial justification of what modern art should be about. They had extended and refined the repertory of modern subjects which Baudelaire had so movingly enumerated in *Le Peintre de la Vie Moderne*.

Huysmans inherits the essentially literary formation of Zola and the Goncourts, perhaps knowing himself to be deficient in the transforming vision of Baudelaire, and it is in his closeness to Zola and the Goncourts that Huysmans first impresses as an art critic. It should be noted here that Huysmans' reviews were more appreciated by contemporaries than had been those of any writer in this study so far: Mallarmé praised him, Fénéon praised him, and, more important, Monet praised him, saying that 'never has anyone written so well, so nobly, of modern artists'. Certainly the reviews in *L'Art Moderne* are a remarkable achievement, not only because in them, without recourse to the coruscating vocabulary of *Les Sœurs Vatard*, Huysmans manages a consistent fidelity to the painted image (no

small victory for so bookish a personality) but because this collection of essays marks the culmination of the century's campaigns in search of a new art form for a new situation. The essays have written in as their central theme the search for, and, triumphantly, the discovery of, the painter of modern life, and as they are divided equally between the official Salon and the Indépendants we are able to see Huysmans exercising the two weapons forged for this worthy successor by Baudelaire and Zola.

The *Salon* of 1879 is in the main a recapitulation of earlier attitudes. Like his mentors, Huysmans begins with an attack on the institution, and although nothing like their equal in fearlessness or the geniality of his abuse, he manages the right note of robust simplicity in his exclamation, *De l'art qui palpite et qui vive, pour Dieu! Et au panier toutes les déesses en carton et toutes les bondieuseries du temps passé.* ('Let's have pulsating, living art, for God's sake. And into the dustbin with all those cardboard goddesses and that devotional rubbish.') Like Zola, he manages to insert into his review of the Salon a long parenthesis on the Impressionists, selecting as his ideal painter of modern life and protagonist in the fight against the traditional ateliers, Degas, who is, as it were, the Manet of the new situation. Like Baudelaire, he can only tolerate landscapes if they are sad (e.g. Millais, *Chill October*), and he also makes explicit the Baudelairean implication that whatever is sad will inevitably be northern. Here we begin to glimpse Huysmans' homing instinct towards the art of the north which culminates in *Trois Églises Trois Primitifs*. In 1879, however, he can find specifically northern characteristics in the suburban dreariness of Raffaelli's *Retour des Chiffonniers*. Here, one suspects, his eye has been sharpened by memory of descriptive passages in the Goncourts' *Germinie Lacerteux*; certainly his descriptions of Raffaelli's work in this and subsequent exhibitions conform clearly to the standards set by that fine book. This emotional attachment to the grey and the bleak makes Huysmans' appreciation of such radiant pictures as Manet's *La Serre* and *En Bateau* the more attractive.

In his review of the Indépendants exhibition of 1880 Huysmans writes as the pupil of Zola, which, of course, at this date, he was. It should be remembered that Huysmans had been introduced to Zola at the Indépendants

exhibition of 1876, and it was Zola the art critic as well as Zola the author of *L'Assommoir* who was very much present at that moment. This may explain the fact that in 1880 Huysmans praises Caillebotte for one of Zola's weaker reasons, i.e. because he has rejected the Impressionist technique in favour of more stable and traditional methods: *(il) a rejeté le système des taches impressionistes qui forcent l'œil à cligner pour rétablir l'aplomb des êtres et des choses; il s'est borné à suivre l'orthodoxe méthode des maîtres et il a modifié leur exécution, il l'a pliée aux exigences du modernisme . . .* ('He has rejected the Impressionist method of strokes which compel the eye to blink before it can restore people and objects to their correct position; he has simply followed the traditional method of the artists of the past and, by modifying their technique, has adapted it to the demands of modernity . . .'). Also in this context it is entirely logical that Huysmans should isolate Degas as the ideal painter of modern life, for here Degas has an almost totemistic significance: he is the replacement of Baudelaire's Guys and Zola's Manet. As if conscious at this point of his inheritance Huysmans writes a particularly fine, measured and uplifting passage on Degas' pictures, and ends the review with the Baudelairean exclamation, *Toute la vie moderne est à étudier encore* ('The whole of modern life has still to be studied'), adding that the world of modern machinery and modern industry, only touched on by Monet in his pictures of the Gare Saint-Lazare, remains to be painted.

Huysmans has no hesitation in finding and naming the painters who please him most. First and foremost is Degas, in his capacity of consummate intelligence and outstanding interpreter of modern life. He is followed by Forain, who, says Huysmans, has *un tempérament très particulier . . . Dans ses bons jours . . . M. Forain est l'un des peintres de la vie moderne les plus incisifs que je connaisse.* ('. . . a very special temperament . . . On his good days, M. Forain is one of the most incisive painters of modern life that I know.') Forain's dilapidated Parisians, seedily lecherous, patiently disenchanted, are particularly close to the protagonists of *En Ménage*, and they are observed with the same ironic gleam by both the painter and the writer (Fig. 27). Huysmans and Forain were to become close friends, and Forain was to follow Huysmans back to the church. Also singled out for honourable

mention are Raffaelli, Fantin, Caillebotte, Mary Cassatt, Berthe Morisot and Renoir. Both Pissarro and Monet are praised but with important reservations—their technique is found to be too experimental, too inadequate. Manet, too, comes in for some familiar strictures. *Chez le Père Lathuile* is hailed as a triumph of modernity, but in the same breath Huysmans can repeat Zola's *canard* about Manet failing to live up to his early promise by producing a solidly composed masterpiece: . . . *M. Manet n'avait ni les poumons ni les reins assez solides pour imposer ses idées par une œuvre forte.* ('M. Manet had neither enough strength in his lungs nor in his guts to impose his ideas by a powerful work.')

Yet on the whole Huysmans is at his best when following the guiding lines laid down by Zola. Even in his appreciation of Gustave Moreau in the *Salon* of 1880—an appreciation which has none of the convulsive nature which it later assumes in *A Rebours*—Huysmans is looking at a curiosity which had already caught Zola's eye.[3] Similarly, his digression, in the *Salon* of 1881, on the use of iron in modern architecture has the stamp of Zola's approval. Rather less happy is the digression on the subject of the English illustrators Walter Crane and Kate Greenaway, in which is included an appreciation of Rowlandson. This attempt to rejoin the Baudelaire of *Quelques caricaturistes étrangers* is doomed. Yet Huysmans departs from Zola and establishes his own originality in one important particular. Whereas Zola could never accept the fact that the Impressionists were performing as audacious and original a task in painting as the Naturalists in literature, Huysmans is perfectly convinced of the parity between the two arts and is constantly drawing literary parallels, making the specific claim that the Impressionists have reformed painting as Flaubert, Goncourt, and Zola have reformed literature, referring to Degas as the pictorial equivalent of the brothers Goncourt, describing Moreau as being overwhelmingly indebted to Flaubert. There is no doubt that this position was more easily established in 1880 than when Zola was writing his pioneer articles, and that Huysmans was devoid of the wider humanitarian ambitions that made Zola examine, somewhat jealously, the intentions of the Impressionist painters and compare them with his own. In 1881 Huysmans was the serenest modern of them all;

he was not at any point in his career as a working art critic seduced by the vision of the genius to come. Working on the material provided, he was able to score correct verdict after correct verdict.

This is particularly true of the review of the Indépendants of 1881, the exhibition that contained Degas' statuette *La petite danseuse*, Pissarro's great landscapes of Pontoise and its environs, and Gauguin's *Nude woman sewing*, among others. In all of these works Huysmans finds the triumph and the consecration of modernity. Degas had provided a further chapter in the history of great artistic revolutions by cancelling at one stroke all the conventions of sculpture, that most hidebound of the arts, as both Stendhal and Baudelaire had formerly had occasion to remark. Gauguin's rather shaky nude is not only a refutation of the theories of Winckelmann—still obtaining, it should be noted, in the Salon—it reveals an unmistakably modern temperament. There is something ironic in this accolade bestowed by one modernist on another. Within a few years both Huysmans and Gauguin were to reveal themselves as splendid twilight examples of different and doomed varieties of Romanticism. But it is in his appreciation of Pissarro, whose works demand specific qualities and disciplines of the eye, that Huysmans is at his most impressive. He even names Pissarro as the summit, the maturity of all Impressionist endeavours, a master-stroke of judgement that was denied to both Baudelaire and Zola. It is impossible to close *L'Art Moderne* without feeling that their investigations have reached a natural and final conclusion.

It is also impossible to close the volume without feeling that Huysmans is for once writing in the best French tradition. Generally speaking, as a stylist he operates on its fringes, achieving spectacular but variable and frequently fallible results. At his most successful, as in *Les Sœurs Vatard*, he can take the Goncourts' style to an even higher pitch of brilliance, but this is a tour de force, unrepeatable and unrepeated. At his worst, as in *Là-bas*, he seems to be writing in the style later favoured by the less individual authors of the Olympia Press. But in *L'Art Moderne* he manages an entirely uncharacteristic sobriety without falling into the lugubriousness that responds to his innate personal character. He writes fine, elegant, nervous prose, and moreover

finds the correct style in which to discuss works of art without imposing his own personality between subject and object.

Yet this moment of equilibrium was not to be maintained. In 1884 Huysmans published a novel which he dedicated to a new friend, Léon Bloy, 'in hatred of the present century'. This novel, in which Huysmans takes a giant step towards overt autobiography, is of course *A Rebours*, on which his notoriety still regrettably rests. In 1903, in a preface to a later edition, Huysmans was to describe *A Rebours* as a forerunner of his Catholic novels, *une amorce de mon œuvre catholique qui s'y trouve toute entière, en germe* ('a beginning of my Catholic work which is all contained there in embryo'). It is also a summary of his early naturalist enthusiasms, but in this instance summary also means reaction, for in this story of Duke Jean Floressas des Esseintes, who retires to an elaborately furnished villa at Fontenay-aux-Roses in an attempt to shut out the horror of the modern world, the methods of Baudelaire, Zola and Edmond de Goncourt are turned to ridicule. In his excellent introduction to the Penguin translation of this novel,[4] Dr. Baldick has stressed Huysmans' continued dependence on his literary forebears, but has not, perhaps, emphasized the fact that such dependence comes to an end in this book. Des Esseintes is best known by his attributes; languid as a latter-day Obermann, vitiated by the philosophy of Schopenhauer, he nevertheless retains his power to corrupt and deprave, and one feels that Huysmans rather exults in his freedom to do so. The formation of his elaborate library provides him with an excellent opportunity to review the works of his favourite writers, and some of them are slightly shaken in the process. For example, although no one can doubt the sincerity of Huysmans' admiration for Baudelaire, expressed most resoundingly in the preface to Théodore Hannon's *Rimes de Joie* of 1879,[5] the ludicrous episode of the mouth-organ, an arrangement of liqueurs which the ultra-sensitive des Esseintes can combine at will while enjoying the sensations and images which the resulting tastes evoke for him, is a pointed and not ineffective comment on Baudelaire's never very securely argued theory of correspondences. By the same token, Edmond de Goncourt's *La Maison d'un Artiste*, which provides the pattern for the descriptions of des Esseintes'

rooms, is dealt a body blow: if imitation is the sincerest form of flattery, it was the form least appreciated by Edmond de Goncourt. Only Zola appears to emerge unscathed, for *A Rebours* contains the impressive passage in praise of *La Faute de l'Abbé Mouret*, yet Zola quite rightly assumed that Huysmans' book, which is anti-naturalist, was a criticism or satire of his method and his achievement, and the first chapter of *En Route*, in which Huysmans makes an overt attack on naturalism, is contained *en germe*, as he would say, in *A Rebours*.

It is interesting in this context to compare the reactions to this curious work of Zola and Edmond de Goncourt. Zola, who was an extremely good friend to Huysmans, registers the sideswipe at himself and his methods, disguised transparently as praise, with percipience but with humour: *Quant à nous autres, à la fin, nous sommes là un peu par complaisance de l'auteur, n'est-ce pas?* ('As for us, in the last resort we are all in it thanks to the author's obliging kindness, aren't we?') He continues, before passing on to more biographical matters, with a shadow of reproach—*Curieuse définition de Baudelaire*—not on his own behalf but on that of their great literary ancestor.[6] From so generous a man as Zola this strikes quite a minatory note. Goncourt, on the other hand, whom Huysmans privately found a crashing bore but to whom he continued to pay extravagant homage, considered the book as almost a tribute to himself. An entry in the *Journal* for 16 May 1884 reads, *A Rebours de Huysmans, ça a l'air d'un livre de mon fils bien-aimé . . . Et une écriture artiste par là-dessus.* ('Huysmans' *A Rebours*, it's like a book by my dearly beloved son . . . And a born writer into the bargain.')

A Rebours is also famous for the passages of appreciation of painters and graphic artists, notably of Moreau, Redon, Jan Luyken and Bresdin. What is less frequently stressed is the fact that the highly coloured prose now masks a dwindling aesthetic response. From the point of view of art historians, *A Rebours* marks the transition from the impeccable receptivity demonstrated in *L'Art Moderne* to the more or less paranoid exclusivity apparent in his second book of art criticism, *Certains*. For Huysmans or des Esseintes is now more interested in the subject matter of these artists than in the fusion of style and image, and his interest is informed by a growing fear and hatred of the modern world. Thus the logical culmination of *A Rebours* is the first

surprising essay in *Certains*, or rather that part of it given over to Gustave Moreau. There are remarkably close lines of continuity between the two. Huysmans states his position by refuting Taine, and by implication Zola, explaining that the theory of environment (*race, milieu, moment*) can frequently be observed to work in reverse, by reaction—*à rebours*. Thus, those baffled by the dream world of Gustave Moreau will find an explanation and a justification of it the moment they step out from the gallery into the street, where the sheer horror of modern life will be revealed to them. There follows a passage of description so paranoid that in comparison with the Huysmans of 1889 the Huysmans or des Esseintes of 1884 appears as a kindly hermit: *A la réflexion, alors qu'on se promenait, que l'œil rasséréné regardait, voyait cette honte du goût moderne, la rue; ces boulevards sur lesquels végètent des arbres orthopédiquement corsetés de fer et comprimés par les bandagistes des ponts et chaussées dans les roues de fonte; ces chaussées secouées par d'énormes omnibus et par des voitures de réclame ignobles; ces trottoirs remplis d'une hideuse foule en quête d'argent, de femmes dégradées par les gésines, abêties par d'affreux négoces, d'hommes lisant des journeaux infâmes ou songeant à des fornications et à des dols le long des boutiques d'où les épient pour les dépouiller les forbans patentés des commerces et des boutiques, l'on comprenait mieux encore cette œuvre de Gustave Moreau, indépendante d'un temps, fuyant dans les au-delà, planant dans le rêve, loin des excrémentielles idées secrétées par tout un peuple.* ('Thinking it over, when one began walking and the soothed sight began to look around, and saw that horror of modern taste; the street: those boulevards with their vegetating trees, orthopaedically corseted in metal bands and trussed up by the Highways Department into hoops of cast iron; those streets, shattered by enormous omnibuses and wretched advertising vans; those pavements teeming with a hideous crowd after money, women worn out by childbirth and stupefied by horrible trafficking, men reading vile newspapers or thinking of fraud and fornication as they pass by the shops and are spied on by the licensed sharks of business and commerce, ready waiting to fleece their prey. All this gave one a still better understanding of the work of Gustave Moreau, timeless, escaping into the beyond, hovering in the realm of dreams, remote from the fetid ideas secreted by an entire people.')

Yet at the end of *A Rebours* des Esseintes is forced to return to this night-mare city which in fact Huysmans had never left, apart from his military service and a journey to Belgium and Holland in 1876. Although an emotional northerner, his intellectual formation was entirely Parisian. Des Esseintes packs his bags for Paris with a prayer for salvation on his lips and the desire for another form of retreat germinating in his mind. Huysmans himself stuck it out quite a bit longer, and although there is little doubt that the prayer of des Esseintes is undeniably his own, there is equally little doubt that he had great difficulty in leaving the world behind, and that he continued to value Paris and Parisian life as an abrasive agent which stimulated him to his most brilliant intellectual best. Nowhere is this more vehemently demonstrated than in *Certains*, a volume of occasional essays on artists and works of art published in 1889. Some of the material is familiar—the passages on Moreau, Redon, Degas, Chéret and Raffaelli—but the attitude is changed. Whereas *L'Art Moderne* bore the stamp of enlightenment, *Certains* is animated by a convulsion of distaste, and is not free from spite. Here Huysmans demonstrates his emancipation from his predecessors in the genre: to take one small and obvious example, he begins the book with a blanket condemnation of *la foule* and makes this amazing statement: *le critique d'art est généralement un homme de lettres qui n'a pu produire de son propre crû une véritable œuvre*. ('The art critic is usually a man of letters who has not managed to produce a real work of his own creation.') That for Stendhal, Baudelaire and Zola! His more specific judgements are equally extreme and partial. He refers to 'that animal Courbet' with his 'working-class mind'; on the other hand the indifferently talented Belgian porno-grapher Felicien Rops is placed on the same level as Memlinc, because he has *'un âme de primitif à rebours'*. It is also, says Huysmans, about time we admitted the fact that Millet's pictures are bad, and that nineteenth-century Paris is an architectural disaster. And yet these blemishes, although obtrusive, pale into insignificance beside the sheer brilliance of judgement and expression achieved by this misanthrope, this self-flagellant, this epitome of Romantic sado-masochism, who on this occasion—and it is the first and last time we see him doing it—manages to capture something of that child-

like vision so esteemed by Baudelaire. The Eiffel tower, for example, which acted as a lightning conductor for his ferocity, is variously compared with an oil well and a '*suppositoire solitaire*'. Huysmans distinguishes himself from his contemporaries by noticing how small it is, and is there not something genial, even Baudelairean, about this statement: *La Tour Eiffel est vraiment d'une laideur qui déconcerte et elle n'est même pas énorme*. ('The Eiffel tower is really disturbing in its ugliness and it isn't even enormous.') Similarly, hear him on Delacroix and Ingres. He is perhaps the first critic of the century to be equally knowing and enthusiastic about their perfections and imperfections. Delacroix, for Huysmans, is distinguished by *des sursauts, des exultations, des cabrements de nerfs mal dominés* ('the sudden starts, exultations and contortions of uncontrolled nerves'), but if anything goes wrong, *Delacroix devient singulièrement inférieur* ('Delacroix becomes distinctly inferior'). *Homme étrange, incomplet, presque toujours rageur et languide, superbe quand sa fièvre flambe, cabotin et vieux mélo quand elle charbonne . . . il a infusé, à défaut de santé, dans la peinture de son temps, une bravoure acculée, un fluide nerveux, une force intermittente de colère, une pulsation d'amour*. ('A strange, incomplete man, almost always passionate and listless, magnificent when his inner fever flares up, but as hackneyed as a third rate actor when it dies down . . . he breathed into the painting of his time not health, but a sort of last-ditch bravura, a nervous fluidity, sporadic bursts of anger and the pulsations of love.') Ingres is similarly flawed. He labours like an ox, he has the soul of a provincial drill sergeant; he is capable of painting the mortuary portrait of Mme Moitessier, a portrait composed of steel, wallpaper, and floor polish, yet is also capable of the wonderful *Mme Devauçay* (Huysmans says De Vançay), in which, *à force de travail et de bonne foi, le vieil aphasique est parvenu à pousser un cri* . . . ('by sheer hard work and good faith the short-winded old gentleman has managed to utter a cry . . .'). More important, *l'École impressioniste s'est souvenue de ce plaquage japonais, de cette naïveté presque féroce des tons, de cette gaucherie imagière, voulue, de cette sincerité de primitif.* ('The Impressionist school remembered this Japanese application of colour, almost ferocious honesty of tones, deliberately gauche style of picture-making, and this sincerity of the early masters.') Huysmans' partiality

leads him to cite a portrait by Forain as an example of this inheritance. We should perhaps be more likely to think of Manet's *Portrait of Berthe Morisot with a bunch of violets*.

Yet undoubtedly the most singular essay in this connection, and the one best known to readers of Mario Praz' *Romantic Agony*,[7] is the one on Bianchi di Ferrari's very mild altarpiece in the Louvre, which Huysmans sees as a sort of anagram of sexual deviations (Fig. 28). Huysmans clings to two well-worn and mutually contradictory theories about human behaviour. The first is that vice, or pleasure, wears you out; the second that virtue, or continence, wears you out because it encourages you to think about vice. In the faces of the Virgin, St. Benedict, and above all St. Quentin, can be read these various degrees of fatigue. If chaste, the explanation of their apparent listlessness is easily come by. But are they chaste? Saints they may be, but let us not forget that they are saints painted by *an Italian*. And signs of depravity are not difficult to find. St. Quentin, *'un éphèbe au sexe indécis'*, has suspiciously long hair, wears delicate linen and a blue ribbon, and Huysmans notices *ces doigts fureteurs égarés sur une arme, ce renflement de la cuirasse qui bombe à la place des seins* ('those prying fingers straying over a weapon, this armour bulging in the place of the breasts'). Then, in a moving sentence, Huysmans wonders whether St. Quentin is still waiting to experience a state of grace, *la combustion de l'âme qui fond et s'écoule en le Seigneur, cet état parfait de l'extase, où l'esprit s'enivre de délices dans l'existence essentielle . . .* ('the soul on fire, melting and flowing into the Lord, that perfect state of ecstasy in which the spirit grows intoxicated with the delights of eternal life . . .'). But this explanation is rejected and another proposed. The saints are clearly in a state of mortal sin, and the family resemblance between them is no accident, for St. Benedict is the father of the Virgin and St. Quentin, and they in their turn have given birth to the wretched little angel playing the viola d'amore. This conceit, says Huysmans, is typical of the perfidious Renaissance which so regrettably replaced *'la rigide blancheur du Moyen Age'*, which he was to spend the rest of his life celebrating.

This essay is very mad indeed and it is not an isolated instance. When Huysmans paid a visit to Frankfurt in 1905, he found to his horror that not

only did the Museum contain certain Italian paintings but that the town itself was full of Jews. The rigid whiteness of the Middle Ages was nowhere in sight. Reverting to a polemical brilliance which marks a dynamic contrast with the flaccid writing of *La Cathédrale* and *L'Oblat*, Huysmans draws a parallel between these two phenomena. *La Florentine* (a picture which is in fact now attributed to Bartolomeo Veneto) could only have been painted by 'an Italian living at the court of Rome, and in a state of considerable personal depravity'. Only such an artist could have painted this masterpiece of tranquil perversion. (We hear no more at this date of the theories of Taine working *à rebours*.) And it is entirely fitting, concludes Huysmans, that this symbol of the shame of the Papacy should end up in Frankfurt, the town in which the rout of the Church is being accomplished '*entre les mains des Juifs*'.

The Romantic agony of J. K. Huysmans becomes explicit in *Là-bas*, acute in *En Route*, and becalmed in *La Cathédrale*. Of the three books, *Là-bas*, the one which deals with satanism, is the most Romantic, for the first page presents us with a condemnation of naturalism, the story contains characters—notably Carhaix, the saintly bell-ringer of Saint-Sulpice, who might have escaped from a discarded chapter of Victor Hugo's *Notre-Dame de Paris*—while the whole tenor of the story, with its simple confrontations of black and white, its grave acceptance of phenomena like incubi and succubi, demands a credulity which the author evidently possessed in greater quantities than many of his readers. *En Route*, the impressive account of Huysmans-Durtal's trial period at the Trappist house of Igny (called Notre-Dame de l'Atre in the story) drops all this literary paraphernalia and although Huysmans professed to have written the book '*surtout pour le monde intellectuel de Paris*',[8] it is the clearest and most candid of all his works, as honest in its portrayal of the descent of grace as is Durtal's relief when he gets back into the train for Paris. But in *La Cathédrale* the Gothic syndrome is present again in full force. This book, which incidentally is contemporary with the Dreyfus affair, is a study of the cathedral of Chartres. Huysmans abandons the naturalist method here; he made only two or three day trips to Chartres and seems invariably and characteristically to have

picked bad weather, which gives him a pretext for dissertations on the dolorous but holy medieval world, although in summer Chartres has a limpid blond serenity and an open aspect that confound religious fatalism of any denomination. The book was composed from a number of manuals of architectural history, medieval treatises on the symbolism of colours, numbers etc., and whatever Huysmans' quarrel with naturalism, it is evident that he is on shaky ground when he abandons the method of direct observation.

For art historians, the late novels are a curious experience, for although Huysmans still has plenty to say about painting, his critical faculties have been displaced by other considerations. His connoisseurship is now applied to religious orders or the quality of plain chant to be heard in various monasteries and convents. He has escaped with considerable relief from the modern world and his long flirtation with the religious life now fills his entire horizon. He looks at many religious pictures and does not hesitate to dismiss whole schools of painters for lack of unction. His choice is finally narrowed down to Fra Angelico, Grünewald and the Flemish masters. The passage on Grünewald's Karlsruhe *Crucifixion* (Fig. 29) in *Là-bas* is justly famous: here is part of it in a particularly fine translation:[9]

'Dislocated, almost dragged from their sockets, the arms of the Christ seemed pinioned from shoulder to wrist by the cords of the twisted muscles. The collapsed armpit was cracking under the strain. The hands were wide open, the thin fingers contorted in a wild gesture of supplication and reproach, and yet also of blessing. The chest quivered, greasy with sweat. The torso was barred and furrowed by the cage of the sunken ribs. The flesh was swollen, stained and blackened, spotted with flea bites, spotted as with pin pricks by splinters that had broken from the rods at the scourging and still showed here and there under the skin.

'Decomposition had set in. A thicker stream poured from the open wound in the side, flooding the hip with blood that matched deep mulberry juice in colour. Discharges of pinkish serum, of milky lymph, watery fluid the colour of grey Moselle wine, trickled from the chest and soaked the belly and the dripping loin-cloth below. The knees had been forced together so that

the knee-caps touched and the relaxed legs hung helplessly to the feet, curved apart, and meeting again only where the distended feet were pressed one on top of the other, stretched out in full putrefaction and turning green beneath the rivers of blood. These feet, spongy and clotted, were horrible, the swollen flesh rising above the head of the nail, the clenched toes, contradicting the imploring gesture of the hands, seemed cursing as they clawed with their blue nails at the ochreous earth, impregnated with iron like the red soul of Thuringia . . .'

This passage of course is not about painting but about physical suffering, just as his life of the Blessed Lydwine of Schiedam is about physical suffering rather than sanctity, but it is the last of Huysmans' aesthetic writings to have any kind of energy or attack. It is also the last characteristic passage he wrote on a painting, for the readable but tetchy pages on the School of Cologne or Rembrandt which occupy the latter part of *La Cathédrale* might have been written by Edmond de Goncourt on one of his healthier days. The condemnation of Rubens (also in *La Cathédrale*) takes us a long way from the optimistic blood-links established in *Le Drageoir à Épices*. Saddest of all, in his attempt to find a modern religious art, Durtal-Huysmans commits a form of critical apostasy which would have been unthinkable ten years earlier: he prefers those saintly amateurs Paul Borel and Charles Dulac to one whose name is not mentioned but who is easily recognizable from references to *tricheries de corps gauches cernés par des fils de fer* ('those fakes, those clumsy bodies encircled in wire cages'): Gauguin (Fig. 30).

After his retirement from the Ministry of the Interior in 1898 Huysmans spent two years as a Benedictine oblate at Ligugé in Poitou. In 1901, however, the Waldeck Rousseau law on religious associations dissolved the community and sent him back to Paris, where, yet again, he suffered in a succession of chilly, noisy rooms. In these years he wrote his most committed works, *L'Oblat* and *Ste. Lydwine de Schiedam*. Something of the old irascibility reappears in *Les Foules de Lourdes*, in which the horror of the architecture occasions a brief struggle between faith and criticism.

Huysmans' terrible last illness, which he bore with immense courage, is always cited by his Catholic biographers as the final triumph of an arduous

spiritual pilgrimage, and on this point, of course, dissentient voices must be silent. Art historians may regret the fact that Huysmans failed to live up to his early critical brilliance. Perhaps the truth of the matter is that criticism cannot be a full-time occupation for the thinking, feeling man. For this reason, Stendhal 'missed' Delacroix, Baudelaire 'missed' Manet, Zola 'missed' Cézanne, and Huysmans 'missed' Seurat. Our final dissatisfaction with Huysmans in the context of this particular study is surely that he turned his back on all those sparkling truths discovered by Diderot. Huysmans is 'gothic' in the pejorative sense habitually employed by Diderot, i.e. appertaining to the superstitious and obscurantist Middle Ages. The long chain of belief in the idea of perfectibility has been abandoned. The genius of the future has surrendered to the safer doctrine of the genius of the past.

NOTES

1. For a variety of interpretations, see Ernest Seillière, *Huysmans*, Paris, Grasset, 1931; Helen Trudgian, *L'Esthétique de J. K. Huysmans*, Paris, Conard, 1934; Pierre Cogny, *Huysmans à la recherche de l'unité*, Paris, 1953; Robert Baldick, *Life of J. K. Huysmans*, Oxford, 1955; John Brandreth, *Huysmans*, Bowes and Bowes, 1963; Philip Ward Jackson, *Art Historians and Art Critics VIII: J. K. Huysmans*, Burlington Magazine, November, 1967.

2. J. K. Huysmans, *Lettres inédites de Huysmans à Émile Zola*, by Pierre Lambert, with an introduction by Pierre Cogny. Geneva, Droz, 1953.

3. *J'y vois . . . une simple réaction contre le monde moderne* ('I see in it simply a reaction against the modern world'). Zola, *Salon of 1876*.

4. *Huysmans. Against Nature.* A new translation of *A Rebours* by Robert Baldick· Penguin Classics L.86.

5. *J'ai nommé le poète de génie qui, de même que notre grand Flaubert, ouvre sur une épithète des horizons sans fin, l'abstracteur de l'essence et du subtil de nos corruptions, le chantre de ces heures de trouble où la passion qui s'use cherche dans des tentatives impies l'apaisement des folies charnelles, j'ai nommé le poète qui a rendu le vide immense des amours simples, les hantises implacables du spleen, le déroute des sens surmenés, l'adorable douleur des lents baisers qui boivent, le peintre qui nous a initiés aux charmes mélancoliques des saisons pluvieuses et des joies en ruine, j'ai nommé le prodigieux artiste qui a gerbé les Fleurs du*

Mal, Charles Baudelaire! ('I have named the poet of genius who, like our great Flaubert, by a single adjective opens up boundless horizons, the abstractor of the finest essence of our corruption, the bard who sings of those twilight hours when wasting passions seek to quell their carnal madness in blasphemous impulses; I have named the poet who described the vast wastes of uncomplicated love, the relentless obsessions of spleen, the collapse of the jaded senses, the exquisite pain of those long, engulfing kisses, the artist who initiated us into the melancholy charm of rainy seasons and of wrecked joys. I have named the prodigious artist who garnered "Les Fleurs du Mal": Charles Baudelaire.') (Preface to T. Hannon's *Rimes de Joie*, Brussels, 1881. Preface signed Paris, 1879.)

6. Médan, 20.5.1884. Lambert and Cogny, *op. cit.*

7. Mario Praz, *The Romantic Agony*, translated by Angus Davidson, London, 1933, 1951.

8. Letter to Dom Micheau, 25.2.1895.

9. Brandreth, *op. cit.*

Index

INDEX

INDEX